American Art

from the Dicke Collection

American Art from the Dicke Collection

This exhibition is composed of a major loan of paintings, sculpture and works on paper from the Dicke Collection of American Art.

Exhibition Schedule:

The Dayton Art Institute, Dayton, Ohio: June 15 - August 31, 1997

First Edition

Library of Congress Catalog Card Number 97-65853

ISBN 0-937809-14-4

Designed by Jennifer Perry

Typeset in Helvetica Neue, Young Baroque, and Bodoni

Printed on Consolidated Productolith Dull 80lb. Text and 100lb. Cover
 by Brown and Kroger Printing Company

Bound by Dayton Bindery Service, Inc.

Printed in the United States of America

Contents

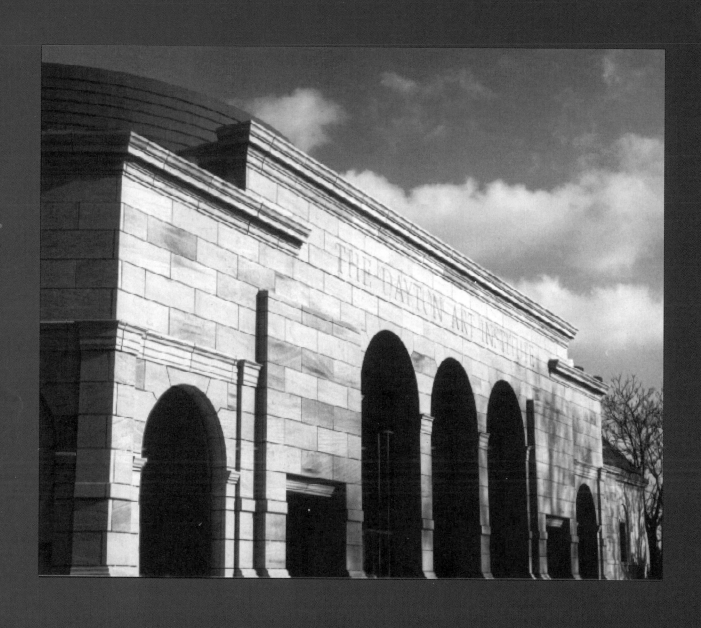

Preface

The opening of *American Art from the Dicke Collection* marks the beginning of a new era for The Dayton Art Institute. This, the first opportunity for the public to see the Dicke Collection in its near entirety, also heralds the reopening of the museum after the completion of an 18 month, all-encompassing construction and renovation project. This capital improvements program, the largest in the history of the Art Institute, has expanded and improved one of this nation's greatest museum buildings with astounding results.

It is most fitting that this new era and building be ushered in with the stunning collection of American art which has been assembled by the Dicke family. *American Art from the Dicke Collection* reflects the 78-year history of the Art Institute in its celebration of the legacy of art collecting, as one that carefully mirrors the history of art and the personal taste of the collectors. Endeavoring in much the same way as The Dayton Art Institute's numerous collectors and directors have, it is two generations of Dickes, a prominent New Bremen, Ohio family, who privilege the museum with not only the gracious lending of their fine collection, but also with their generous financial support of the Art Institute's permanent collection. Visitors to the museum's galleries of American art will find these wonderfully transformed spaces in the newly named "Dicke Wing of American Art."

The Dicke Collection

It is also a personal statement. In this catalogue, Jim Dicke II shares with us valuable insight into the formation of the collection and the rewards his family has derived from the process of amassing 130 works of art. As an endeavor involving two generations of Dickes, the collection is delightly eclectic. Its unique variety reflects, not only the Dicke family taste in art, but also the history of art in America, echoing the ever-changing blend of traditions, influenced by forces in Paris, Britain, Germany, Japan and other parts of the globe.

As with many private and public collections, the Dicke family began acquiring works of art which attracted them. A keen eye, reliable dealers and an indefatigable zeal for learning aided the family and resulted in a dazzling collection of American painting, sculpture and works on paper from the thirty years preceding World War I. The collection continues into the 20th century with the works of American regionalist painters such as Doris Lee and is complimented by holdings of contemporary of art of international, national and regional importance. The collection is not stagnant and in years to come it will be rewarding to see the Dicke Collection as it reaches higher and higher plateaus.

The catalogue includes essays on two artists featured in the collection: Arthur Wesley Dow and Doris Lee. These contributions by Nancy E. Green of the Herbert F. Johnson Museum at Cornell University and Todd D. Smith, Associate Curator of American Art at the Art Institute, and curator for this exhibition, are an additional tribute to the Dicke's focused approach to assembling a collection of note. Additionally, the catalogue features individual entries on the paintings and sculptures, 84 in all; the former include reproductions of their frames. These entries have been authored by Smith, Green and Kristin Fedders. Eli Wilner, one of America's foremost framers, who has worked closely with the Dicke Collection almost since its inception, has provided an insightful essay on the frames which grace the collection.

A Collecting Spirit

Jim Dicke II, in his "A Personal Approach to Collecting" in this catalogue, provides readers with a wonderful narrative journey through the adventures of assembling this marvelous collection. The collecting spirit which formed (and continues to form) the collection can be seen throughout the museum's newly renovated galleries. The encyclopedic collections of The Dayton Art Institute are the result of many avid and beneficent collectors who have bestowed upon the museum their treasures for future generations to enjoy. The founder of the museum, Mrs. Julia Shaw Patterson Carnell started the legacy of collecting in the first quarter of this century. Today, numerous treasures of Asian art grace our galleries because of her generosity. In that same tradition, through the years, Mr. and Mrs. Jefferson Patterson and Mr. and Mrs. Eugene Kettering contributed works of Asian art which now number in the thousands. Last year alone, Mrs. Virginia W. Kettering contributed more than 500 works of art to the Asian collection. It is this same spirit that the Dicke family has continued, adding to the American collection with works by Rockwell Kent, Cyrus Dallin, Doris Lee and Robert Brackman. The Dayton Art Institute's permanent collection, which now numbers more than 10,000 objects, carries the names of other donors, far too numerous to enumerate here.

A New Museum

This special exhibition signals the successful completion of the museum's most ambitious capital effort in its history. "The Renaissance of A Dayton Masterpiece," a $24 million capital campaign, is highlighted by $17 million in renovations to the original 1930 Italian Renaissance-revival building and the addition of nearly 35,000 square feet of additional space. The newly constructed space completes the original plan as conceived in the 1920s by noted museum architect Edward B. Green of Buffalo, New York. We now have an octagonal building which provides visitors a simple, wonderful flow; brilliant vistas, both interior and exterior; and a majestic space in which one can reflect upon the artistic accomplishments of more than 5,000 years of human creativity.

The rebuilt museum opens with more than 60,000 square feet of gallery space, lit by more than 1,700 lighting cans, lining almost

two miles of lighting track. More than 1000 works of art are reinstalled into the permanent collection galleries; these works are complemented by a more comprehensive plan of educational materials, informative labels, and didactic panels to enhance the visitor experience.

The museum's galleries, including the special exhibition wing which houses *American Art from the Dicke Collection,* have been masterfully reworked through the brilliance and tender caring of team of professionals: architect Tom Thickel and the firm of Levin Porter; designer Elroy Quenroe; and to invoke the overused adage, last but not least, the Art Institute's Chief Curator and project director for this undertaking, Marianne Lorenz and her team of curators, educators, registrars and art handlers.

Thanks to a dedicated and determined capital campaign chairman and former president of The Dayton Art Institute, Brad Tillson. The $24 million is significant for many reasons. First, not only is it the largest campaign even undertaken by the museum, it represents a total more than three times the sum of all previous capital endeavors at the Art Institute, including the creation of our National Historic Landmark structure. The campaign is the largest ever accomplished by a not-for-profit organization in the region and even eclipses similar efforts in nearby Cincinnati and Columbus, and it surpasses the original campaign goal by nearly $4 million. Thanks to the generosity of leadership gifts from Mrs. Virginia W. Kettering and the Kettering family; the Berry family; the Dicke family; the State of Ohio; and corporations such as NCR, Mead, General Motors, Bank One; and other organizations such as the Kresge Foundation and Montgomery County; a new museum is open for this generation and many more to enjoy.

Join me in celebrating this "Renaissance" of The Dayton Art Institute and the wonderful treasures of *American Art from the Dicke Collection.*

Alexander Lee Nyerges

Director, The Dayton Art Institute

Introduction

The Dicke Collection of American art is indeed a collection of riches. From the beautiful, inspired portrait by Julius Stewart which dons the cover of this catalogue to the stern and stoic image captured by Georges Schreiber in his *I Raise Turkey and Chickens* (Plate 62), from the images by Arthur Wesley Dow which range from Barbizon-inspired to nearly abstract landscapes to the contemporary renderings of nature by Harold Gregor and Stephen Hannock, the exhibition presents a vast display of styles from the last 130 years of American art. This is an exhibition with something for everyone, and this catalogue has been organized to highlight the exhibition's broad appeal. The catalogue includes essays which focus on and present new scholarship on two featured artists within the collection—Arthur Wesley Dow and Doris Lee; entries and colorplates for each of the 84 paintings and sculptures in the show; a perspective from Jim Dicke, II which not only retells the building of this collection but offers insight into collecting for novices and pros alike; and finally a short piece by one of America's foremost framers, Eli Wilner, on the frames in the collection.

In the organization of this exhibition and catalogue, we realized that the Dicke collection houses two subcollections within its significant holdings—one of Arthur Wesley Dow and one of Doris Lee. Thus instead of writing a history of American art through the works in the entire collection, a history which admittedly would have been a forced one, we chose to focus on Lee and Dow and to publish an essay on each of them. The individual entries provide an entree into each of the works, while presenting them within the larger context of American art history.

Nancy Green of Cornell University's Herbert M. Johnson Museum of Art is considered a foremost expert on Arthur Wesley Dow, and it is my pleasure to have Ms. Green as a contributor to this project. Her essay provides a biographical discussion of Dow and the forces in his life which shaped his art. As someone who loves the challenge of archival research in the history of American culture, I was thrilled by the Doris Lee project. Here is an artist who was voted by high school students in Chicago in 1942 as as the sixth most popular artist (in front of Winslow Homer), but whose name has fallen out of the canon of American art history. My essay attempts to reconstruct one of the discourses which shaped Lee's popularity and in the end may have accounted for her fall from critical favor; this discourse is the midcentury concern with middlebrow culture.

The connections that a majority of these artists have to The Dayton Art Institute are significant. Many of them are represented in our permanent collection, while still others have been exhibited at the Art Institute over the decades. As Nancy Green points out in her essay on Dow, this modernist painter was known as much for his teaching style as for his paintings and prints. His

influence reached Dayton in numerous ways, the least of which was through the sales of his textbook, *Composition*. One of the Art Institute's earliest instructor's, Martha Schauer greatly admired Dow and even possibly studied with him at either Columbia Teacher's College or at the Pratt Institute; and her notebooks and lesson plans draw heavily on Dow's methodology.

Likewise, Doris Lee is making a return to the Art Institute. As part of a traveling exhibition in 1939, Lee's work was featured in a display of American Scene Painters. Other artists in this show at The Dayton Art Institute included Grant Wood, John Steuart Curry, Thomas Hart Benton and Lucille Blanch. According to the *Dayton Sunday Journal-Herald* story on the show, written by Merab Eberle, Lee "was made famous because so many disagreed with the verdict of the jury sitting on merits of the Art Institute of Chicago Annual of several years back."

As Jim Dicke's essay lays out, one of the motivating factors guiding the Dicke collection has been the belief that a collector owes a service to his/her community and particularly to young artists. This commitment coupled with the Dicke's interest in vibrant, and often under-recognized, American art from the decades surrounding the Turn-of-the-Century has made for a collection which both looks to the past while casting its eye forward. Even a brief review of the checklist for the show will demonstrate the range of works in the collection, something in every style and for every level of collecting.

One of the intentions of this exhibition is not only to bring out in to the open the works of art themselves, but as importantly, to focus on the topic of collecting. Like other museums around the country, The Dayton Art Institute has relied (and continues to rely) heavily on the gifts of local collectors. While the Dicke family has been contributing to the cultural and social life of the Miami Valley for over two decades, their involvement with the Dayton Art Institute has been more recent. Through generous gifts of art-works, acquisition funds, conservation funds and time on museum committees, the Dicke family has aided the Art Institute in greatly increasing the quality of its collection of American art.

The inclusion of the essay by Eli Wilner on period frames, the color reproduction of the frames with each of their canvases, and pertinent information on many of the frames acknowledges the relationship between Dicke and Wilner. A recently purchased painting rarely leaves New York City for New Bremen without the specialists at Eli Wilner having a go at the work.

Like all projects of this magnitude, there is an army of persons who have made the road a little easier. First of all, I must thank Jim Dicke, II. His interest in American art is only surpassed by his desire to share this with a wider public. To visit the offices of Crown Equipment Corp. in New Bremen, Ohio is to take a walk through a constantly changing gallery of American art history. At Crown, Julie Ahlers, Jim's assistant, proved indispensable. Her willingness to aid the Art Institute in this project is a testament to her dedication. I have often told her that she has had more training in the art world than most veteran museum employees.

At the Art Institute, special thanks must be extended to Jane Dunwoodie and Kristina Sullivan, Librarian and Assistant Librarian respectively, who unfailingly and often without too much of a grimace helped me track down some rather obscure leads and who processed interlibrary loan requests with breakneck speed. In my own department, Lora Stowe, Curatorial Assistant, proved invaluable, providing me with support and a sympathetic ear as we overturned seemingly every stone in search of the best image for the Lee essay. I have had the luxury of being assisted by two interns from the University of Dayton during this project—Amy Stidwill and Michael Somple. These two students have aided me in compiling the extensive bibliography on each of the artists represented in the show and have helped me track down any number of research needs.

The production of this catalogue owes a tremendous debt to the Art Institute's Graphic Designer, Jennifer Perry. Jennifer has undertaken this immense project with a remarkable graciousness and determination, not to mention a deep reservoir of talent. Dan Mueller has painstakingly prepared each of the color plates for printing, including outlining every one of the frames for reproduction. Ed Amatore, Registrar at the Art Institute, handled all of the details for the loan and transport of this collection with his usual good nature. Dominique Vasseur, Senior Curator; Marianne Lorenz, Assistant Director for Programs and Exhibitions; Alex Nyerges, Director of The Dayton Art Institute deserve thanks for their indefatigable commitment to this project and insightful comments on the catalogue.

My research outside of Dayton benefitted from the generosity of the staffs at the National Museum of Women in the Arts (which holds the Doris Lee papers) and at the Woodstock Artist Association. Krystyna Wasserman, Director of the Library and Research Center at the NMWA, and her staff gave me access to the Doris Lee papers and made my stay in Washington both enjoyable and fruitful. In Woodstock, Linda Freaney not only gave me access to their files on Lee but more significantly introduced me to several people who not only knew Doris but knew her well. Both Alice Lewis and Andree Ruellan gave of their time and their memories of Lee, Arnold Blanch and life in Woodstock over the years. A still active artist, Andree Ruellan, whose kindness of spirit and generosity of time should give us cause to cherish all memories, told of Woodstock during the 1930s when she and a group of artists, including Doris Lee, would meet in the evenings to talk of art, and during one period of time, to read and translate Eugene Delacroix's journals. Thanks to David Henry and his colleagues at D. Wigmore Fine Art in New York, which currently handles Lee's estate for his encouragement for this project. Susan Davis of the Special Collections at the Syracuse University Library assisted me in securing the imagery from the Associated American Artists scrapbooks. And I extend appreciation to the staffs at the Ryerson/Burnham Library at the Art Institute of Chicago and the Art Library at Northwestern University for their assistance.

To the essayists, Nancy Green, Eli Wilner and Jim Dicke, I would like to offer my deep thanks for a job well done and to Kristin

Fedders who contributed the majority of catalogue entries, a special thanks for her perseverance and all-too-discerning mind. And finally, I would like to extend a deep appreciation to Karen Kettering, Kristin Fedders and Ben Hood who have indulged my archival eurekas on Doris Lee and especially to the last of these three who has even begun to dream of Doris. These three individuals have buoyed my spirit during the course of this project and I will always be indebted to them for this.

Todd D. Smith

Associate Curator of American Art, The Dayton Art Institute

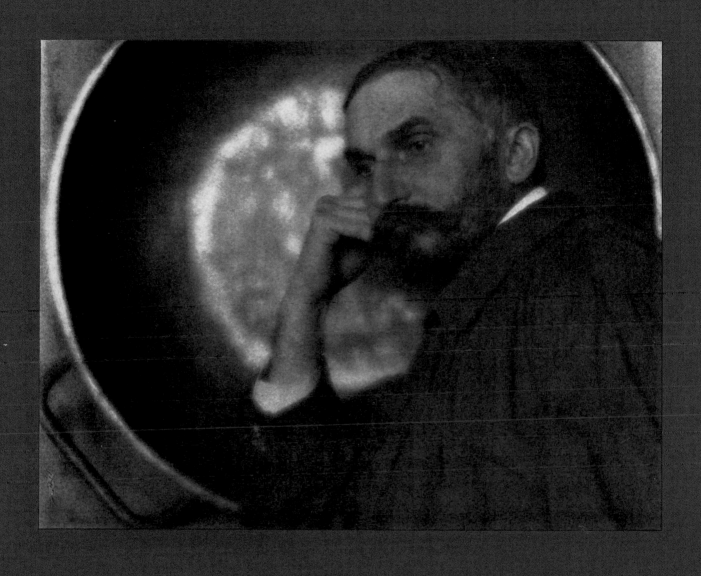

Arthur Wesley Dow: An American Modernist

Arthur Wesley Dow: An American Modernist
by Nancy E. Green

Unlike many of his contemporaries, Arthur Wesley Dow (1857-1922; fig. 1) came to art late. Partly because his interests were so varied (he had a strong education rooted in the Classics and showed an early interest in becoming an antiquarian) and partly due to financial considerations, Dow took several years to decide on a career in art. His strict New England upbringing also added to the mix: in his hometown of Ipswich, the term "artist" was used pejoratively, and the idea of pursuing an artistic education was viewed as self-indulgent. Henri Murger's 1848 book *Scènes de la vie Bohème* confirmed this view of the decadent life of artists in Paris and attracted a generation of Americans, including James McNeill Whistler, to study there. It was not the life of the bohemian but rather the artist's rural communion with nature described by Blanche Willis Howard von Teuffel thirty-five years later in her book, *Guenn, A Wave on the Breton Coast*, which would inspire Dow and his generation.

Dow's early life was spent in a spiritual quest. It was as a result of this quest that he discovered the romantic and mystical aspects of art, a discovery that finally helped him overcome all his career doubts. In this decision, he was supported by his mother who encouraged his first project of sketching the old houses of Ipswich. Largely self-taught, Dow worked enthusiastically. The results, while naive in their rendering, were generously appreciated by the Reverend Augustine Caldwell, a professional antiquarian. Caldwell hired Dow as correspondent and illustrator for the *Antiquarian Papers*, a monthly periodical published from October 1879 to July 1884. It was here at the *Papers* that Dow attempted his first efforts in printing, though much of what he learned was by trial and error as he reproduced his sketches in woodcuts, lithography and heliogravure.

Through Caldwell, Dow met his first patrons, the Farmer family. Moses Farmer had been chief engineer at the U.S. Torpedo Station in Newport, Rhode Island until 1881 and was an inventor of various electromagnetic conveniences; his wife Hannah was a noted philanthropist and religious enthusiast like her daughter Sarah. These friends stimulated Dow's widely varying interests, and it was the Farmer's home *Green Acre* , a haven of learning and support, that would poignantly epitomize these happy times.[1] It was here that Dow found refuge from his disappointments as well as encouragement for his early achievements. Besides advice and financial help, the Farmers treated Dow to sketching trips in New Hampshire and Maine and frequently took him with them to New York to enjoy the museums and the galleries there. They also introduced him to the work of William Morris Hunt, champion of the Barbizon style and well-known teacher at the School of Fine Art in Boston.

By the early 1880s Dow was firmly committed to making his way as an artist. In July 1880, at Caldwell's advice, he began art

FIGURE1
Alvin Langdon Coburn.
Portrait of Dow, 1903.
Platinum Print, 8-7/16 x 10-5/8.
Collection of Photography at the
George Eastman House

lessons with Anna K. Freeland, an historical and portrait painter in Worcester. This was followed by more lessons in February 1881 when he sought out James M. Stone, in Boston. It was here in Stone's studio that Dow met Minnie Pearson, a fellow student, who would become his wife, and Frank Duveneck whom he admired as the leading American artist of the time. The two would remain friends until Duveneck's death in 1919.

As a teacher, Stone was an interesting choice — he had studied at the Académie Julian in Paris under Gustave Bouguereau and Jules LeFebvre, as well as studying under Duveneck at the Munich Royal Academy. Stone was a great colorist while Dow, uninterested in the emotive properties of color, restricted himself to a Barbizon palette of soft, muted tones. But Dow wanted to learn landscape painting and when Hunt died suddenly in 1879, there were few other options available in the Boston area.

For Dow, stimulated by Hunt, Stone, and Howard von Teuffel's book, the next obvious step in his pursuit of an artistic career was to go to Paris. To raise money he began giving lessons in flower painting which he loathed almost as much as the pastel portraits he drew for additional income. He found his students mostly to be young female dilettantes, without any real love for the work at hand. But he persevered and by maintaining an ascetically frugal lifestyle he was able to save enough to begin study abroad.

Setting sail in October 1884 for Paris, Dow's goal was to follow in Stone's footsteps. He was twenty-seven years old at the time, older than most of the students arriving in Paris and with his maturity and his knowledge of French it seems that the other Americans relied on him to help ease them through the muddle of settling in and acclimating to their new surroundings. Dow himself quickly settled at the Hôtel de l'Univers et du Portugal, located just off the Rue de Rivoli, convenient to the Louvre and the center of the city. He signed up almost immediately for classes at the Académie Julian where LeFebvre still taught along with Gustave Boulanger. He also attended night classes at the Ecole Nationale des Arts Decoratifs where the critic Francis D. Millet oversaw the students' work. Dow learned and absorbed quickly, but he soon discovered the academic method to be more pedantic and less fulfilling than he had anticipated.

The Académie Julian had originally been established to provide an alternative to the Ecole des Beaux Arts and its stiff entrance requirements, but teachers at the former soon demanded the same level of achievement from their students. Accuracy became nearly an obsession at the Académie Julian, though Dow noted in his diary entry that Boulanger criticized him for paying "too much attention to details — too little to the ensemble." [2] LeFebvre, on the other hand, tended to be more complimentary, and a month later Dow wrote, "LeFèbvre today — he said I was working intelligently and seriously — working in the right way. But I had better make several sketches a week — two or three ensembles, to get familiar with outline." [3] At his most frenetic, Dow

set little enthusiasm: "I confess to sympathy with all who reject traditional academicism in art. I often regret the years spent in the Académie Julian where we were taught by professors whom we revered, to make maps of human figures."[4] It was this rejection that would become the decisive factor in Dow's evolution into one of the most innovative artist/educators of this century.

Given his feelings, it is not surprising that Dow left Paris with seeming relief to spend the summer and fall of 1885 in Brittany. His natural reticence and inherently quiet demeanor made him uncomfortable with the antics of his fellow students and what he considered to be the dissolute life lived by the students in Paris. In late 1884 a cholera epidemic ravaged the city, and this too served as a symbol of the rot Dow felt at the core of the city and provided him with an additional impetus for escape to the countryside.

Accompanied by his friend Henry Kenyon, Dow arrived in Brittany in time to enjoy the beautiful summer and fall months of 1885. Ironically, the artists working there apparently resented the bright, sunny days which hindered their attempts at producing that much-desired silvery gray light characteristic of dull and overcast days, a quality necessary for good tonalist work. Dow returned the following year to Pont Aven, studying with Alexander Harrison (Plate 8), and staying at the Pension Gloanec, a favorite with students. Paul Gauguin arrived at the Pension the same summer; historians have made much of this overlap of the two artists who shared so much theoretically but so little otherwise. Despite their close proximity and shared common room dining, the two never became friendly. Ironically, Dow would later teach many of the same ideas expounded by Gauguin at Pont Aven.[5]

Harrison, on the other hand, seemed to inspire Dow. The probable model for the artist Everett Hamor in Howard von Teuffel's *Guenn, A Wave on the Breton Coast*, Harrison had a non-academic approach to painting *en plein air*. His only criteria for a successful work seemed to be the achievement of an overall harmonious effect of balanced light and color relationships. Despite his great urge to work out in the open, Dow should not be confused with the impressionists; for him the very word was abhorrent, signifying shoddy workmanship, and a complete disregard for any of the structures that ensured quality in art.[6]

Dow's first commercial success came when *A Field, Kerlaouen* (Plate 9) was accepted for the 1887 Salon. Buoyed by this, he returned home anxious to test the waters of the art market. On January 11, 1888, his first major one-man show opened at the J. Eastman Chase Gallery in Boston. Unapologetically he hung his French works side by side with images of Ipswich and Boston's North Shore. This strategy worked well, winning the approbation of his old friend Duveneck. In all of his work, Dow consciously strove to hold onto that something which he recognized as essentially American. Whether he was painting the Breton coast, Japanese waterfalls or the monuments of ancient Greece, Dow maintained a nineteenth century mystical connection with the sublime as witnessed in the grand vistas of landscape and ineluctably entwined with an inherently American spiritualism. It was this uniquely American quality that appealed to Duveneck and made this Dow's most commercially successful exhibition.

During his year at home Dow was offered a job teaching at Oberlin College in Ohio. Although he found the offer tempting and knew it would give him the financial stability he desired, he turned the position down, fearing it would divert his efforts as a painter. Instead, with the proceeds from his exhibition, he returned to Paris and Pont Aven in 1889, this time with his fiancée Minnie.

Dow's last year in France was devoted to painting something acceptable for the Salon and the Exposition Universelle. In search of an unusual view near Pont Aven he settled on the desolate Isle of Raguenès, whose landscape was nearly interchangeable with the some of the more remote shores of Ipswich. For the 1889 exhibitions Dow had three paintings, including *Les Sables de Raguenès*, accepted and all were hung "on-line," even receiving honorable mention for his painting *Au Soir*.[7] With this success he returned home to Ipswich where he established an artists colony similar to Pont Aven, but he so jealously guarded what he considered to be "his" views that few artists with the exception of Kenyon stayed. This was probably just as well as the Ipswich townsfolk did not relish this intrusion into their peaceful community. Dow, the returning artist, was viewed with some suspicion, and in an attempt to assuage some of this negative feeling in 1890, he, along with the congregational minister, Thomas F. Waters, co-founded the Ipswich Historical Society.

At the same time, frustrated with the counter-productiveness of his academic training, Dow began to search out answers in the art of other cultures. He had always had a great respect for the decorative arts, spending hours at the Musée de Cluny studying the carvings, tapestries and porcelains. Once back in America he began to examine Aztec, Oceanic, African, and Italian trecento and quattrocento art, looking for a solution. He finally found it one evening in February 1891 when he discovered Hokusai. In a letter to Minnie he described the recognition and inspiration he felt: "It is now plain to me that Whistler and Pennell whom I have admired as great originals are only copying the Japanese. One evening with Hokusai gave me more light on composition and decorative effect than years of study of pictures. I surely ought to compose in an entirely different manner and paint better."[8]

From then on things happened in rapid succession. The next week Dow went to the Museum of Fine Arts in Boston to visit the Japanese collection and there met the curator, Ernest Fenollosa. The two immediately recognized a common bond in their urgency to incorporate Eastern methodology into a western artistic sensibility. For both men, Japanese art represented the epitome of quality in both decorative and fine art, as a result of its reliance on the simple harmonious choices of line, color, and *notan* (a word that roughly means the juxtapositions of lights and darks or tones). Dow and Fenollosa maintained that by paying equal attention to all three elements in the process of making the crucial choices during creation, an artist or artisan would be able to consistently produce quality works of art.

At first it appeared that Dow was the mouthpiece for Fenollosa's ideas. Eventually, though, the student outshone the teacher; it

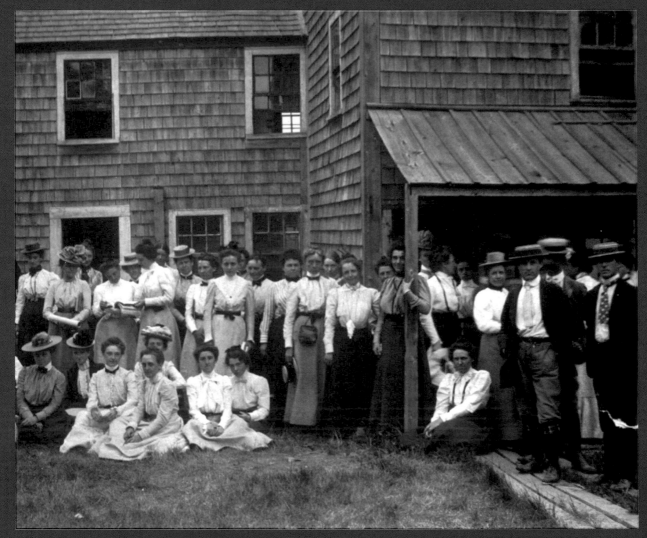

FIGURE 2

FIGURE 2
Summer School at Emmerson House.
Photograph by Susan Howard Bolce.
Ipswich Historical Society

was Dow's name that became synonymous with a teaching method, derived from an East/West synthesis, which allowed the artist to combine the best of both cultures while making critical personal decisions during the creative process. It was imperative that these ideas be incorporated into the American sensibility on all levels, from artistic teaching as early as kindergarten to the raising of decorative art to an appreciated art form. And it was Dow who had the ideal forum for passing on these ideas in his Ipswich Summer School (fig. 2).

In June 1890 Dow had begun teaching art classes in Ipswich on a modest scale. This was the beginning of the Ipswich Summer School which ran until 1907.[9] At its peak it attracted hundreds of students from all over the world and was a popular school, in many ways similar to the Byrdcliffe Colony in Woodstock, New York. An 1892 circular advertising the school claimed, "the method to be used would be synthetic and would aim at developing a creative grasp in rendering subject rather than a narrow line of abstract technique."[10]

The School provided fertile ground on which Dow could test his theories. He insisted that there should be no distinction between fine and practical art and all should be both useful and decorative. In this he emulated William Morris and the English Arts and Crafts movement, exhorting his students to achieve perfection in the finely crafted and the beautifully rendered. As he began to de-emphasize the importance of painting, he experimented with batik, tie and die, stenciling, block printing for textiles, pottery, photography, and weaving (fig. 3 and fig. 4). This approach attracted a variety of students like the photographer Alvin Langdon Coburn and many of the designers and decorators from the Newcomb Pottery in Louisiana, including Mary Sheerer, Amelie Roman and Harriet Joor, and from the Overbeck Pottery in Ohio including Margaret and Mary Frances Overbeck.

In September 1893 Dow was made full assistant to Fenollosa at the Museum of Fine Arts and he was finally in a position to marry Minnie. At the same time, woodcut prints were becoming his newest obsession. At first, he used pine blocks (later switching to maple, a much harder, more durable wood) to produce his little pillar prints. In creating these prints, he employed both the wood grain and the paper texture to enhance the tactile quality of the image as well as experimenting with a score of color variants. By printing the same blocks in different color combinations, he was using what he referred to as the "lost chances." This allowed him to print the image in a variety of color juxtapositions, something not possible in painting. Dow got many of his ideas from Sylvester Rosa Koehler, the technical assistant for ten years of the important printer/publisher Louis Prang. Koehler went on to become print curator at the Museum of Fine Arts from 1887 to 1900, and this is probably where the two met. Dow considered the process of printmaking — the control of brush, hand, and color saturation — equal to a painter's efforts and reveled in the ability to print a scene differently each time, as a sunrise or a sunset, a winter or summer scene, daytime or night.[11]

In April 1895 Dow had his first public showing of these prints in the Japanese corridor of the Museum of Fine Arts. Fenollosa

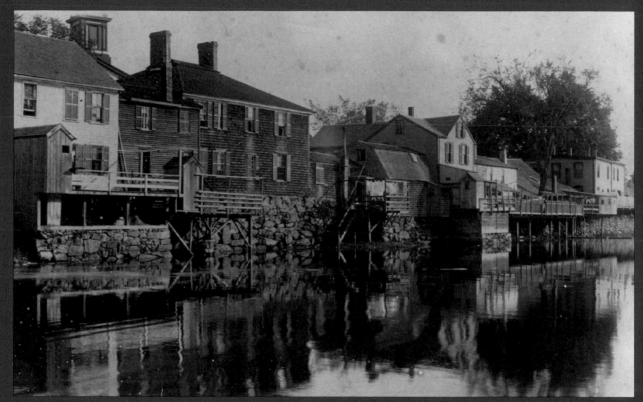

FIGURE 3

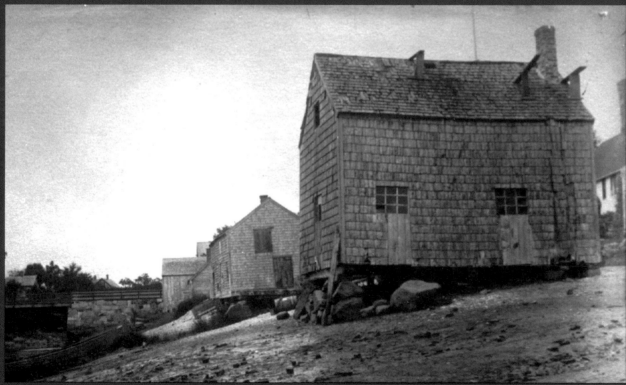

FIGURE 4

wrote the introduction for the modest catalogue, describing the uniqueness of Dow's approach:

> The artist is as free with his blocks as the painter with his palette . . . pigment washed upon the wood, and allowed to press the sheet with touch as delicate as a hand's caress, clings shyly only to the outer fibers, the hills of its new world, leaving the deep wells light in the valleys, the whiteness of the paper's inner heart, to glow up through it and dilute its solid color with a medium of pure luminosity.[12]

This show and the friendship between Dow and Fenollosa had a far-ranging effect. As Dow grew more conversant with the woodcut medium he began to write articles for *The Knight Errant*, *The Lotos*, and *Modern Art* in which he described the process in detail, winning converts along the way. In this manner he also came to the attention of many interested and influential people, including Charles Freer, who was a great admirer of Dow's ideas, and Frederic Pratt. Pratt approached Dow and Fenollosa as a team, asking them to teach at his recently founded art school, the Pratt Institute in Brooklyn.[13]

In the fall of 1895 Dow and Fenollosa were to assume their new positions. Dow was again to be Fenollosa's assistant but before this could happen Fenollosa created a scandal by divorcing his wife, hastily remarrying and then retreating to Japan. This left Dow as the sole person in charge, and he accepted the challenge undaunted. Commuting between Ipswich, where the summer school still met every year, New York, and Boston, Dow still managed to continue publishing articles expounding on the ideas formulated in his many discussions with Fenollosa. For both men, the basis of any good work of art, whether fine or decorative, remained the harmonious marriage of the elements of line, color, and *notan*. Dow also experimented with commercial art, creating his beautiful *Modern Art* poster, a classic of its type. And in 1899 he began teaching on alternate Saturday mornings at the Art Students League in New York City. The same year saw the first printing of his wildly successful how-to art manual, *Composition*. This treatise clearly outlined his and Fenollosa's thoughts on what constitutes quality in art. For Dow, the word "composition" denoted an expression of a beautiful idea, always balancing the three compatible elements of line, *notan*, and color, whereas he considered "study" to be its antithesis, implying copying or mere representation. This distinction between composition and study formed the basis of his book.

Dow was a successful teacher, exposing his students to disparate artistic ideas, both Eastern and Western, offering them options denigrated by other art institutions. He was from all accounts a kindly, patient man, though adamant in his beliefs and a zealot for his own cause. His practices had a far-reaching influence, not only with his students among whom he counted Max Weber,[14] Alvin Langdon Coburn (fig. 5), and Georgia O'Keeffe, but also among scholars, such as Dr. William Sturgis Bigelow and Edward S. Morse. His influence can also be noted on artists and pictorialist photographers, such as Charles Prendergast, Herman Dudley Murphy, Frank Benson, Gertrude Käsebier and Clarence White, as well as on many of the American Arts and Crafts artisans, who were all interested in the East/West connection. Dow's was a life rich in discussion and experimentation, learning and teaching at every stage.

FIGURE 5

FIGURE 5
Alvin Langdon Coburn,
The Dragon, 1903.
Photograph by Emil Ghinger.
Private Collection. Courtesy Howard
Greenberg Gallery.

24

By the early 1900s *Composition* was in common use throughout the public school systems across the country. But as Dow's fame spread, his obligations widened and he was able to devote less time to painting. This was partially due to his consuming interest in woodcut but also his teaching and travels diverted much of his energy. During this comparatively fallow period, Dow still managed to exhibit regularly, winning a bronze medal for painting as well as an honorable mention for his woodcuts at the Pan-American Exposition in Buffalo in 1901.

In 1903 Dow executed three sets of prints (six prints in each set) called *Ipswich Prints*. These were inexpensively produced mechanical wood engravings made for distribution in the public schools as a way of teaching good design and composition at the grade school level. He believed that if American children, like their Japanese counterparts, were taught young enough to recognize and appreciate quality in design, even in everyday functional objects, that this knowledge would go a long way towards eliminating mediocre workmanship.

The culmination of all of Dow's efforts came about in 1903 when he was offered the directorship of the art department at Teachers' College, Columbia University.[15] Although intrigued by the proposal, Dow hesitated for some time as he was just about to embark on a long-cherished dream — a trip around the world that included Hawaii, Japan, India, Greece, and Egypt. Dow negotiated a year of absence and committed to begin at Teachers' College in the fall of 1904.

The trip was assiduously planned, and with his many connections Dow was treated like a visiting dignitary during his stay in Japan. He traveled to Kyoto, Tokyo, and Nikko, enjoying all the sites he had read about for so long. He met with scholars and artists, including two Americans, Helen Hyde and Charles Hovey Pepper, who were both working in Tokyo at the time. As an avid collector of *japonisme*, he visited many dealers in search of screens, prints, textiles and pottery. Although he was some-what disappointed with the quality of what he found, he did purchase prints by Hiroshige and Hokusai, Motonobu, Mironobu, and a triptych by Kunisada. He also studied with Kano Tomonubu and received technical instruction from the noted Hiroshige publishers Murata Shojiro. Dow even met Emperor Mutsuhito who presented him with copies of black and white paintings from his collection of ancient art.

Back in New York Dow started his new job with renewed vigor, rejuvenated by his recent experiences. Teachers' College offered degrees in drawing and painting, design in industry, house design, costume design, and fine arts education. As the years went by, his students served as a conquering army, filling newly created positions in art departments across the country, spreading the gospel of *Composition* and dispersing Dow's ideas wherever they went.[16]

During this period, Dow was also showing regularly at the Macbeth Gallery and, after 1908, at the Montross Gallery, in New York.

Bement. During the academic year Bement taught at Teachers' College and it was he who encouraged O'Keeffe to come to New York to study with Dow. Her impressions echoed those of many of Dow's other students: "This man had one dominating idea: to fill a space in a beautiful way — and that interested me. After all, everyone has to do just this — make choices — in his daily life, even when only buying a cup and saucer. By this time I had technique for handling oil and watercolor easily; Dow gave me something to do with it."[21] He never wavered from this initial agenda, and each new edition of *Composition* only served to solidify his conviction.

Dow's health began to fail after a fall during his 1919 trip to the Grand Canyon. He remained at Teachers' College, and his students and colleagues remembered him as uncomplaining, continuing on in the same gentle vein with which they had become accustomed. In December 1922, shortly after delivering a lecture, he died, leaving many saddened friends and students behind.

Assessing Dow's career is difficult. Certainly he was not commercially successful; many of his paintings, without a market, remained unsold at the time of his death. His subjects, like the man himself, were quiet and unobtrusive and, placed in the context of their time, do not appear particularly innovative or exciting. Perhaps his approach was ultimately too tentative, too self-conscious to achieve greatness. To his contemporaries he may have appeared too dilettantish; he experimented with many styles and ideas but seemed unable to find a comfortable niche. Throughout his career Dow remained stymied by the use of color, even after many years of experimentation. Though he seemed to understand color on a psychological plane, he was hard put to translate it intuitively to canvas. Ironically, through his ideas and his teaching, Dow served as the bridge into the twentieth century while his own arrival eluded him, a frustration that persisted until his death.

Dow's real legacy was his teaching. When Thomas Munro assessed the Dow method of teaching in a 1929 article, he presented a fair-eyed view, noting that "for all its inadequacies, it deserves respect as a landmark in American education, for its clear statement of a method still far in advance of those used in most schools, and for the example it offers of a sensitive and penetrating mind at work upon a generous variety of artistic forms."[22] The popularity of his methods waned after the final edition of *Composition* was published in 1941; by then his approach appeared to be formulaic, lacking the spontaneity and emotionalism sought by younger artists.

Dow's students always remembered him fondly and dedicated a 1924 issue of *Dark and Light* to him. Anna P. Brooks, a former Ipswich Summer School student, captured the magic of her experience and summed up the inspiration that Dow engendered in her generation:

> Never shall I forget the first lecture when we, the summer school students, walked up the country
> road past the tansy-covered stone walls, through pasture and apple orchard, to his studio on Bayberry Hill.

It was dusk when we arrived, and the large room was lighted with nail-pierced Paul Revere lanterns which hung from the ceiling. This seemed like fairyland, but — the lights were put out and, on a large screen there appeared wondrous, unbelievable pictures of Anaradapura, India, the lost city of the jungle. We listened in awed silence to the story told by the quiet man standing in our midst. The beauty, the grandeur and the pathos of it all moved us strangely, and its spell followed us as we wound our way home through the trees hung with Japanese lanterns and out into the moonlit country road . . . Mr. Dow brought to his students a new, progressive, logical, appreciative way of studying art, but he did much more — he opened new vistas, he removed the scales from blind eyes, he put songs in people's hearts, and sent forth to bless the world many, many students whose lives have been touched to higher issues by his inspiration.[23]

Endnotes

1. On hearing the Farmer homestead was to be sold Dow wrote Minnie: "It is really a home to me — for I have been there so much. I was engrafted to the family tree." Arthur Wesley Dow to Minnie Dow, 8 November 1900, Arthur Wesley Dow (AWD) Papers, Ipswich Historical Society.

2. *Arthur Wesley Dow Diary*, 5 November 1884. Archives of American Art.

3. Ibid., 3 December 1884.

4. Dow, "Modernism in Art," lecture notes, undated, AWD Papers, Ipswich Historical Society.

5. The two artists shared so much philosophically yet remained aloof from one another. In 1886 Gauguin organized a showing of Japanese prints. It is difficult to imagine that Dow was not aware of it, but he seems to have taken no notice; perhaps because he had such a dislike for the messenger, he ignored the message. Ironically, once back in the States, and with his own new-found interest in Asian art, Dow taught a synthetic approach very similar to Gauguin's. Dow never was able to think kindly of him and years later, in a letter to Kenyon, he wrote, "When I hear of Gauguin I can see him thumbing his nose at Wigand and me. I can't see anything in his work or Van Gogh's that isn't in the most ordinary Japanese print." Dow to Kenyon, 15 January 1915. Archives of American Art.

6. Dow's conviction was that impressionism "ran counter to elements of composition." Arthur Wesley Dow, "The Responsibility of the Artist as Educator," *The Lotos*, IX, (February 1896): 611.

7. Both *Les Sables de Raguenes* and *Au Soir* were given

by Dow's widow, Minnie, to the Ipswich Public School System which still owns them today.

8. Arthur Warren Johnson, *Arthur Wesley Dow, Historian, Artist, Teacher* (Ipswich, MA: Ipswich Historical Society, 1934), 54.

9. The only exception was the summer of 1896 when Dow went to Italy to study primitive painting.

10. *Circular for the Ipswich School*, 1892, Lawrence Chisholm Collection, Yale University; quoted in Madeliene Fidell, "Arthur Wesley Dow" (master's thesis, New York University, 1968).

11. Sadakichi Hartmann, who knew Dow and shared many of the same ideas, was enamored of Dow's work in woodcut: "sumptuous in coloring, piquant in his naivete, and fascinating in his poetry." Sadakichi Hartmann, *History of American Art*, 2 vols. (Boston: L.C. Page and Co., 1902), 271.

12. Ernest Fenollosa, *Special Exhibition of Color Prints, Designed, Engraved and Printed by Arthur W. Dow*, exhib. cat. (Boston: Museum of Fine Arts, 1895), 4-5.

13. The Pratt Institute opened in 1888. It was an unusual art school, offering courses in both fine and decorative arts and holding classes for kindergartners and high schoolers as well as higher level classes.

14. Weber was, by Dow's account, only slightly above a mediocre student during his first years at Pratt, but he finally settled down to apply himself, winning a scholarship in 1899. Many years later Weber wrote glowingly to Dow's niece, Ethelwyn Putnam,"When I got to Paris in 1905 I was struck by the fact that Mr. Dow anticipated some of the aesthetic principles of art the Fauves had striven for only years later. Mr. Dow was one of the

greatest art educators this country was blessed with."
Weber to Putnam, 1958. Archives of American Art.

15. Teachers' College was established in 1892 to com-
bine the manual arts with the advantages of academic
training and scholarly recognition. In 1897 the Fine
Arts department was founded.

16. Freer wrote in support of a Dow student for a teach-
ing job, saying, "Professor Dow is unquestionably the
foremost American in art education and his graduates
now working in public and private schools are accom-
plishing great good." Frederick Moffatt, "The Life, Art
and Times of Arthur Wesley Dow" (Ph.D. diss.,
University of Chicago, 1972), 235.

17. In a letter to his dealer William Macbeth, Dow con-
fessed that "I had no commercial hopes, for I am not
a 'seller.'" Dow to Macbeth, 22 February 1908. Archives
of American Art.

18. Johnson, 87-88.

19. Ibid., 251.

20. *New York Evening Post*, 12 April 1913 Clipping at the
Archives of American Art.

21. Katherine Kuh, *The Artist's Voice* (New York: Harper
and Row, 1962), 190.

22. Thomas Munro, "The Dow Method and Public School
Art," in *Art and Education*, ed. John Dewey (Marion, PA,
1929), 337.

23. Anna P. Brooks, "Arthur Wesley Dow: An Intimate
Sketch," *Dark and Light*, 2 (March 1924), n.p.

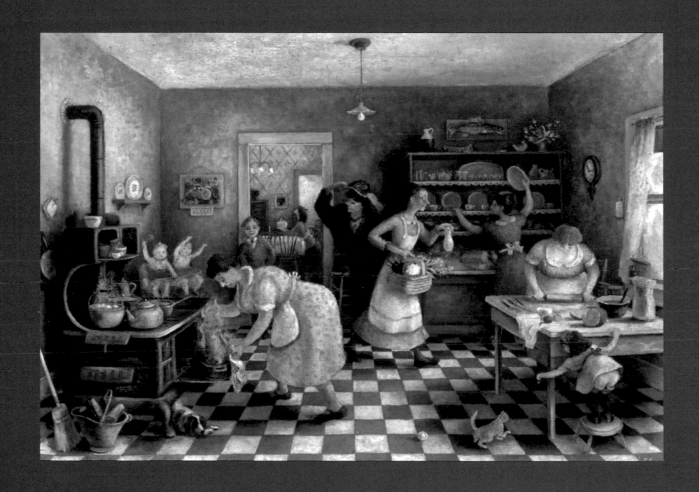

Painting for the Middlebrow:
Doris Lee and the Making of a Popular Artist
by Todd D. Smith

1935 witnessed the appearance of Doris Lee (1905-1983) on the American art scene. Presented with the Logan Prize from the Art Institute of Chicago for her painting *Thanksgiving* (fig. 1) in the fall of that year, the artist became, essentially, an overnight success. The award alone may have been enough to launch the career of the thirty year old artist; however, Lee was aided by the furor which the award provoked from Josephine Hancock Logan, the award's namesake. Bemoaning her inability to, as she put it, "withdraw the prize," Mrs. Logan formed the Sanity in Art movement whose task it was to eradicate the art world of such "modern" paintings as *Thanksgiving*.[1]

More important than the controversy surrounding the painting and its award was the role which the painting scripted for Lee to play over the next twenty years; that is, the role of a popular painter. Many people who read the notices of the Logan brouhaha were undoubtedly a little bewildered. How could anyone not like the prosaic, charming, and even humorous treatment of this slice of American life? And throughout her career, Lee was always held to the standard of *Thanksgiving*. Her 1945 canvas, *A Country Wedding* (fig. 2), is a prime example of her trademark style. The achievement of such fame, so quickly, only hindered Lee's development. While the artist had trained in avant-garde aesthetics, and even studied in Paris with the cubist painter Andre L'Hote, Lee was to be sought for her subject matter, a designation she resented.[2]

This contradiction between Lee's intention and her reception is not uncommon among producers of texts, be they visual, literary or political. What makes the Lee situation of particular interest is that this contradiction was only one of many which operated throughout her career.[3] The photo from the mid-1950s showing Lee and her husband Arnold Blanch in their Woodstock, New York home illustrates these dichotomies (fig. 3). An artist known for twenty years as the champion of a style of painting owing more to Americana than to modernism is depicted in her modern ranch-style house. Shot to accompany an article in *American Artist*, the picture suggests, and this essay will expand upon, the competing tendencies within the making of Lee, tendencies which were almost always eschewed by the media and the public in favor of a straightforward, uncomplicated view of both the artist and a regard for her art as accessible (and thus popular).[4]

The height of Lee's popularity, 1935 to 1955, corresponded to some of this century's most pronounced discussions on the make-up and functions of the different levels of culture. Historians and cultural critics writing in the 1930s, contended that, prior to the 1930s, society consisted of two types of groups—those who championed the high arts and those who enjoyed the folk traditions; in other words high and low cultures. By the 1930s, however, with the appearance and advancement of the means of

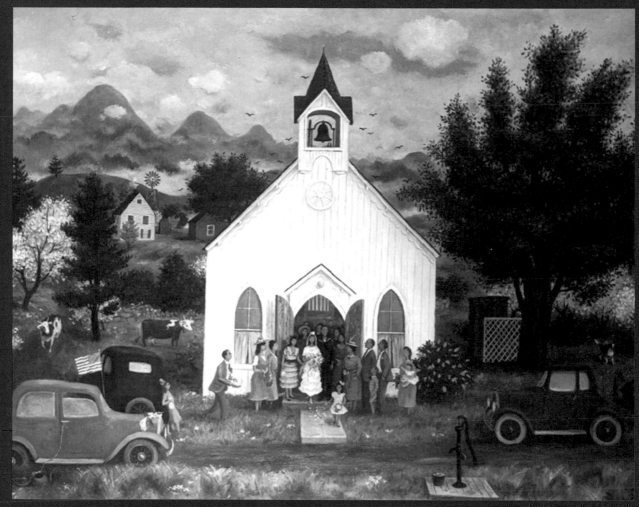

FIGURE 2

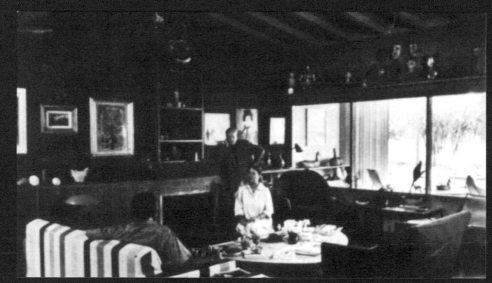

FIGURE 3

FIGURE 2
Doris Lee, *Country Wedding*, 1942.
Oil on canvas, 30 x 44 1/2.
Albright-Knox Art Gallery, Buffalo, New York.
Room of Contemporary Art Fund, 1943.

FIGURE 3
Doris Lee and Arnold Blanch in
the living room of their
Woodstock home, from
American Artist, April 1955.

mass production and reproduction—including radio, print media and film—a culture of mass-produced objects found their way into the market and served to complicate the seemingly easy split between high and low.[5] Added to this debate was the period's overriding concern with locating and codifying the exact split between high culture/modernism and popular/mass culture. The placement of Lee's career within this historical moment is predicated on a thoroughgoing knowledge of the terms and scope of this split; and it is the thesis of this essay that Lee's career calls attention to the gap between high and low culture, between the highbrow and lowbrow—that is, her career has been constructed by both the critics and the general public viewers to occupy the site of the middlebrow.

Before looking at Lee in depth, it is necessary to provide a brief introduction to the nature of this debate about high, low and mass cultures.[5] During the period, two left-leaning groups emerged—the Frankfurt School and the associates of the journal *Partisan Review*. They shared a similar project of defining the parameters, interests and effects of the newly powerful mass and popular culture; both of these groups held mass culture, for all intents and purposes, in contempt. Unlike earlier twentieth century cultural commentators, who saw in mass culture, and in more general terms in mass society, an opportunity for betterment, these midcentury groups worried of the negative effects that the expanding mass culture could have on both the existing high and folk traditions. The Frankfurt School of Social Research, a group of emigrated Germans including such cultural critics and philosophers as Theodor Adorno and Max Horkheimer, contended that mass culture needed to be analyzed not as to its forms and structures, but rather from the viewpoint of how the "culture industry" utilized these mass-produced objects.[7]

The second group of critics were associated with the *Partisan Review*. Through his writing for the magazine, Dwight Macdonald emerged as the most vociferous opponent of mass culture within this group.[8] Macdonald saw the differences in clearly defined terms; mass culture, or as he termed it "masscult" had grown out of the folk traditions. But he makes one key distinction between the folk and the mass: "folk art grew mainly from below, an autochthonous product shaped by the people to fit their own needs, even though it often took its cue from High Culture. Masscult comes from above."[9] He goes on to argue that "(f)or Masscult is not merely a parallel formation to High Culture, as Folk Art was, it is a competitor."[10] The differences between high and mass culture are not merely the issue of popularity; Macdonald acknowledges that some good things (i.e. products of mass culture) are popular. For him, the disparity is more fundamental: "difference lies in the qualities of masscult . . . its impersonality and its lack of standards, and total subjection to the spectator."[11]

For Macdonald, however, the dichotomy between high and masscult is not as clear cut as one might think, for into this equation he adds a third concept—the midcult. According to Macdonald, midcult shares certain qualities with masscult. They both rely upon a formula, a built-in reaction, the lack of any standard except popularity; but Midcult "decently covers them with a cultural fig leaf."[12] In other words, midcult aspires to be more like high culture, while in most ways adhering to the structures of its

competitor, masscult. Macdonald cites the Museum of Modern Art's reasoning for their tribute to film director Samuel Goldwyn because "his movies are alleged to be (slightly) better than those of other Hollywood producers" as his example.[13] This bastardization of high and masscult results in blurring of distinctions and the exploitation of the avant-garde. In terms of painting, Macdonald's high culture corresponds to the avant-garde, first of the surrealist and later of the abstract expressionists while the masscult's interest in art rests squarely on the shoulders of commercial illustrators and color reproductions of accepted Old Master works.[14] In the end, the artists who continued to paint in representational, anecdotal forms but whose work was still commissioned and shown in galleries find their home within the midcult. And it is into this system of high, low, mass, midcult and masscult that Lee's painting and, more importantly, her career can be placed.

Admittedly the above debates were conducted in a rather rarefied field of cultural criticism, mostly far removed from the real life of the majority of society. This is not to say, however, that the effects of these disputes were not expressed in more mass cultural texts. Beginning in *Harper's Magazine* and continuing in *Life*, cultural commentator Russell Lynes enjoyed a widespread following with his insightful and somewhat sarcastic portrayals of the interests of all of these factions. Lynes states that "what we are headed for is sort of a social structure in which the highbrows are the elites, the middlebrow are the bourgeoisie, and the low brows are the *hoi polloi*."[15] Through each "brow's" outlook on art appreciation, one can get an insight into the operations of each category. The highbrow believes, in Lynes' schema, that "the average citizen is a creature incapable of receiving the sacrament of art, blind and deaf to pure beauty."[16] Additionally, he is "often more interested in where the arts have been and where they are going than in the objects themselves."[17] The lowbrow, on the other hand, "doesn't give a hang about art qua art. He knows what he likes . . . The arts created by the lowbrow are made in the expression of immediate pleasure or grief . . . or of usefulness."[18] The highbrow and lowbrow are not competitors, for if anything the lowbrow is unaware of the terms of the struggle while the highbrow perceives no threat, just a possibility for co option. Similar to Macdonald's midcult concept, the middlebrow ruins the picture by providing the big threat to the balance of high and low. The middlebrow is the villain and often gains its definition in opposition to the high and lowbrows.[19] As such, Lynes paints a scenario of a highbrow fantasy in which the middlebrows would "have all their radios taken away, be suspended from society until they had agreed to give up their subscriptions to the Book-of-the-Month, turn(ed) their color reproductions over to a Commission for the Dissolution of Middlebrow Taste"[20]

Before proceeding to review Lee's career within this culturally pervasive system, a caveat should be made about the use of this system in general. It is not the intention of this essay to delimit Lee's career to its compliance with the qualities of the middlebrow. A one-to-one match is not in order, nor would it result in a better understanding of midcentury concerns. Rather, the utilization of brow rhetoric is meant to suggest a discourse, albeit as constructed as Lee's career, which elucidates not only the issue of Lee's place within midcentury art history but hopefully expands understanding of one of the forces which guided many considerations of culture and class during this period.

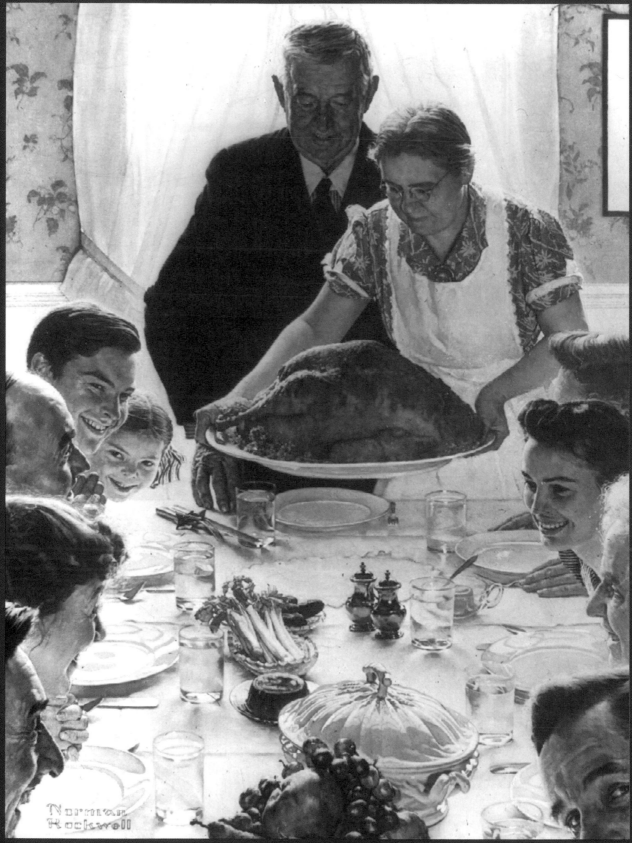

FIGURE 4

FIGURE 4
Norman Rockwell,
Freedom from Want, 1943. Photo
courtesy of The Norman Rockwell
Museum at Stockbridge
© The Curtis Publishing Company

\mathscr{R}emembering Thanksgiving

For several decades after its appearance, *Thanksgiving* enjoyed a sort of cult status among Americans enamored with nostalgia. Often competing with the likewise popular *Freedom from Want* by Norman Rockwell (fig.4), Lee's painting has been called upon to serve a number of roles. In an advertisement for Ackemann's store which appeared in the Elgin (IL) *Daily Courier-News* on November 24, 1943, the image was reproduced from the original lithograph. The copy reads, in part: "This is the year. . . to cook up a real, old-fashioned Thanksgiving crammed with unrationed cheer. It's simple to prepare—for the only equipment you need is a big, open heart." The piece goes on to describe the elements for a successful wartime holiday meal including "family, any size"; "friends—old ones" and "lonely ones"; and "to make up for your absent loved ones—stir up some men and women in uniform who are far away from home."[21] To be sure, the painting pictorially serves well the logical separation of men from the families, but more importantly for the present purposes, it provides an initial example of how the painting has been transformed from its original setting to a more generalized service.

The Ackemann's advertisement is only one of many uses to which the painting has been put. A year after its appearance in the newspaper, the painting was featured on the cover of the *School Savings Journal for Classroom Teachers*. Explaining the choice of this particular image, the editors of the magazine felt that "its vigor and hearty humor so truly present our folkways." In post-war rhetoric, the editors continue, "the picture makes us realize with heartfelt thankfulness the reality of the heritage which we have fought to preserve."[22] Without understanding the contradictory nature of the phrase, "the reality of the heritage," the magazine presents a straightforward and unrelenting appeal to the truth of our past—whether it be the Revolutionary past, the antebellum past or the recent past of World War II and in the end, the painting represents a past of unspecified time. At the end the magazine expresses its "earnest hope that this reproduction will find a place in every school room in America." The educational value of the painting rests not in its aestheticism, or for that matter in its role as an institutionally-sanctioned example of fine American art; rather, its use for children mirrors that for adults (Ackemann customers or school teachers) as a tool in the inculcating of nostalgia as virtue.

Whether for a war-weary domestic audience or for a group of public school teachers, the painting created a community of believers in a certain past, a group of consumers who hungrily awaited the next appearance of the painting. Its invocation only acted to keep at bay feelings of anxiety and self-doubt which permeated the middle years of the 1940s.[23] Not unlike Grant Wood's *American Gothic* and Rockwell's *Freedom from Want*, Lee's *Thanksgiving* became a ready-made symbol whose meaning, never completely codified at its initial presentation, could be transformed by any number of interests.[24] In many ways, the painting's quick absorption into the discourse of popular Americana and American memory removed it from any discussion of its topical aspects.[25] What the popularity of *Thanksgiving* and the painting's subsequent uses have eclipsed is the complex meanings of

the work within 1930s discourses on the family, society, history and the search for a usable past. In one of the most trenchant and influential analysis of the decade, Warren Susman has extracted two overriding concepts—culture and commitment. The historian writes:

> *I discover that in this period the people under study are trying to make their own world comprehensible*
> *by their self-conscious awareness of the importance of the idea of culture and the idea of commitment,*
> *their self-conscious search for a culture that will enable them to deal with the world of experience and*
> *a commitment to forms, patterns, symbols that will make their life meaningful.*[26]

It is with the second aspect of Susman's analysis—commitment—that *Thanksgiving* interacts more directly; that is, as a quickly employed symbol of an imagined past, the work soothes anxieties about unstable gender norms, about community values and about the importance of the past.[27] While the modernism of the decade exulted the newness and efficacy of mechanical advances within the domestic sphere, these new contraptions have no place within the world of Doris Lee's canvas. Rather, her emphasis on the hard work of the women only underscores the lack of interest on behalf of these women in reducing the level of their work. The painting, while within its frame speaks of production (in this case the creation of a bountiful feast), its result upon its contemporary viewers is one which denies modern production.

By exploring the dynamics of husband/wife relationships during the Depression-era, family historian Elaine Tyler May provides a context in which to examine possible meanings produced by, and later neglected in, *Thanksgiving*. In line with Susman's claim for the search for meaningful symbols, May argues that during the period, "the path toward traditional domestic arrangements appeared to be the one most likely to bring Americans toward the secure homes they desired."[28] The quest for security within the domestic was meant to counter the uncertainty of a market-driven economy which left a future of unknown scope. *Thanksgiving* falls in line behind other attempts to bolster and solidify traditional gender roles. While the early 1930s saw the marriage rate at an all-time low, as May reasons, because "young men and women postponed marriage or opted to remain single," she also points out that by 1937 "so widespread was the concern about delayed marriage that over one-third of Americans favored the extraordinary idea of governmental subsidies to help young couples marry." Most women, the evidence suggests, "embraced the homemaker role as significant, important, and fulfilling."[29]

The focus on community which the Elgin advertisement and the teacher's magazine solicits from the painting calls attention to the discussions raging during the period about the role of the individual within the community, his/her responsibilities to the community and obversely, the community's obligations to the individual. In an era which witnessed one of the most significant questionings of the place of the individual within society, and with so many citizens on the government dole and many more a single degree away from it, never, it was contended by leading sociologists, had the individual been forced to re-evaluate his/her role within the community on such a scale.[30] As one historian notes of the period, "individual personal achievement is no longer sim-

ply measured by accumulation of wealth or even status or power. Success is measured by how well one fits in, how well one is liked by others, how well others respond to the roles one is playing."[31] To return to the painting, it can be argued that the work celebrates the community over the individual; it is the coming together of individuals for the common good which makes the painting work and which makes the intra-diegetic action work.[32]

Recently, the painting reappeared within popular discourse. For so long, Norman Rockwell's *Freedom from Want* has usurped Lee's work as the poster image for that most American of holidays. In 1987, however, *Country Living* magazine's remake of the Lee image (in their own likeness) and their accompanying reissue of the print of the painting for purchase continues the oversight of meaning for the work, an oversight occasioned at the hands of the painting's popularity.[33] *Country Living*'s creation contained identified members of its staff donning the roles and outfits of the original members of Lee's family. The image is complete with a re-creation of the kitchen, including an almost identical new floor by Armstrong Flooring. The editors make their interest in the image obvious to their predisposed audience:

> All of us who cherish the notion of a less complicated American past see in her art a sense of security, the absence of self-doubt and a deep appreciation for community. Country folks today are searching for—and finding—the world so deftly rendered by Doris Lee. They're discovering anew the joys of sharing and the rewards of family, and they're re-creating the warm atmosphere captured forever in paintings like Thanksgiving.[34]

Even more revealing than the magazine's editorial voice were the letters to the editor after the November 1987 story and picture ran.

A reader writes in to recount her own Doris Lee/*Thanksgiving* story. When a young bride, this reader was presented a copy of the painting by her mother who instructed her, at some point, to re-create the painting in her own family's likeness, a task the daughter did years later. The correspondence continues with the writer acknowledging a "kindred spirit" she felt with Doris Lee. She writes, "I have had this same feeling all these years and now I have the same attachment to each of you. I'm so glad you identified each person in the picture because somehow I feel we are all members of the same family!"[35] The community spirit of the painting experienced in the Depression-era as something contentious and part of a larger struggle to define the individual vis-a-vis the whole has been remade into something soothing and comforting.[36]

The picture gained (and continues to gain) its power from its ability to draw upon nostalgic ideals of domesticity. In other words, its nostalgic representational strategy makes its concern with contemporary problems palatable; furthermore, by cloaking the scene in the past, Lee has provided her audience a powerful, moving symbol of an American way of life, albeit an altogether fictive one. The glorification of the painting's readability only underscores the distance between its appreciation and its possible meanings. All of its implications for a viewer of the 1930s have been overlooked in order to create an icon of the American way

of life.

Thanksgiving, while admittedly a paean to a childhood remembrance of the preparation of a holiday meal, became more than a nostalgic reminiscence. The work, through its varied uses, took on a universal quality; it was removed from the place of Lee's childhood and began to stand for all that was past and in many ways all that was present. It did not matter that Lee had based her picture on, as she put it, "what I saw in a New England kitchen some time ago;" the painting had resonance for contemporary audiences—no matter whether it was the 1935 audience at the Art Institute of Chicago, the 1943 audience for the Ackemann's ad, or the 1987 audience for *Country Living*'s re-enactment.

Country Living's remake of the original calls attention to the nature of representation, to the concept of the simulacra. Despite the work's mediated basis, over a short period of time, it acquired a truth; it was mistaken for the real. It is on this final point that the painting and its subsequent uses comes to rest fully within the defined boundaries of the middlebrow. For Russell Lynes, the highbrow is characterized by the belief that the facsimile (an object of the middlebrow) is no substitute for the genuine. *Country Living* has completed a cycle by bringing out into the open the valid impact of the painting: it is there to play the role of empty signifier. To be sure, the magazine created a likeness of the original, but in so doing they depleted the painting of its "original aura." They have created a copy, but in so doing have forced us to realize that the original is lost, its meaning had only ever existed as a facsimile. The original has never existed, only its use for middlebrow representational strategies.

*L*ee in the Bastion of Middlebrow

If *Thanksgiving* gives us a first look at the scope of Lee's popularization, her involvement with *Life* magazine and in Hollywood a decade later only confirms her position as a middlebrow artist. The two mediums—the Lucepress and Hollywood—were regarded by commentators on American cultural life, such as Macdonald and Lynes, as epitomizing the interests of the middlebrow.

Subject of an early article in 1938 by *Life*, Lee, a few years later, became an active agent with the publication, contributing articles and artwork and serving as a special traveling correspondent throughout the 1940s and 1950s. Long a supporter of American Scene artists, the magazine took a special interest in Lee, and from all indications, their relationship was a smooth one. Much has been made of the major falling out between the magazine and Thomas Hart Benton after his commissioned piece, *Hollywood*, was pulled from publication because its acknowledgement and reliance upon the labor unrest in Hollywood as subject matter raised the ire of the editors.[37] A few years later when *Life* decided to try again to capture the tinseled life of Hollywood, it chose an artist it thought would be a sure bet—Doris Lee. In 1945, Lee's reputation was one of an accomplished purveyor of uncomplicated, and thus non-controversial, glimpses of American rural life (fig. 5). Her style of folksy, often humorous anecdotes

touched chords in viewers' collective rethinking of their history and that of the country. While *Thanksgiving* was created in a time of monumental uncertainty about financial well-being, her output from that painting until the middle 1940s was likewise executed during a time of anxiety and self-doubt—this time at the hands of the international scene and the daunting promise of a new world order and all of its accompanying threats.[38]

In 1945, *Life* commissioned two Hollywood assignments from Lee. The first appeared in the magazine in October 1945 and the second in December 1945. The former provided the artist an opportunity to "watch, work and generally enjoy herself" in Hollywood; for the second piece, she focused on the production of the film musical, *The Harvey Girls*. For the first piece, she executed paintings of the film capital which appeared in the magazine. One of these, *Grauman's Chinese Theater* (fig. 6), highlights one of the many famous attractions of the town. *Life* is very forthright about its interest in Hollywood and in Lee's capturing of it. The editors claim that "Hollywood has seldom been seen through a painter's eye. And few painters are so well-equipped to capture its peculiar exuberance and its splendid extroversions of color as the exuberant, extroverted artist Doris Lee."[39] The flowery language cannot mask the unstated aims of the magazine. Burned as it had been by Benton's portrait of the city on the verge of labor unrest, the magazine was taking no chances as to what it would be getting for its money. Rather, the magazine was banking on Lee's popularity, her proven ability to work under deadlines and penchant to produce highly readable, if somewhat idiosyncratic, illustrations for a wide, mass culture audience. The short editorial piece fronting the series of paintings made Lee's perspective on Hollywood unmistakably clear. The article states:

> Her first impression of a movie studio was of 'hundreds of people waiting around for five hours and working for five minutes.' Later she learned greatly to respect the technicians and the farm-hours hard work of the stars; she 'felt they deserved all those fabulous pennies they received.'[40]

Positioned as the "everyman" or "everywoman" who might look askance at the production end of Hollywood and especially the salaries paid its stars, Lee progressed from skepticism to celebration of the labor practices in Hollywood, a journey which took advantage of Lee's homespun reputation and her ultimately pragmatic approach to work.[41] Lee goes on to uncover the "real" Hollywood; she is quoted as stating, "behind all the Hollywood front, I found everyone very human and had a very good time."[42] So the earlier threat of an evil Hollywood—evil either from a labor or moral point of view—had been contained by the artist and the magazine. Hollywood had been cleaned up, literally in the case of *Grauman's Chinese Theater*, and humanized by the artist for use by one of its biggest promoters.[43]

Featured in *Life* as its movie of the week for December 3, 1945 and a subject for six of Lee's canvases (fig. 7), *The Harvey Girls* tells the story of the turn-of-the-century phenomenon of the Harvey House Restaurants situated along the rail lines.[44] First introduced by Fred Harvey to the Atchison, Topeka and Santa Fe line in 1876, the concept of a semi-formal restaurant which offered

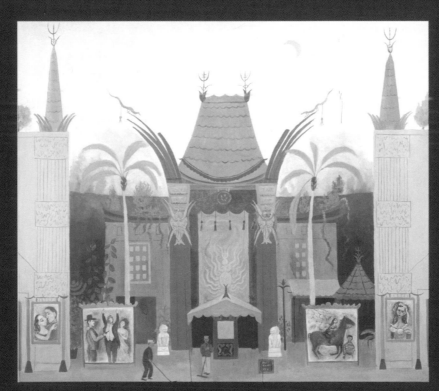

FIGURE 5
Doris Lee, *Fisherman's Wife*, 1945.
Oil on canvas, 1945. 22-1/2 x 28-1/2".
Collection of Cranbrook Art Museum,
CAM 1945.27

FIGURE 6
Doris Lee, *Grauman's Chinese Theater*,
1945. Oil on canvas, photograph by
BBS images (Dayton, OH), Collection
The Dayton Art Institute (Dayton, OH).
Museum purchase with funds provided
in part by the Dicke family, 1996.273

a clean, safe, and not to mention tasty, alternative to earlier wayside eateries took off. According to *Life*, by 1886 the Harvey Restaurants stretched from the Great Lakes to the Pacific and were known as "the civilizers of the West." As popular as the restaurants were the so-called Harvey Girls. These women acted not only as waitresses in the Harvey Houses but also represented the human side of the civilizing effect of the restaurants. Through their charm and wholesome manners, these women from the East and Midwest "began to reform wayward citizens."[45]

The movie was based on the 1942 novel by Samuel Hopkins Adams of the same name as well as on several other accounts of life within these dining halls. The film's plot revolved around the conflict between Judy Garland and Angela Lansbury for the attention of the local saloon-keeper, played by John Hodiak. Garland has come out West to meet her lonely hearts club penpal. On the train, the Atchison, Topeka and Santa Fe, Garland shares a car with a group of women on their way to the frontier town of Sandrock to open a Harvey House establishment. When they arrive in Sandrock (and after a rendition of the Academy-award nominated song, the *Atchison, Topeka and Santa Fe*), Garland meets her betrothed. As we have learned earlier, her betrothed was not, in fact, the author of the letters to Garland; it was, rather, the saloon-keeper who had served as the ghost writer for the love letters. Garland and her betrothed realize the mistake in their folly and proceed to call off the nuptials. This, of course, leaves Garland without a reason for being in Sandrock. She decides to approach her train friends and inquire about a possible position as a waitress, a job she immediately gets.

The viewer quickly realizes the romantic tension between Garland and Hodiak, a tension exacerbated by their antagonistic jobs— she an upright Harvey Girl and he a saloon-keeper—and by the activities of show girl, saloon employee and Hodiak's amorous follower, Angela Lansbury. Through a series of confrontations, each one revealing a growing interest in the other, Garland and Hodiak fall in love. By the end of the film, Hodiak has agreed to move the saloon, the Alhambra, to another city; without telling Hodiak, Garland renounces her status as a Harvey girl in order to follow him with the saloon. Unbeknownst to Garland, Hodiak decides to let the saloon move without him. In the end, the couple is reunited along the rails and the conclusion solidifies their relationship.

Drawing upon the star power of Judy Garland and in particular her role in *Meet Me in St. Louis* the previous year and the popularity of nostalgia, the film proved quite successful. It was one of the more profitable films for the year, grossing over 5 million dollars in its initial release.[46] The reviews were consistent in their praise for its Technicolor brilliance and the high entertainment value, but they often stopped there. Bosley Crowther in *The New York Times* review of the work provides an exemplary assessment: "It may not be the ultimate along the musical comedy line, but folks around here will find it a pleasant thing with which to pass the time of day."[47] Crowther's use of a vernacular language only underscores the less than serious tone which the movie and the review present. *The New York Herald Tribune* provides a more biting indictment of the historical accuracy of the film.

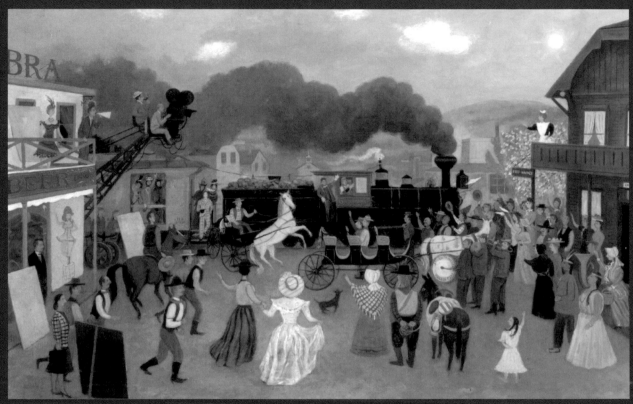

The paper states, "It has about as much to do with the Fred Harvey chain of restaurants . . . as a commercial calendar, but it is bustling and beautiful."[48]

More recent writers have placed the film within the category of the folk musical, and it is such a designation which connects the film thematically and structurally to the work and career of Lee. There are three types of classic Hollywood film musicals—each one defined by "a different device" which "mediates between the spectator's reality and the unreal world for which he/she yearns."[49] The types are the show musical which uses the technique of a show within a film as the mediating function between the real and unreal; the fairy tale musical which employs the otherworld imagination as well as the idea of Hollywood as itself a fairy tale; and the folk musical, the most complex of the lot. While the first two genres "create an atmosphere of make-believe which by definition combines the real with unreal," the folk musical relies on the "transforming power of memory."[50] Memory acts as a slippery signifier, a concept which is "suspended between observation and dream vision."[51]

With its use of a fictionalized account from American history, *The Harvey Girls* sets well within this category of a folk musical. Historian Rick Altman may have been describing the film specifically when he stated that "the folk musical thus neither depends entirely on American history, nor ignores it completely; it takes place within that intermediary space which we designate by such terms as tradition, folklore and Americana."[52] It is into this space that we might place Doris Lee's popular art and more directly it might go a far way in explaining her interest in the film. In her study of Hollywood musicals, Jane Feuer provides another angle from which to discuss the connection between the film, Lee's style and popularity and the larger cultural interest in the folk. Feuer reasons that "the Hollywood musical becomes a mass art which aspires to the condition of a folk art, produced and consumed by the same integrated community."[53] She argues that the ideal concept of community within the musical serves as the "bridge" between the performer and the audience; it is the concept of community which the film musicals uses to create the folk relations. In *The Harvey Girls*, the ersatz family of the waitresses and their older female mentors/chaperones signify to the audience the presence of a valid and wholesome community. And as Feuer suggests, the folk relations within the films "cancel the mass entertainment substance of the films."[54] Thus the structure of the folk musical, with its emphasis on the *folk*, overcompensates for the economic modes of production which characterize this mass produced art form.

In this sense, Lee's work, and particularly the public's fascination with it, parallels these folk musical systems. Simply put, the reception of Lee's style and iconography goes a long way in covering up the gap between the real and the folk, between the underlying order and balance of the works and their received playful, almost naive qualities. Much the same way that the spontaneous dances within (folk) musicals "mask the technological capability of the medium,"[55] Lee's admired folksiness belies her advanced training and her developed appreciation for the most avant-garde. Similarly, while the audience is all to aware of their

status offscreen as a professional vocalist, the singers within folk musicals, such as Judy Garland, enjoy their filmic part as amateur performers, for, unlike the show musicals, the performances take place in unexpected locales and not high atop a stage. This split between the amateur and professional can be seen as functioning within the career of Doris Lee, a subject to be addressed fully in the next section. For now it is sufficient to note that singer/artist enjoy walking the line between novice and accomplished, between naive and trained.[56]

If the structures and styles of folk musicals like *The Harvey Girls* and Doris Lee's pictorialism and reception are similar, then the association of the film and the artist is only amplified by the forum for the presentation of their similarities—*Life*. More than any other medium of the 1940s, the magazine signified the American way of life. Publisher Henry Luce writing in his own magazine speaks of the twentieth century as the American century. He claims that in all the world the American—particularly the Midwestern—is the least provincial. Luce once penned that pictures "were a 'common denominator with low-brows.' Thus, if properly 'mastered,' pictures could solicit and direct mass opinion."[57] As a recent historian has noted, "If *Life* acted as a cultural tastemaker for the masses in its frequent features on regionalist art and its pictures of recent American history, it also served as America's middle-class movie magazine by heavily promoting Hollywood's movies, stars and studio systems."[58]

\mathcal{D}efining Lee at Midcentury

While the first sections of this study have looked at significant works from Lee's oeuvre, it is now time to turn our attention to the broader question of her status as an artist in the 1940s and 1950s. With the popularity of folk and naive art steadily on the rise among art circles and the middle class by this point in the century, there appeared much discussion on both what constituted folk, naive, and primitive art and which artists could be categorized as such. Paralleling these discussions were those which focused on the differences between amateur and professional artists, and the distinctions between fine and commercial artists. To be sure, these attempts at separating artists and art into rigid categories proved a futile endeavor, for as Lee's career represents the lines are never as clear as one might hope. Lee's position within these discourses was problematic, due to the style of her work, the means of presentation, and middlebrow projects with which she became associated. Her career, as will be demonstrated below, had the proverbial one foot in each camp.

The interest in folk and naive art which flourished at midcentury owed the weight of its effect to none other than a diminutive elderly woman. From her first gallery show at the Galerie Saint Etienne in 1940, Anna Mary Robertson Moses (a.k.a. Grandma Moses) became the darling of the 1940s art scene (fig. 8). Although her work did not receive overwhelming critical praise, Moses's art did garner deep support from the middle class, which enjoyed among other things her outsider status. To Moses, art was not something foreign—either in the geographical or philosophical sense—and her work was considered "a healthy

note amoung contemporary artistic abortions."[59] Her life was presented as a corrective to the emergent myth of the brooding, alienated urban painter; she had lived a rustic life, replete with a farm, farmhouse and the responsibilities of raising a large family. According to one article, "She knows as little about Picasso paintings as she does about Freud's writings. Impressionism and cubism have no meaning for her."[60] Her visions were rooted in an American past, albeit a past of her imagination. Nevertheless, the mere fact that she was in her late seventies before she began painting in earnest led her followers to the conviction that she had lived the scenes which she painted. In a review of Moses's autobiography, *Grandma Moses: My Life's History*, Marshall Davidson suggests that "Grandma Moses speaks fondly and knowingly of that American past which is almost legendary to most of us, and she bears direct and simple testimony of a living witness."[61] With such a designation, Moses was seen as the most authentic interpreter of a certain past.

It should come as no surprise then that appreciation for Lee's work during the height of Moses's popularity would be mediated by the latter's presence. The similarities in their works and careers are there, so are significant differences. To many viewers, the art of these two women was nearly interchangeable. Both created canvases of slices of rural life executed in an almost childlike manner. The figures appear stiffly rendered, almost as stock types, while the composition is often flat and only alludes to a believable perspectival system. To a more knowledgeable audience, however, the differences in style were noted. Writing in the magazine *American Artist* in 1949, Dorothy Grafly marks the distinctions between these two artists' styles. In an article which attempts to clarify the differences between untutored artists and those tutored artists who merely draw upon the style of the untutored, the author argues that "it is impossible for the man or woman who has spent long years studying the subtleties of art to shed them as for the untutored to retain his freshness once he has discovered them."[62] To make the distinctions, Grafly uses Doris Lee as the tutored and Grandma Moses as the untutored. Grafly is very direct In her comparison of Moses and Lee:

> *Grandma Moses paints figures as she sees or remembers them, and they have an unstudied, crude flexibility not found in the Lee composition where the stiff forms are rounded and polished self-consciously. Obvious, also, is the knowing organization of the Lee composition, the antithesis of lucky chance and intuitive spotting.*[63]

Although Grafly continues this sort of comparison between "natural" artists, such as Moses, and trained artists, such as Lee, she concludes with a statement which succeeds in placing the two categories of artists and styles into a larger cultural discourse. She suggests that "discovery of true 'primitives' by artists, and their acceptance by collectors suggests . . . a deep human nostalgia for direct, simple expression, whether the subject chosen be part of daily expression, or a reconstruction from memory or imagination."[64]

For some historians today, the gap between Lee and Moses loses Grafly's midcentury distinctions; rather, through a reassessment of Moses's style, the spontaneity and freshness of her composition and design have been replaced by a belief in Moses's

systematic presentation of forms and characters. As John Vlach points out, Moses "arrived at her technique through diligence and hard work."[65] Likewise he claims that "far from being an avowed primitive, Moses worked in a careful manner, observing her own ad hoc rules of perspective and paying strict attention to the lines of her popular models."[66] Moses relied heavily on her imagination, often choosing this source over nature itself. It should be noted however that this memory owes a great debt to the subject matter of popular Currier and Ives prints (a precedent she shares with Lee).

A second matter in the construction of Lee during the period was her involvement with the growing amateurization of art. Like her position as an untutored, tutored painter, Lee was also regarded as a professional amateur. Called by one historian as the "do-it-yourself author of record," Lee was caught up in the midcentury quest for leisure-time activities.[67] Her book, *It's Fun to Paint: Painting for Enjoyment*, which she co-authored with her husband Arnold Blanch, appeared in 1947 and remained in print for decades afterwards (fig. 9). It was a text which sought to teach adult students the first stages of the artistic process. In its opening pages, the book quickly warns however that it will not "teach you to paint professionally," instead the authors believe that they could "help you to teach yourself to the extent of being able to have a very good time."[68] So although the book makes the distinction from the outset of the line demarcating the authors (a.k.a. professional artists) from the readers (a.k.a. leisure-time dilettantes), within the discourses of the early cold war period, the mere association of Lee (and Blanch) with the amateurization of the art world placed them on the side of the amateurs. They might be the leaders of this group, but they are nonetheless a part of the group.[69]

During the popularity of their book and possibly owing a little to it, Lee became an integral part of the Famous Artists Schools, a correspondence school based in Westport, Connecticut. The premise of the school was rather straightforward; students would pay a fee and would receive lessons from the school. These lessons, in turn, would be returned to the Westport campus where a battery of professional artists (known as Fine Arts painters-teachers), most of whom made their careers as illustrators, would critique and grade the assignments. Above the team of painters-teachers was the Guiding Faculty. This group consisted of nationally-known artists whose expertise, supposedly, would be filtered through the teaching artists and directly onto the palette of the at-home students.

Doris Lee's major involvement began in 1954 when the Famous Artists Schools decided to expand its general art offering to include a new class, the Famous Artists Painting Course. One of ten "distinguished fine art painters," Lee was joined on the Guiding Faculty roster by Ben Shahn, Stuart Davis, Arnold Blanch, and Adolf Dehn, among others.[70] Writing in the school's magazine, *Famous Artists*, the editors explain the reasoning for the addition of this course: "Because of the constantly growing worldwide interest in amateur painting and because there was no comprehensive home study course of instruction in Fine Arts painting available, your Famous Artists Schools recently launched the Famous Artists Painting Course . . . designed to fill the specif-

FIGURE 8.
Grandma Moses, *Catching the Thanksgiving Turkey*, 1943.
Oil on canvas. Copyright © 1973, Grandma Moses
Properties, Co., New York. Courtesy the Galerie St.
Etienne, New York.

FIGURE 9.
Ansei Duncan and Dorie Lee during their collaborative work.
It's Fun to Paint: Painting by the Number, published 1947.
The National Museum of Women in the Arts, Library and
Research Center, Washington. Source: Gift of William B. Bendick
and B. Weinborn Fine Art, Inc., New York.

ic needs of the amateur painter."[71] Even though this statement stresses the amateur status of the student, the School was equally concerned with transforming these amateurs into professionals, specifically into illustrators and graphic designers.

One of the features in its *Famous Artists* was a focus on the success of its alumnae, and more often than not these were successes within the corporate end of art—illustrations, layout and graphic design. Writing in spring 1954, in the same issue which heralded the introduction of the Painting Course, Edwin Eberman, Director of the School, admonishes the students to "get out of the ivory tower." In advice to a qualified student who is having trouble finding a job, Eberman sternly reminds the alumnus that "you're not in an ivory tower business. You're in a business where the greatest success goes to those who understand people and how they act." He continues, "most successful artists are dual personalities. They feel at home in the world of businessmen as well as the world of art."[72]

If Lee blurs the distinction between amateur and professional, she likewise muddies the waters of fine and commercial artists. Throughout her career, Lee was fortunate to have gallery and museum exhibitions and to be spoken of within art publications. But during her showing at sanctioned high art venues, she was producing art for numerous corporations for use in their promotional materials. Included in this group were such companies as Abbott Laboratories, American Tobacco Company, Swift and Armour, and Standard Oil. With the institutional support of the Associated American Artists and its business pioneer Reeves Lewenthal, Lee along with a battery of other artists received commissions from corporate clients. For Lee, these jobs kept her anecdotal style in the public's eye, despite her attempts in her gallery pieces to venture into a more abstracted vocabulary.[73] This latter move by Lee was one which the artist herself had desired for a long time. As she stated later in her life, she had always been much more interested in shapes, colors and forms and resented her association with the Americana subject matter. But for Lee, this retrograde subject matter remained her stock in trade well into the 1960s.[74] In addition to her illustration commissions via the Associated American Artists, Lee was involved in two other AAA promotions—Stonelain and Pioneer Pathways fabrics—which worked to challenge the line between the fine and the commercial artist.[75]

Introduced in the fall of 1950, Stonelain was, according to the official correspondence of the AAA, "the most important program we have ever sponsored and we want the program to create a sensational impact when it is launched."[76] The product was a creation of the studio laboratories of the AAA and was described as "a clayware with stoneware's durability and porcelain's texture."[77] During the first season, the AAA offered a collection of 70 pieces of which many were offered in 3 or 4 color glazes. Lee was among many AAA artists who took part in this project. She was joined by other artists such as Joseph Hirsch, Robert Gwathmey, Georges Schreiber, William Gropper, and Arnold Blanch. The range of shapes, sizes and uses for the Stonelain pieces was as wide as possible, from ashtrays to vases, from figurines of Johnny Appleseed to cigarette boxes.

Like other AAA projects, the Stonelain line drew attention to the economics of art production and consumption by providing

affordable art to the middle-class home. Although the pieces were first shown at Lord & Taylor in New York City, this higher-end department store setting did not deter the AAA officials from offering a price range (from 5 dollars) which was within almost everyone's (or at least the middle-class's) reach (fig. 10). In all of the promotional materials released to stores and to the media, it was stressed that artists would receive five percent of the retail price for each of their items sold. The public relations department also emphasized the differing roles and thus status for each of the participants in the project—the painter/sculptor and the ceramicist. The latter was regarded as an artisan, with the former the "real" artist. To make the point even stronger, each Stonelain piece was titled and accompanied by a booklet with the artist's biography.

In their discussion of the Stonelain line, the media also focused on the economic plight of the struggling artists. Emily Genauer asks the simple question in her piece for the *New York Herald Tribune* that if the artists are the first to suffer from any squeeze on the American economy and if this problem is more chronic than acute, what are the artists and society to do. Ms. Genauer contends that projects like Stonelain will go a long way in redressing the discrepancy. According to her, "it manages to be not only thoroughly realistic and commercial in its conception and development but at the same time more idealistic and less opportunistic."[78]

The second AAA project to involve Doris Lee—the "Pioneer Pathways" fabric collection—was characterized by even more discussions of the distinction between the fine and the commercial artist. In 1952, Betty Pepis in the *New York Times Magazine* acknowledges the gap between artist and designer to be a "twentieth century digression." In a hopeful tone, though, she continues that "a revival of the old concept of an artist as one who can apply his creative talents to all kinds of things rather than restricting them to priceless productions for museums has become apparent since the end of the war."[79] It is into this context that Lewenthal's project can be placed. Often designated in newspaper headlines as "paintings by the yard," the Pioneer Pathway collection was the first collection of artist-designed fabrics produced in cooperation with Riverdale Fabrics. Artists included were Laura Jean Allen, Arnold Blanch, Aaron Bohrod, Witold Gordon, Luigi Lucioni, Anton Refreger, Grant Wood (posthumously) and Lee.

It is not coincidental that the Americana theme was chosen for the first season, nor is it accidental that Lee was one of the eight artists picked by AAA for inclusion in the first run. Her work, "Curio Cabinet," featured carefully chosen old objects placed on a series of shelves; the effect was to evoke a cabinet of nostalgic curiosities. For fear of loosing any audience, the press release on Lee's fabric highlighted the modernity of the style as well, stating that the "sharp clean pattern . . . stresses the functional lines of modern furniture." Her style, composition and design had been transformed from naive primitive and folk to a more suburban aesthetic (fig. 9).

FIGURE 11
Plan-a-Home Display of Lee's
Curio Cabinet, 1952. At Macy's
Department Store, New York City.
Associated American Artists
Scrapbook, Syracuse University
Library Special Collection.

FIGURE 10:
Stonelain Display in Lord & Taylor,
1950. Associated American Artists
Scrapbook, Syracuse University
Library Special Collection.

The tactics of the AAA, Riverdale and the marketing activities of the department stores around the country represent a split mind-set on the better way to sell the fabric. First there were the efforts by Reeves Lewenthal to remove these painters from the supposed rarified world of high art. In an unidentified piece, but probably publicity material from AAA, Lewenthal states, "Art needn't be mysterious . . . Today's artist is a designer, not an Ivory Tower tenant. His is a field of practical creativity and every American room can become a showcase for his genius." He concludes by pointing out that each fabric "is a signed original."[80]

On the other hand, marketing relied heavily upon the connections to high art (fig. 12). In Baltimore, for example, an exhibition of paintings by the artists involved in the fabric designs was presented at the Baltimore Museum of Art, and for its window display, a department store in Buffalo borrowed a painting from the Albright Art Gallery. Many local papers used press releases from AAA and wire dispatches to create stories about the fabrics, some of which, likewise, put the fabric into the sanctuary of high art. One such piece, written by an Associated Press correspondent, appeared in the *Durham (North Carolina) Herald* on March 14, 1952. Referring to the lot of patterns available, it stated that "the designs represent American folklore and culture and the design of the artists' group is to give the budget-minded housewife decorative fabrics and home accessories with a museum background."[81] *The Scranton Tribune* concurs: "Associated American Artists see this project as a stimulant to all art appreciation. People who have paintings can coordinate them with fabrics of the same color. Those who cannot afford original art, can now live with fine design."[82] Finally in an advertisement for Kaufmann's store in West Chester, New York, the rhetoric is the same: "So magnificent you can use them for framing, they're practical enough to use for upholstery on your chairs."[83]

For one designer, Beatrice West, there was no reason to make this distinction between wall and furniture. Along with many decorators and homemakers-as-designers, she used the fabrics on a number of surfaces. According to Macy's Department Store, in 300 identically predecorated and prefabricated model homes set up around the United States in August 1953, West used Lee's "Curio Cabinet" exclusively to decorate the living room. To compliment the "clean lines of Paul McCobb's furniture and lamps from Directional Modern and with the tweedy texture of the Waitrend rug," the fabric was used as a wall covering on a living room wall and brise bise in the adjoining kitchen.[84] Indeed the design (subject matter, if you will) of the fabric lent itself to a number of decorating and marketing uses—modern and traditional, high and low art. And in the end the Pioneer pathways fabrics and the Stonelain ceramics used both strategies to attract attention and, hopefully, consumers. Lee's service to both projects did not in itself set her apart from other AAA-stable artists who participated; it was, however, the inclusion of these projects in the growing list of middlebrow cultural objects for which she, more than her colleagues, became associated that marks her as firmly entrenched in middlebrow culture.

Lee's involvement in the Stonelain and Riverdale Fabric endeavors positioned her as an artist betwixt and between the worlds of high art and interior decorating and her involvement with the Famous Artists Schools and *It's Fun to Paint* likewise put her in the

FIGURE12

the middle position between fine and commercial art and between professional and amateur. Although by today's standards, Lee's split reputation might seem less than remarkable, and the distinctions unnecessary, this was not the case for audiences in the 1940s and 1950s. The rhetoric of the promotional materials for all of these projects together with other noted cultural phenomenon signal the grave stakes for this construction. Paralleling discussions of middlebrow culture were concerns about the artistic profession. There were, to be sure, artists whose work, at first glance, defied popular co-option. Similarly, there were artists whose work fell quickly and almost naturally into the lap of the masses—take for instance Norman Rockwell. Yet between these two poles of public perception lay a host of artists who had one foot in each of the two camps. How do these figures factor into our accepted notions of the history of American art from the midcentury? Even though regionalism had officially been declared dead by the late 1940s, why then did Lee's work which for all intents and purposes appeared to the public to be from the same palette as Benton, Wood and Curry continue to find its place in a variety of art forums?

\mathcal{W}restling with the Gender Issue

Throughout this analysis of Doris Lee's position within middlebrow culture, there has been one central element which has escaped our attention. How does the issue of gender operate within the construction of the middlebrow, or more broadly within the discourse of mass culture? Doris Lee offers a rich case-study for this question, a case-study which will serve as the conclusion for this essay. Even a cursory look at Lee's oeuvre will result in an acknowledgement that Lee paints overwhelmingly of a female homosocial world. Her subject matter and her characters almost always are caught up in the performance of socially-coded female activities. Whether it is the preparation of a holiday meal, as in *Thanksgiving*; the serving of meals and beer to a hungry clan of men, as in *Harvest Time* (Plate 64); or the world of dressmaking and communal sewing, as in *Designers* (Plate 66); Lee paints the spaces of the female, relying heavily on the role of community often at the expense of the individual.

It is tempting with Lee to suggest that she, like other female artists, suffered at the hands of the patriarchal art world and that her reputation was hindered as a result of her gender. Such a claim would be unfortunate for it actually hides more than it reveals, providing an all-to-easy foreclosure of the issue. Gender is, to be sure, operative within the making of Lee, but a reclamation project for a (currently) under-recognized female artist does little to expose the systems of gender within the historical moment. Rather, it is the purpose of this conclusion to suggest how caught up in the discourses of gender were the contradictions noted above and how might such revelations assist in rethinking the gap between the assumed polarities of high and low; professional and amateur; and fine and folk.

Lee's success came with a price. Considered in the 1930s and 1940s as one of the most well-known and popular artists, she enjoyed a level of success that many of her male colleagues from the same artistic school did not; her husband Arnold Blanch is a prime example. In the years since her heyday, Lee has attracted some attention in museum exhibitions and gallery

shows, the latter mostly after her death in 1983. She has become regarded as a somewhat important female artist of the twentieth century but has fallen quite behind the reputations of those artists (including Georgia O'Keeffe) she surpassed in the height of her own career. It would be easy to conclude that the patriarchal system of art history has been the active agent in confining Lee to this status. However, this explanation does not take into account the nature of Lee's reputation both during and after her heyday. For that explanation, we must look a little further into the gendered operations of mass culture.

Lee's reputation has suffered as a result of the feminization of her art. To be clear, this is not the same as stating that her reputation has suffered because she is a female artist. Rather, Lee has been feminized, and thus devalued, by her co-option into mass culture. Her confinement to the middlebrow world was accompanied by the relegation of the middlebrow to the realm of the female. Historian Andreas Huyssen has convincingly argued that modernism (i.e. highbrow) has necessarily constructed mass culture (i.e. low and middlebrow) as the Other. With its insistence on autonomy and its focus on production, modernism has been associated with the male world since the latter decades of the nineteenth century, while mass culture has been defined as debased and caught up in the spectacle of consumption. Huyssen suggests that this process comes to an end during the middle decades of this century. Lee's career, then, might provide one of the last instances of this system.

The feminization of Lee, then, can be said to come from two sources. First of all, the products and projects with which she was associated were relegated within midcentury discourses to the realm of the feminine. Her style of representational, anecdotal and illustrative imagery, in an era which began to associate such popular realism with sinister forces of Fascism and isolationism, remained popular because it had been confined into the female sphere. Her espousal of Popular Front ideology during the 1930s was replaced by the 1950s with her support of slipcovers as a valid form of expression.

The second factor in the feminization of Lee and her place within the midcult was the ultimate consumption value of her art and her career. As Huyssen suggests, "the lure of mass culture has traditionally been described as the threat of . . . merely consuming rather than producing."[85] Through subject matter, style, media and popularity, Lee was a consumer's artist. But more importantly, through the discourses of mass culture, Lee was made to be consumable. Any tinge of modernism and complexity was subsumed within popular discourses about Lee. In the end her art was conscripted to play to a mass audience, often at the expense of her intent and of more involved meanings. Huyssen might have been speaking of Lee's career when he wrote:

> Thus the nightmare of being devoured by mass culture through co-option, commodification, and the
> wrong 'kind' of success is the constant fear of the modernist artist, who tries to stake out his territory
> by fortifying the boundaries between genuine art and inauthentic mass culture.[86]

For Lee then, her work and its popularity disallowed the stabilization of these boundaries, or at the very least foregrounded the possibility that these boundaries do not even exist.

Endnotes

1. For an account of Mrs. Logan in the context of the Chicago art scene, see Sue Ann Price, " 'Of the Which and the Why of Daub and Smear': Chicago Critics Take on Modernism," in *The Old Guard and the Avant-garde in Chicago, 1910-1940*, ed. Sue Ann Price (Chicago: University of Chicago Press, 1990), 95-117. Logan also published a treatise of sorts, in conjunction with her organization, titled *Sanity in Art* (Chicago: A. Kroch Publisher, 1937). This book includes many encouraging responses to Logan's efforts. Logan makes her position quite clear: "My first reason for bringing this organization into being was to help rid our museums of modernistic, moronic grotesqueries that were masquerading as art; my second purpose was an endeavor to reestablish authentic art in its rightful position before the public"(10).

2. In her 1946 monograph, the artist writes, "often I think it is because they have liked the subject and this discomforts me somewhat, for I like shapes best, or, at least that is what I work hardest for" *Doris Lee* (New York: American Artists Group, 1946), n.p.

3. Other contradictions include the difference between her down-home imagery drawn from a rural life and her life in Woodstock, New York, even then known for its radical social practices. Also, Lee's art, to be sure, focuses on the world of the family, and especially the interaction of mother and child, while the artist herself was not a mother and her relationship with Arnold Blanch was a result of an affair they had while married to their first spouses. Whether or not Lee's art serves as a wish-fulfillment for the artist around the issue of family and children cannot be substantiated.

While the scope of this project is limited to looking at her career from a position of the debates about class and culture of the middle decades of this century, there are other possible avenues to pursue. For instance, although this analysis concludes with a brief and purposely schematic look at the systems of gender norms which have aided in the construction of Lee, I can envision anentire project predicated on an investigation of Lee's career from the perspective of gender studies and in particular her place among the masculinized discourses of American regionalism. It is my intention to offer the present essay as a starting point in our review of the artist, her work and her position within the history of American art, not as a definitive monograph on the artist. In addition, an analysis of Lee's style falls outside of the parameters of this project; instead, as will become obvious, my interest in Lee stems from her fence-walking position with regard to high and low cultures.

4. For instance, what kept Lee creating in a style which she publicly abhorred? Did she continue to paint homespun illustrations for any of a number of corporations and advertising executives who requested them because she needed the money? Is the answer as simple as that? Or, did she not make the distinction between all of her output and clients? These questions, for now, must remained unanswered, for the documents and the evidence are not available, if they even exist.

5. What is meant, exactly, by products of mass culture? There are two ways of defining these objects. On the one hand, any object which was achieved by the advanced means of production was considered part of mass culture. On the other hand, any object which

was executed for a specific mass audience regardless of its means of production was also considered part of mass culture. For the sake of clarity, though, we will make the following distinction—the former objects will be referred to as part of "mass culture" whereas the latter will be called part of "popular culture."

"In the 1930s, 'mass culture,' 'popular culture,' and 'kitsch' all originally referred to much the same thing—cultural goods produced as commodities for mass consumption and in the service of political or economic goals. These cultural commodities were produced according to formulae rather than arising from individual inspiration." See Richard H. King. "Modernism and Mass Culture: The Origins of the Debate," *European Contributions to American Studies #12: The Thirties. Politics and Culture in a Time of Broken Dreams* (1987): 124.

6. Let it be clear from the outset, the theories on mass culture expounded below are not meant to force all discussions of the artist to see her within these terms; rather it is meant to provide what is probably the most cogent beginning for the understanding of Lee's career.

7. In other words, the Frankfurt School, out of a Marxist perspective, saw the benefit in studying mass culture in its ability to explicate the systems of production, consumption and even oppression which enact meaning.

According to Richard King, "the model they (the Frankfurt School) posited in *Dialectic of Enlightenment* was a fairly crude one in which the production and dissemination of cultural goods was a function of the dominant economic institution, serving to re-enforce that dominant system in all its aspects"(103).

James Naremore and Patrick Brantlinger have suggested that Adorno and this group maintained that the man with leisure has to accept what the culture producers offer him. The authors continue that the Frankfurt

School believes that "the ultimate product of the culture industry isn't movies, newspapers and ads, but the pseudo-individuals who consume these commodities." See James Naremore and Patrick Brantlinger, "Introduction: Six Artistic Cultures," in *Modernity and Mass Culture*. ed. Naremore and Brantlinger (Bloomington: Indiana University Press, 1991), 3.

8. Other intellectuals associated with the magazine included editors Philip Rahv, and William Phillips and writers such as Clement Greenberg.

9. Dwight Macdonald, "Masscult and Midcult," *Partisan Review* (Spring 1960), reprinted in *Against the American Grain* (New York: Random House, 1962), 14. All quotations are drawn from the 1962 printing.

10. Ibid., 34.

11. Ibid., 7. As other commentators of the period have noted, the era is characterized by a shift from the ethos of production to that of consumption. Macdonald, in this case, has merely transcribed this debate onto the definitions of high and mass culture.

12. Ibid., 37.

13. Ibid., 38. Macdonald goes onto to comment that "[M]idcult is the transition from Rodgers and Hart to Rodgers and Hammerstein, from the gay tough lyrics of *Pal Joey*, a spontaneous expression of a real place called Broadway, to the folk-fakery of *Oklahoma*!" (39).

14. There are similarities between the Frankfurt and *Partisan* approaches to mass culture. Christopher Brookeman has written that Macdonald and Adorno "see mass culture as transmitting distorted consciousness through the use of repetitive stereotypes and mechanical narrative formulae." See his *American Culture and Society Since the 1930s* (New York: Schocken Books, 1984), 42.

15. Russell Lynes, "Highbrow, Lowbrow, Middlebrow," *Harper's Magazine,* 198 (February 1949): 19.

16. Ibid., 21-2.

17. Ibid., 20.

18. Ibid., 23.

19. Lynes does subdivide the middlebrow into upper and lower units.

20. Ibid., 28. Any discussion of mass and popular culture and art during the mid-twentieth century must acknowledge the writings of Clement Greenberg on kitsch. For this particular essay, the work of the above critics are more germane, but to present a fuller picture of the period, let us examine briefly kitsch in relation to the outlined concerns of mass culture. In his 1939 article in *Partisan Review*, "Avant-garde and Kitsch," Greenberg presents a dialectic of aesthetics, a dialectic between avant-garde and the rearguard (or kitsch). As an ersatz culture, kitsch relies on the "availability close at hand of a fully matured cultural tradition" (25); "pre-digests art for the spectator and spares him effort" (28); and can be characterized by its products: "popular commercial art and literature, with their chromo-types, magazine covers, illustrations, and slick and pulp fiction, comics, Tin Pan Alley music, tap dancing, Hollywood movies, etc" (25).

More importantly for the current purposes of this essay Greenberg clarifies the issues when he writes that "if the avant-garde imitates the processes of art, kitsch. . . imitates its effects" (28). For Greenberg and for us, this renders the distinction between avant-garde and kitsch in terms of Marxist philosophy, for the avant-garde is about production and kitsch is about consumption. All references to "Avant-Garde and Kitsch" are taken from its republication in *Pollock and After: The Critical Debate*, ed. Francis Frascina (New York: Harper and Row, 1985), 21-33.

We will explore the split between production and consumption within the conclusion of the essay. For now, we can see in Lee's work this split in the amount of emphasis placed on readable content and not on her abstract (i.e. works which are about production) or which call attention to production. Her works are made to appear seamless and effortless.

21. *Elgin Daily Courier-News*, 24 November 1943, n.p. Newspaper clipping from the Doris Lee Papers at the National Museum of Women in the Arts.

22. *School Savings Journal* (fall 1946): n.p. Clipping from the Doris Lee Papers at the National Museum of Women in the Arts.

23. William Graebner's recent text on the 1940s lays out with far-reaching evidence the extent of these feelings of anxiety and self-doubt as well as the actions of the decade taken by a whole host of citizens to stave off these feelings. See his *Age of Doubt: American Thought and Culture in the 1940s* (Boston: Twayne Publishers, 1991).

24. To our contemporary audience, the popularity of *Thanksgiving* has fallen behind Wood's and Rockwell's imagery. At the height of its popular regard (1935-1950), Lee's painting often outranked Wood's image. According to a published report found in the Lee scrapbook materials at the National Museum of Women in the Arts, postcard sales, always a indicator of mass interest in art, were much higher at the Art Institute of Chicago for *Thanksgiving* than for *American Gothic*. In other words, in certain markets in America, Lee's imagery held a greater place in the fabrication of the past than did other, similar visions.

25. It was readily consumed by the mass audience in a strategy like that of Greenberg's definition of kitsch; it was "predigested" for the consumer.

26. Warren Susman, "Culture and Commitment," in *Culture as History* (New York: Pantheon Books, 1973; reprint, 1984), 185.

27. Susman likewise suggests that this "was an age that consciously sought new heroes, new symbols even new myths: an age that rediscovered the 'folk.' It was an age that sought in established and regularized holidays. . . to return ritual to its "proper" place in American life" (204).

28. Elaine Tyler May, *Homeward Bound: American Families in the Cold War Era* (New York: Basic Books, 1988), 57.

29. Ibid., 48. A 1936 Gallup poll makes all of this clear: "82% believed that wives of employed husbands should not work outside of the home" (49).

30. The tension which accompanied this remaking of a relationship forms the basis of the popularity of Dale Carnegie's *How to Win Friends and Influence People* (New York: Simon & Schuster, 1936).

31. Susman, 200.

32. Such an emphasis on the community at the expense of the individual finds an intriguing parallel in the popularity and the operating practices of the Communist Party of the United States (C.P.U.S.A.). In an attempt to attract followers and to make their goals more palatable to a broader section of the American bourgeoisie, the C.P.U.S.A. consciously drew upon American history to legitimize their claims to a place at the American political table, a metaphor which additionally directs attention at the desire by competing interests to be part of the discourse on the all-important family. Citing the revolutionary struggle of the Founding Fathers and using their likenesses at their rallies, the C.P.U.S.A. constructed a history of American political radicalism which included many of the significant heroes (both real and symbolic) from the 150 years of American nationhood. Such a use of history, as all such uses, walked a fine line between the reactionary utilization by the Nazi party and the progressive employment by the Popular Front. In other words, a strict demarcation as to the claims on American history was unrealized and to some extent unrealizable during the Depression-era, for all groups needed the use of history to legitimize their claims on the future.

This is not to suggest that Lee is actively creating a work of leftist propaganda, this despite her own leftist leanings during the period. Rather it is to raise the point that so pervasive was the emphasis on the communal well-being within mid-1930s America and claims on nostalgic and real history that to disregard these aspects only eclipses the complexity of the painting. The co-option of the painting by the apologists for a return to a nostalgic way of living has forced the work into a silence for numerous decades.

33. Unfortunately, the magazine has a policy that denies reprinting of any of its imagery.

34. "A Thanksgiving Country Kitchen," *Country Living* (November 1987): 121.

35. Mrs. B.T. Choate, "Doris Lee with a Family Touch," *Country Living* (February 1988): 14.

36. To extend the reader's commentary a little further, the "same family" of which we are all members is a family without the presence of adult men.

37. For a fuller discussion of Benton's activities in Hollywood, see Erika Doss, "Thomas Hart Benton in Hollywood: Regionalist Art and Corporate Patronage" in her *Benton, Pollock and the Politics of Modernism: From Regionalism to Abstract Expressionism* (Chicago: University of Chicago Press, 1991), 147-228.

38. William Graebner argues that "the confusion and uncertainty (of the decade) extended to the most basic beliefs, values and priorities" (146). His text chronicles the decade in terms of its split personality—one of increasing well-being offset by mounting concern about the self.

39. "Hollywood Gallery: A Painter's Portfolio of Impressions of Movie City," *Life*, 19 (October 15, 1945): 84.

40. Ibid.

41. Time and again, stories on Lee focused on her workmanlike approach to painting. She worked in a methodical manner which often stood in contrast to the commonly held assumptions about the Bohemian lifestyle of many artists.

42. "Hollywood Gallery," 84.

43. Lee's involvement with the rightwing Lucepress and the consumption-oriented Hollywood of the mid-1940s only begs the question of Lee's own political views. Once again, Lee presents contradictory evidence, leading to an inconclusive outcome. In some ways, Lee fits in with a large number of artists who, while they supported the Popular Front during the middle and late 1930s, became more and more enamored and inspired by the center after the war. Walt Disney and Rockwell Kent provide two differing examples of this phenomenon. In the end, though, Lee still stands as enigmatic. If she disliked the scope and nature of her commissions, for as she felt these projects only held her back, then why did she return to these sorts of projects time and time again. Was it a simple matter of economics? Or did she, like others, not see the situation in such terms?

44. "Movie of the Week: *The Harvey Girls*," *Life* 19 (December 3, 1945): 82-6. It is not clear exactly how this particular film was chosen. Did *Life* pick it for Lee or did she decide on it herself? In either case, the canvases she produced accompanied the article in the magazine and acted like "behind-the-scene" snapshots of the movie's production. It is highly likely that the association of Lee's name with the picture, among other factors, aided the box office receipts.

45. Ibid., 82.

46. Clive Hirschhorn, *The Hollywood Musical*, 2d ed. (New York: Portland House, 1991), 266.

47. Bosley Crowther, "Harvey Girls," *The New York Times*, 25 January 1946, 2.

48. Quoted in James Robert Parish and Michael R. Pitts, *The Great Hollywood Musical Pictures* (Metuchen, N.J: Scarecrow Press, 1992), 289.

49. Rick Altman, *The American Film Musical* (Bloomington, IN: Indiana University Press, 1987), 35.

50. Ibid., 272.

51. Ibid., 273.

52. Ibid.

53. Jane Feuer, *The Hollywood Musical*, 2d ed. (Bloomington, IN: Indiana University Press, 1993), 3.

54. Ibid.

55. The fact that they appear spontaneous occludes the many takes and camera repositionings which are necessary within film to obtain an "unrehearsed" scene.

56. This covered distance is further revealed in *The Harvey Girls* when we consider that it is Garland and not the "professional performers" at the Alhambra who gains credibility and succeeds in capturing the film's prize,

John Hodiak. As Feuer points out, "For a movie genre which itself represents professional entertainment and which is so frequently about professional entertainers, there seems to be a remarkable emphasis on the joys of being an amateur" (13).

57. Doss, 171.

58. Ibid., 194.

59. S. J. Woolf, "Grandma Moses, Who Began to Paint at 78," *The New York Times Magazine*, 2 December 1945, 16.

60. Ibid.

61. Marshall B. Davidson, "Symbol of American Folkways," review of *Grandma Moses: My Life's History,* ed. Otto Kallir, *Saturday Review of Literature* 35 (March 1, 1952):11.

62. Dorothy Grafly, "Primitives and Primitives," *American Artist* (October 1949): 46.

63. Ibid.

64. Ibid., 48

65. John Vlach, *Plain Painters: Making Sense of American Folk Art* (Washington, D.C.: Smithsonian Institution Press, 1988), 157.

66. Ibid., 155.

67. Karal Ann Marling, *As Seen on TV: The Visual Culture of Everyday Life in the 1950s* (Cambridge: Harvard University Press, 1994), 74.

68. Arnold Blanch and Doris Lee, *It's Fun to Paint: Painting for Enjoyment* (New York: Tudor Publishing Company, 1947), n.p.

69. As Karal Ann Marling has recently noted, Lee and Blanch's book is part of a larger trend in post War America to pursue art as a leisure-time activity. During the 1950s, as Marling points out, "the paint-by-number sets were the biggest hobby break-through of the decade and a fad so courageous that it amounted to a national mania" (58).

70. In an undated advertisement for the Famous Artists School, Lee is pictured beneath one of her canvases with the following caption: "Doris Lee is not only the most distinguished woman painter in America—as a Fine Arts painter she is probably in greater demand among magazine and book publishers than any other artist." Doris Lee Papers at the National Museum of Women in the Arts.

71. "Painting Course Makes Debut," *Famous Artists* 2 (spring 1954): 7.

72. Edwin Eberman, "[Notes from the Director]," *Famous Artists* 2 (spring 1954): 3.

73. Lee's *The Bathers* (Plate 67) is an excellent example of her style in 1950, whereas her folksy sentimentalism appealed to corporations until the 1960s, particularly Abbott Laboratories and Standard Oil.

74. In an interview in *Famous Artists*, Lee reluctantly acknowledges her reputation for such "primitive" paintings as *Thanksgiving* and *Country Wedding*. "Question: When magazines and advertising agencies commission you to do a painting, I suppose they always ask for one with a primitive flavor, a so-called "genre" scene." "Answer: Unfortunately yes. I do many other kinds of work. But some of my paintings have been reproduced so widely that many people associate me exclusively with *Thanksgiving* or *Country Wedding*. What art directors often want is a repetition of these paintings. Some of these qualities will proba-bly persist in my work, but I like exploring other media

and other subjects—the theater and dance, of instance." Undated clipping. Doris Lee Papers at the National Museum of Women in the Arts.

75. Lee had also been involved with an AAA print project and later with miniature, mass-reproduced color prints. AAA also arranged for many of Lee's book illustrations, holiday and playing card contracts.

76. A letter from the Associated American Artists Gallery (AAAG) soliciting participation in a market research survey on Stonelain, conducted in early 1950. Reel D256, Archives of American Art. The scrapbooks of the Associated American Artists and its gallery are currently held by the Special Collections Library at Syracuse University and are available on microfilm from the Archives of American Art.

77. Press Release from AAAG in 1950 titled "Famous Artists Create New Ceramic Ware to be Publicly Introduced this Fall of Unusual Utilitarian and Decorative Pieces Developed in its own Labs." Reel D256, Archives of American Art.

78. Emily Genauer, "Art and Artists," New York Herald Tribune, 17 September 1950, n.p. Reel D256, Archives of American Art.

79. Betty Pepsis, "Artists as Designers," New York Times Magazine, 9 March 1952, 33. Reel D255, frame 215, Archives of American Art.

80. Unidentified clipping from the Associated American Artists Scrapbooks, Reel D555, frame 221, Archives of American Art.

81. Vivian Brown, "Budget Homes Can Boost Accents in Museum Motif," Durham Herald, 14 March 1952. Clipping from the Associated American Artists Scrapbooks, Reel D555, frame 224, Archives of American Art.

82. "American Artists Do Paintings 'By the Yard' for Housewives," Scranton Tribune, March 1952. Clipping from the Associated American Artists Scrapbooks, Reel D555, frame 225, Archives of American Art.

83. West Chester Local News, 18 April 1952. Clipping from the Associated American Artists Scrapbooks, Reel D555, frame 245, Archives of American Art.

84. "Predecorated, Prefabricated," Retailing Daily, 27 August 1953. Clipping from the Associated American Artists Scrapbooks, Reel D555, frame 244, Archives of American Art.

85. Andreas Huyssen, After the Great Divide: Modernism, Mass Culture, Postmodernism (Bloomington: Indiana University Press, 1986), 55.

86. Ibid., 53.

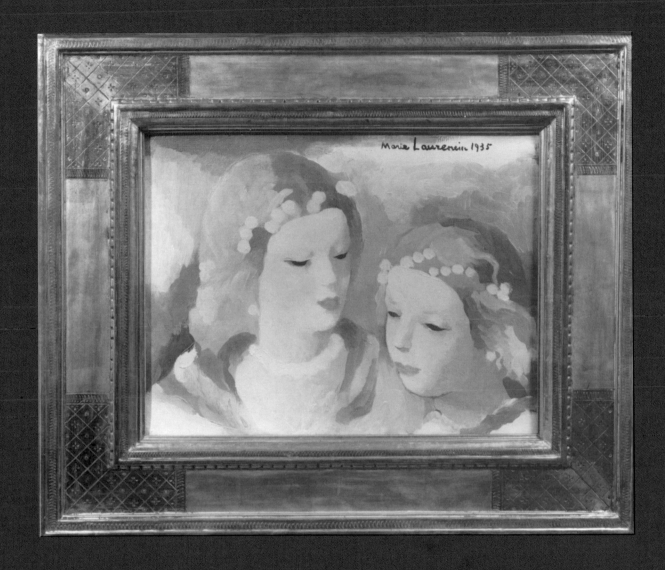

A Personal Approach to Collecting

A Personal Approach to Collecting
by Jim Dicke

When Alex Nyerges, Director, and Marianne Lorenz, Assistant Director for Collections and Programs of The Dayton Art Institute suggested re-opening the museum with the exhibition of the Dicke Collection, I could see why a local collection was an ideal choice. A local collector could be more flexible than a traveling exhibit about accommodating last minute changes occasioned by the re-opening of The Dayton Art Institute. Their suggestion was flattering, but also daunting. I had been a part of only one other exhibition, and that had been a big undertaking. In addition, the Dicke Collection had never been shown in its entirety. Finally, I was concerned about the safety of the collection. It is one thing to carefully move one art object at a time, but to move dozens evokes visions of torn canvas and of damaged period frames. Although such occurrences are unlikely, the easiest path for the collector is to say no; however, two things made us say yes to The Dayton Art Institute. First, my parents, Jim and Eilleen Dicke, were both raised in Dayton, and my mother, Eilleen (Webster), actually worked for a short time at The Dayton Art Institute. These local connections made The Dayton Art Institute the natural place for us to exhibit our collection.

Art collecting is a little mysterious, and it often suits collectors, experts, and dealers to maintain as much mystery about the process as possible. Exhibits of individual collections are often self-congratulatory attempts to inflate the importance of each "masterpiece" shown to match the collector's ego or to enhance the collector's market value with hype. I hope this exhibit will demystify collecting a little, and so will encourage others to begin their own collections, thereby enriching the cultural life of the Miami Valley. Indeed, I hope my comments will provide something of a road map for those wishing to build a collection.

My interest in art came naturally. At age ten, while on a family vacation in Michigan, I bought a small watercolor of horses for about $5, a sizable sum for a kid who received an allowance of a generous 50¢ a week, supplemented by shining shoes for 15¢ a pair and pulling dandelions for 10¢ an hour. At age sixteen, I purchased my first oil, a French painting *de Jeune Fille* by Neumann, from a gallery owner who eloquently compared Neumann's technique to that of Marie Laurencin. Although I had never heard of Laurencin, I nodded solemnly in agreement because I knew that I wanted to own this painting, and that the price was right. Today I know Marie Laurencin's work — in fact, we are fortunate enough to own one (fig. 1) — and I now know her style was very different from Neumann's.

Then, in the early years of my business career, I purchased a few prints and some oils, assembling a collection of pieces that suited my fancy and our pocketbook, but with little real understanding of the items' significance or any sense of what had brought about their creation. My little collection was eclectic and modest. I bought Japanese woodblock prints by Hiroshige, old etch-

FIGURE 1
Marie Laurencin,
Deux Jeunes Filles en Buste,
1935. Oil on canvas.

ings, works by Alexander Calder, by Anders Osterlind, and by Robert Kipness, and—prompted by a single Eisenhower medal my father had in his office—a collection of official presidential inaugural medals.

In those early years, I had little understanding of each item's historical significance, and no sense of the artistic process. Then two things happened which transformed my understanding of art, and guided subsequent purchases. First, I started to read about art, beginning with a Time-Life series of books by John Russell titled The Meanings of Modern Art. This series prompted me to read more, not only about what had influenced those artists, but also about other artists and other styles. I began to visit museums regularly, where I learned the value of viewing the original, rather than a reproduction. Moreover, seeing cracks, holes, dirt, and other problems that plague artworks prompted me to learn about conservation. Second, I heard a lecture by John Marion, then president of Sotheby's, on why auctions are a great way to buy art. I subscribed to auction catalogues from Sotheby's and from Christie's, and began to bid by mail on a few small items.

When you live in New Bremen, don't go to see the auction previews in New York, and know as little about the process as I did, you find yourself bidding on something you have seen only in a black and white illustration. I remember buying one oil on canvas piece by an English artist, only to be shocked when it arrived that it was so large. From the illustration I had pictured in my mind's eye a small painting and had not even considered the dimensions printed in the catalog. I did not know enough to ask the auction house for a "condition report" or even a color photo of an item.

By the early 1980s, having learned both the value of research and the auction process, we decided to make our first important purchase, a painting by Claude Monet. We had seen a color illustration of a Norwegian winter scene by Monet in a Christie's catalogue, and while in New York City a few weeks before the auction, we decided to see if Christie's would allow us to view the painting prior to the public preview scheduled for the following week. They graciously guided us into an art storage room, where we came face to face with a sublime work of art. I resolved to learn all that I could about both Monet and this painting.

On the auction night, I knew how, when, where, and under what circumstances Monet had painted this winter scene, and that a sister work of the same size and scene was in the collection of The Art Institute of Chicago. I knew it was from the Monet estate and had escaped destruction in Monet's later years, when the artist had destroyed many of his own paintings. Either the family had hidden it to save it from his destruction, or he had decided it was one of those pivotal paintings he wanted to keep. The picture was reproduced in one of many books on Monet to illustrate his use of the canvas ground (brown base coating of the canvas) as part of the composition. I knew that Monet had written home from Norway about the painting of these sister works and had described to his wife the snow storm, the small hotel where he was staying, and his fascination with the quality of the light. In short, we had more knowledge about the particulars of this painting than Christie's probably had the time to dig

up—we knew more than Christie's needed to know or had the inclination to research. I thought that it should probably sell for the catalogue estimate. And, I had decided how much I would bid. During the years that we owned that painting, we enjoyed it immensely, and when we realized that our other pictures were of lesser quality, we made a commitment to quality. This purchase gave us the impetus to collect.

While our purchase of the Monet prompted us to collect quality works, Jonathan Westervelt (Jack) Warner, our friend and one of the world's premier collectors of American art, directed our attention to American art, now the focus of the Dicke Collection. Warner said, "American art has a distinctly American and optimistic point of view. We are Americans and that's what we should be collecting." We agreed and began to learn about American art, although we were frustrated by the lack of information about artists such as Doris Lee, Edwin Deming, Cyrus Dallin, and Abbot Thayer. We bought paintings at auction like *The Old Cart Road* by Worthington Whittredge (Plate 16) and *The Desk* by Fairfield Porter (Plate 69) before scholars of American art had written much about these artists. Kim Anderson, a friend and a fellow art collector, insisted that we broaden our access to works by American artists by meeting important dealers such as Vance Jordan, Ira Spanierman, De De Wigmore, and Joan Michelman. I learned that things that come to the auction market are not always fresh from collections. Sometimes they have been in dealers' inventories and have been offered for several years, to the point where they are overexposed. It is good to know what has "been around." Often the greatest paintings trade privately; and besides being in the business to make money, these dealers are people who are doing what they do, I believe, for the love of it. Their knowledge is great and often they have direct connections to the estates of the artists, and all manner of professionals, research and restoration resources. They have practical knowledge of the markets, of who collects what, and of where the market is going in terms of value and taste. Their antennae are so sensitive that I have heard them single out a picture and correctly predict which collector will buy it. The best dealers seem almost to have x-ray vision that lets them see through dirt and discolored varnish to the spectacular painting that exists below. They know which problems of condition can be overlooked as insignificant and which signal that you should avoid the painting at any price. They know enough about an artist's color palette and technique to guess accurately how a painting will restore.

Thanks both to the advice of these friends, and to our own experience with auction houses as well as dealers, we have amassed a collection of (primarily) American art that emphasizes the twenty-five years prior to World War I. Although one would call any collection of American art spanning 130 years eclectic, an aesthetic unites the Dicke Collection. We have tried to focus on American paintings of high quality, rather than either collecting a specific period or region, or compiling a checklist of works by artists deemed important by scholars. We have collected works by important artists, such as Childe Hassam, and works by artists that we consider important, such as Doris Lee. The Dicke Collection includes neither trite nor tortured images, but rather presents images that convey emotions or tell stories. Some images are strong, such as Joseph Hirsch's *Hercules Killing the Hydra* (Plate 58) and Georges Schreiber's *Night Haul, Boothbay Harbor, Maine* (Plate 59). Both beauty and sentiment charac-

ize Julius Stewart's *Woman in an Interior* (Plate 22). Other works, such as Robert Graham's *Jessie and Greenberry Ragan* (Plate 60) and Childe Hassam's *Lymons Ledge, Appledore* (Plate 30) tell a story that demands the viewer's emotional involvement.

The Dicke Collection offers not only a visual and emotional experience, but also a guide for novice collectors. Do not think of an art collection only as a financial investment, because even the most exciting financial gain accrued from the sale of an artwork will probably be no better than that from an alternative investment. The difference between collecting and investing is the psychic dividend of living with a work of art. Many resources are available to the collector, and the following paragraphs will enumerate some of these.

I advise first, and above all, that you not only see as much art as you can, but also research art, artists, and the art market. Purchasing objects for a collection should not be done on a whim, and the "I know what I like" sentiment is a poor basis for a collecting plan. Many collectors start by buying whatever strikes their fancy, only to find that they have paid top dollar for poor quality. In moments of candor, some of America's greatest collectors admit to such mistakes when they first started. In building the Dicke Collection, we were lucky to avoid many bumps along the learning curve that collectors find discouraging. We never bought a lot of mistakes, or felt burned, or quit, or started over.

To learn more about the collecting process in general and what makes markets, no matter what the collection, Joseph Alsop's out-of-print book *The Rare Art Traditions*, is a gem on the subject. Although either dealers or art consultants can offer helpful advice, you must be interested enough to read, to research, and to develop your own judgment, or you should do something else!

If you are willing to do the research, then many resources are available. I recommend subscribing to art magazines, especially *American Art Review, Art and Auction* for information about the market, and *Art in America* for both its coverage of contemporary art and its annual directory of dealers and artists. Auction house catalogues and auction price records provide another valuable source of information. Art book dealers such as Ursus and Hacker in New York City and Bernie Rosenberg at Olana Gallery in Brewster, NY provide the widest selection of books. In addition, attending lectures, visiting museums, and meeting local artists and their dealers also will broaden one's horizons.

Information gleaned from these resources will assist you in determining whether the price of the work reflects its importance within the context of the artist's oeuvre. From our collection, John Joseph Enneking provides an excellent example of the relationship between price and period taste. Enneking was born in Minster, Ohio, in 1841. He went to Cincinnati for art instruction, then to France, and then to Boston, where he established a successful career as regional artist. Today, most scholars consider him

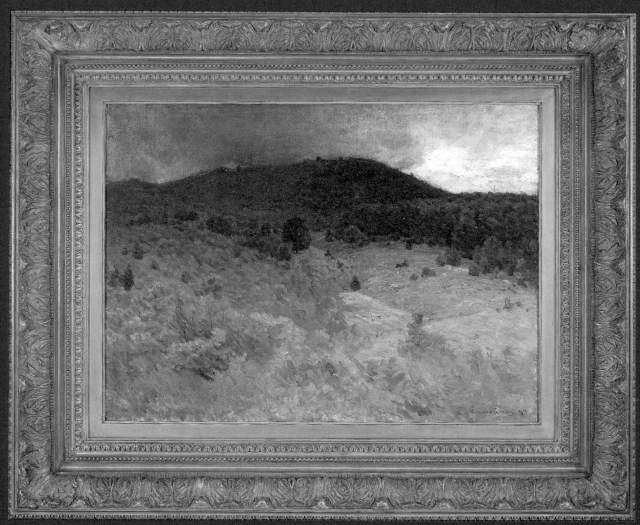

FIGURE 2

FIGURE 2
John Joseph Enneking,
Spring Storm Approaching, 1897
Oil on canvas.

72

a Boston artist, some categorize him as a member of the Ohio school, and many more label him an impressionist. The paintings he did in orange and rust tones were popular in his own time; however, today his most valuable works are landscapes in hues of green, such as *Spring Storm Approaching* (Plate 23; fig. 2). Often, you can find minor Ennekings for sale for $2,000 or $3,000, although his significant works might sell for as much as $80,000. Without research, you can easily pay twice what you should for an Enneking. Research will help you evaluate both the historical importance and the market value of a painting.

What an artist is famous for almost always commands a higher price than other work by the same artist. Work from the period when the artist was at the height of his/her creative power will also be more desirable, as will famous pieces or work pivotal in the development of the artist's career. Knowing where a piece fits in the artist's career makes ownership and the act of living with a piece more fulfilling, and is essential to understanding its price.

You must also consider whether you should spend that $100,000 and purchase one significant work, or buy ten or more lesser examples. Be selective, and buy quality, not quantity. One significant painting, or a few great paintings, will define the importance of a collection. Moreover, the indiscriminate enthusiast, having spent his budget on several secondary paintings, must pass up the opportunity to acquire an expensive gem when that work appears on the market. And when the value of an artist's work does increase, the greatest gain accrues not to those lesser works, but to those primary works. Value always has to do with a piece's rarity, desirability, condition, and historical importance. Warhol's *Dollar Bill* (Plate 68; fig. 3) is a case in point. Scholars debate which images are quintessential Andy Warhol—his soup cans, his portraits, or his early work. What would Andy have said was his own artistic motivation? It was the world of art, money, and fame coming together in a society that was both manufactured and materialistic at the same time that it was artistic, expressionist, and original. Warhol, I think, considered his money paintings to be the playful expression of the paradox that was central to understanding what Andy Warhol was all about. It took me a lot of reading to come to that conclusion, and Warhol experts will certainly point to more "important" Warhols than this, but the whole process of knowing about Warhol and appreciating the subtleties like the dot on George Washington's forehead makes this painting the right Warhol for this collection and adds to the pleasure of seeing it each day. Although experts may not number *Dollar Bill* among Warhol's most important works, this painting does, I think, express the interconnectedness of art, money, and fame that characterized the early 1960s.

Although you can research the style, subject matter, and significance of an artist's works, you may find it more difficult to learn how to deal with dealers. Much as you may value your relationship with a local dealer, do not restrict yourself to one dealer. You may be tempted to do so because that dealer may be a friend who understands both your taste and your budget; however, an uninformed collector dealing with a single dealer will be unhappy in the long run. In addition, with few exceptions—such as the Richard Gray Gallery, Chicago, or the Ralls Collection, Washington, DC—most of the top-quality work will be sold by New York

74

galleries. Several times a painting that I have seen at auction in either Boston or California will show up conserved, reframed, and on sale at a New York gallery.

Whether local or international, reputable dealers will conform to a code of ethical behavior. Art dealers who hype an artist and his rapidly escalating prices should make you wary. For example, a dealer once showed me in quick succession a group of paintings which had been properly, improperly, and laughably priced—a trick to see if I knew the market. On the other hand, at times dealers price some items more aggressively, because the painting may be on consignment from an owner who demands a high price. Even among experts reasonable pricing is a matter of judgment; however, you too must use your judgment. If you don't trust a dealer, go elsewhere.

Among the factors to consider when working with dealers is the resale of the item you wish to purchase. When you want to either sell or trade a work, often the best place to go is the place where you made the purchase. In fact, dealers and purchasers can make agreements about reselling a piece. Dealers with an inflexible, all-sales-final policy should make you wary, because if a dealer is selling you a desirable painting at a fair price, then the idea of re-selling that object should be welcome. Remember, however, that you, as a collector, should have reasonable expectations: the dealer needs to make a living. He has normal business constraints, including rent, overhead, and probably a bank line of credit to support his inventory.

Provenance and authenticity are other factors to consider when buying from a dealer. A dealer should stand behind the authenticity of a work. As for provenance, the dealer may either own the work, or he may be selling on consignment. He may not be at liberty to tell you the source of the painting, because he may, for example, be concerned about damaging his relationship with a collector who is allowing him to liquidate a collection. Even the provenance of the most significant paintings may be described euphemistically, with phrases such as "descended through the artist's family." Although you may not know where the artwork came from and why it has been sold, you can, and should, insist upon proof of an unencumbered title to an authentic work of art.

Both dealers and collectors are subject to market forces. As a collector, you must realize that the value of significant art fluctuates, although, with notable exceptions, the value of most great art has tended to rise over time, despite short-term losses. In the overheated art market of 1989, works were selling at record prices. When the market crashed, dealers had inventories of works for which the cost was often higher than the now lower, and more realistic, market prices. By 1991, the market was at such a low, that works that had sold at auction for $800,000 a few years earlier failed to find buyers at half that price and dealers with fine work could only sell if they were willing to sell at below-value prices. As a result, few good paintings were on the market. Even as late as 1997, few works have returned to the 1989 prices.

layers of soot and centuries of dirt, very spontaneous and brilliantly colored, with hairs from Michelangelo's brushes still encased in the fresh wet plaster. Experts who had explained his painting in sculptural terms had to rethink completely what Michelangelo and this great work had been all about in the first place. Most accepted this restoration as a new opportunity to research and understand the artist's original intent. Others insisted that Michelangelo's original artistic intent had been irreparably harmed. The dirt and soot, they argued, was a protective coating intended by the artist himself to help create the final effect. They argued, in essence, that Michelangelo had intended the now-revealed underpainting to be covered by the tinted coating. This was decidedly the minority view. The artist himself was silent on the subject and we will probably never find written comments by the artist about his original intent. Instead, we study the comments and writings of those who saw him doing the work, or who saw the work in its early years, and we draw conclusions based on what we know of the lamps and tapers that lighted the room at the time.

Framing is another important factor, so important that Eli Wilner has written an essay for this catalogue on the art of the frame, and the paintings *and their frames* are reproduced in this catalogue. A frame can significantly influence the appearance of a painting, and the frame you see may not be the frame that the artist intended to use. Although a painting may have an old frame, this may not be the original frame. Indeed, buyers sometimes purchase a minor painting for the frame! The artist's intent, if known, offers the best place to start when choosing a frame for a painting. Many artists had definite ideas about how they wanted their paintings framed and displayed. Other artists, such as Fairfield Porter, used simple strip frames to reduce his cost, although he had no objection to either the dealer or the buyer placing his painting in an important frame. Joan Mitchell, on the other hand, conceptualized her work unframed, and only later allowed her dealer to place the painting in a handling frame, the barest strip of metal which prevented handlers from touching the paint surface.

Although framing, conservation, market-forces, dealers, auction houses, and art history are all essential factors for each collector to consider, each collector will develop both a personal philosophy and unique plan. Collections are made in small steps, with thousands of small judgments and changes of direction along the way. Although many collectors fail to conceive of their collection as a whole, a collection should be greater than the sum of its parts.

One collector I know is fascinated primarily by the quest; he is less passionate about enjoying the art he already owns. He is motivated by the desire to own a particular work of aesthetic, historic, and personal interest and has been known to spend a huge sum for a work of art and not even pick it up from the dealer or auction house for several weeks or months. Another collector stopped collecting works he personally liked. He tried to assemble a teaching collection of the finest examples of each stage in the evolution of American art. In the process, he confessed to losing much of the enjoyment of collecting. It is important for collectors to be realistic about where they want to head with their collecting and to be clear about what motivates them.

Inevitably, their level of discernment will change, perhaps improving (perhaps not), as they learn more. Most collectors find themselves selling work over time as well as acquiring it because their interests change and the opportunity to buy an even better example of an artist or style comes along. Choose your own collecting path. Collectors may focus on either a period or a style, or even a single artist. Others buy only masterpieces by recognized artists. I recommend following both your heart and your mind when choosing pieces for your collection. Artistic reputation is important, but so is your emotional tie to the work.

Finally, discerning collectors should put aside part of their budget to collect, encourage, and support today's crop of artists. The geniuses among today's working artists will be recognized only if they can make enough of a living, feel their work is appreciated, and stick with it. And being exposed to these up-and-coming artists is broadening for the collector. You can see the connection between what is going on today and the sweep of historical forces. What Julius Stewart worked to accomplish is alive and well with Nelson Shanks. The breakthrough work of Alexander Calder is being carried forward by Sam Gilliam. Otto Duecker follows the modern tradition of DeScott Evans and John Peto.

Even for those who do not see themselves primarily as collectors of living artists' work, let me make a pitch. The reason we can enjoy today great works of art by artists who were painting 50, 100, or 200 years ago is that there were people then who supported those artists emotionally and by buying their work. And their work has survived and stayed in good condition because of an unbroken chain of people who owned and cared for the work. As the newest person in that chain, you become part of an ongoing trust for future generations, as well as a beneficiary of that chain of care. What will happen with today's artists? Which benefactors will buy their work and take a personal interest in them and their careers? Will we leave a strong cultural legacy for the generations to come?

The Frame is the Soul of the Painting:
Period Frames in the Dicke Collection

The Frame is the Soul of the Painting:
Period Frames in the Dicke Collection
by Eli Wilner

When Jim Dicke first walked into my gallery in New York, I could see an instant recognition on his face as he looked at the frames on display. That this catalog includes photographs of the paintings with their frames is evidence not only of Jim Dicke's personal appreciation of the period frame, but also of his and The Dayton Art Institute's commitment to promote an awareness of how vital the frame is to one's perception of a work of art. While this is the first time that frames have been included in a catalog of this type, it comes as no surprise to those of us who know his wonderful collection of period frames that the Dicke collection should be featured in such a premiere event.

"Frame" in old English means "to Further." In Latin it means "to put in order." I believe that the purpose of a successful frame is to reveal the essence of a painting. The frame needs to set up a vibration between itself and the painting that is so compelling that one cannot be envisioned without the other. A successful marriage of painting and frame can enhance the poetry, the mystery, and the subtleties in the artwork. There are many considerations when selecting a frame for an artwork. With rare exceptions, the primary aim of uniting a period frame with an artwork is to create an aesthetic match which is historically appropriate. The issues involved include scale, color or tonality and the composition of the frame's design. Every painting is unique and the individual qualities of each artwork are reflected in the ideal frame.

Many of America's finest painters and craftsmen understood this special relationship between a painting and its frame. During the turn of this century, artists moved away from the prevailing frame styles and created new designs that complemented the innovative styles of painting emerging at the time. The early years of the twentieth century saw the return of the hand-carved frame and exploration of the varying tonalities possible with the gilded surfaces. As painters changed their palettes, gilded frame surfaces were sensitively modulated to harmonize specifically with each artwork and many artists and craftsmen adopted the practice of signing and/or dating their frames as independent artworks. At their best, American frames from this period were marked by a level of craftsmanship that is unparalled: they were as unique and rare as the paintings they surrounded. This exhibition includes some exceptional examples of finely crafted American frames from both the late nineteenth and the early twentieth centuries. Since all the marriages of painting and frame in the Dicke Collection were made with special care and attention to detail, it would be difficult to single out a few as outstanding, so I will focus on some of my personal favorites.

In framing the very subtle and understated double portrait by Marie Laurencin, dated 1935, Jim chose a frame made by the fram-

FIGURE1
Original Stanford white frame, c. 1890s, applied ornament and gilded, from Eli Wilner & Company Collection.

maker and painter Frederick Harer. The frame, carved and gilded and signed on the verso by Harer himself, has a subtlety of design and a deep rich golden color that enhances the softness and delicacy of the image of the girls in the painting. Harer resided in Bucks County, Pennsylvannia and was the son of a successful furniture maker, learning valuable woodworking skills from an early age. His techniques and methods are evidence of his extraordinary creativity—stencils, incising, matte and burnished gilding of surfaces and designs punched into frame surfaces with nails he had cut and filed down to specific patterns aided him in producing frames whose beauty has only increased with time.

One of the most exquisite combinations of painting and frame in the collection is the painting *Ponte Vecchio* (Plate 34) by William Merritt Chase, which Jim has surrounded by a frame made by the framemaker and painter Max Kuehne. This frame, with its festive and lively decoration incised into the surface, has a profile called the "cassetta" style. "Cassetta," which is Italian for "little box," refers to the flat panel with raised inner and outer edges. The profile first appeared in Italy during the Renaissance then resurfaced again in the early twentieth century, when American painters and framemakers were taking their inspiration from their travels in Europe as they studied great works from previous centuries. Chase's view of the Ponte Vecchio, all at once summons up the charm and excitement of the present and the mystery of the past; the Kuehne frame, with its silvery surface provides a complement to the cool palette of the painting while the rich and vibrant Italianate decoration provides the perfect context. In the craft of framemaking Kuehne was a protege of Charles Prendergast. His frames display innovative uses of silver gilding and a talent for carving and incised surface decoration that are hallmarks of both Prendergast's and Kuehne's frames.

Ipswich Study-Flowerfield (Plate 42) by Arthur Wesley Dow, surrounded by an 1890's frame of gilded oak, is another example of a frame resonating with the atmosphere created in the painting. The wide sloping panels of the frame, with the wood grain visible through the gilding, evokes the rugged feeling of outdoors; the soft swirls in the grain echo the gentle curves in the landscape. The frame seems to expand and open up this small jewel of a painting. Frames gilded in the traditional water gilding method have a preparatory layer of gesso which covers the wood surface; in this method, the gesso is eliminated and the gilding applied directly to the wood surface which renders a less bright and reflective gilded surface as well as a textural effect of great subtlety.

What a strongly sculpted frame can do for a painting is evident with Childe Hassam's *Lyman's Ledge, Appledore,* (Plate 30), surrounded by a carved and gilded American impressionist frame. The texture of the Hassam painting, the roughness of the rocks, and the round forms in the composition are echoed in the shape and decorative elements of the frame around it. Hassam was one of the many painters in the early twentieth century who were very concerned with the union of painting and frame. In some of Hassam's frame designs he included his initials in the carved design elements and specified pale silvery-green shades

of gilding to harmonize more specifically with his paintings.

The same sensitivity exhibited when framing landscape paintings is also evident in frame choices for interior paintings. *Tea Leaves* (Plate 44), by Francis Coates Jones is a quiet and reflective painting. The women's downward gaze and stillness almost give one the sense of intruding on a very personal moment. It would be very easy to overwhelm and spoil the painting and the wonderful atmosphere that Jones has taken such care to create. The frame chosen is a very simple and elegant frame from about 1910, which is ideal for the mood of the painting. The bare unadorned panel complements the simple tablecloth and garments of the woman, while the design at the inner and outer edges of the frame enhances the decoration on the china and the back of the women's chair. This combination of painting and frame illustrates the importance of tying in elements of the painting with design elements in the frame; it helps create unity.

One of the rarest frames in the collection is the original Stanford White frame on the painting *Young Child* (fig. 1; Plate 6), by Anna F. Hunter. Best known as an architect in the firm McKim, Mead & White, Stanford White designed many exceptional frames for his artist-friends. The wide, flat frame is decorated with numerous rows of classic architectural ornament and a strong gadroon element at the right edge. The frame is able to convey importance with a refined and sophisticated combination of elements.

Edward Potthast's painting *The Bathers* (Plate 45), is enclosed by an extraordinary frame by the Newcomb Macklin Company of Chicago and New York. Newcomb Macklin was most active during the early years of the twentieth century, working extensively with individual artists. The company employed salesmen who traveled from coast to coast and brought their elegant frame designs from the East Coast to the Taos School painters as well as many others. The frame on Potthast's painting displays the masterful carving and sophisticated designs that are frequently a hallmark of the Newcomb Macklin Company's fine frames. The painting *Ten Pound Island, Gloucester* (Plate 50), by the artist Theodore Wendel is an interesting study in the effect of form and texture in both art and frame. The painting shows the rocky shoreline, the well-worn tools of the fisherman, the sailboats on the waves in the water, and the sun shining down illuminating it all. The frame suits the painting well. The scale of the frame matches the power and strength of the rocks in the foreground while the rippled moldings amplify and compliment the textures and motion in the composition. The profile, which slopes away from the canvas, also reinforces the viewer's sense of standing on the rocky foreground and looking out toward the water.

In order to do justice to this collection of frames an entire book would have to be written. This is a growing collection of beauty which continues to surprise and delight all who are fortunate enough to view it. Framing the Dicke collection has been one of the high points of my career as a framer. Jim Dicke has clearly manifested the fact that "the frame is the reward for the artist."

American Art

from the Dicke Collection

George Cochran Lambdin
(1830-1896)

A Recruiting Party, c. 1864

Oil on canvas

10-1/2 x 14"

Period American frame, c. 1870, applied ornament and gilded, from the Eli Wilner & Company Collection

George Cochran Lambdin, a Philadelphia painter known primarily for his detailed paintings of flowers, first attained both popularity and financial success with both childhood scenes and Civil War subjects.[1] In *A Recruiting Party*, exhibited at the Pennsylvania Academy of the Fine Arts in 1864, three children stage a parade like those intended to both raise morale and encourage enlistment in the Union Army.[2] For many late-nineteenth-century viewers, sentimental images of children evoked a mythical past when life was simpler and moral values were unquestioned, a theme of particular poignancy during the Civil War. Lambdin donated paintings such as this one to the Sanitary Commission which organized fairs and auctions in order to raise funds for the Union wounded.[3] Lambdin also marketed engraved reproductions of some of his Civil War subjects, enabling a broader audience to own his images.[4]

KUF

1. George C. Groce and David H. Wallace, *The New-York Historical Society's Dictionary of Artists in America, 1564-1860* (New Haven: Yale University Press, 1957), s.v. "George Cochran Lambdin," with bibliography.

2. Peter Hastings Falk, ed., *The Annual Exhibition Record of the Pennsylvania Academy of the Fine Arts, 1807-1870*, 3 vols. (Madison, CT: Sound View Press, 1988), vol. 1, s.v. "George Cochran Lambdin." *A Recruiting Party* appeared as entry #129, M. Baird owner.

3. Brandywine River Museum, *George Cochran Lambdin, 1830-1896*, essay by Ruth Irwin Weidner (Chadds Ford, PA: The Brandywine Conservancy, 1986), 13.

4. Annette Blaugrund and Lee M. Edwards, "George Cochran Lambdin," *Arts Magazine* 61 (December 1986): 107.

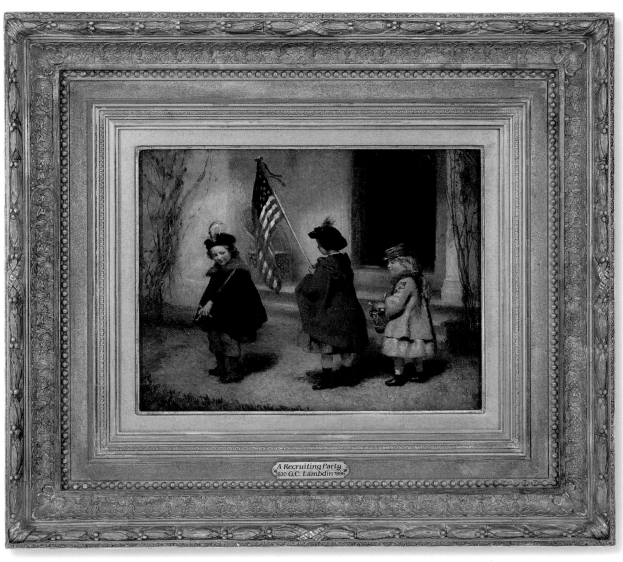

A Recruiting Party
1830 G.C. Lambdin 1896

~2~

91

John George Brown
(b. Durham, England, 1831-1913)

~3~

Little Girl with a Broken Toy, 1866

Oil on canvas

8 x 8"

Period American frame, c. 1890s, applied ornament and gilded

J.G. Brown exemplified the practical approach to painting that prevailed before the 1880s, when an emphasis on personal expression supplanted the artisanal ideal. He successfully promoted his work by joining professional organizations, by exhibiting annually at prestigious venues such as the National Academy of Design, by releasing chromolithographs of his paintings, and by tailoring his subjects to suit public taste. Brown insured commercial success by painting sentimental scenes of both rural and urban children. *Little Girl with a Broken Toy* varies a compositional theme that he pursued during the mid-1860s.[1] A wall limits the background, focusing attention on the foreground where a girl poses in a minutely detailed glade dappled with light. The broken toy suggests the transience of childhood, an age idealized by many late-nineteenth-century artists, writers, and audiences as being one with nature, and thus an antidote to urbanization.[2]

KUF

1. Martha J. Hoppin, *Country Paths and City Sidewalks: The Art of J.G. Brown*, exhib. cat. (Springfield, MA: George Walter Vincent Smith Art Museum,1989), 10.
2. Sarah Burns discusses the late-nineteenth-century notion of childhood in "Barefoot Boys and Other Country Children: Sentiment and Ideology in Nineteenth-Century American Art," *American Art Journal* 20 (1988): 24-50.

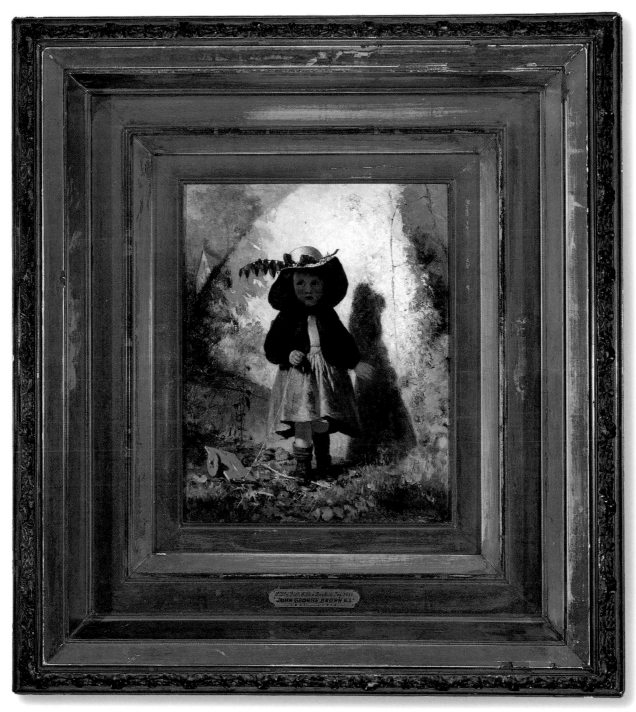

Dwight William Tryon
(1849-1925)

~4~

Summer—Connecticut, 1882

Oil on canvas

20-1/4 x 30-1/4"

Original American period frame, c. 1890, gilded oak

Dwight W. Tryon painted *Summer—Connecticut* after returning from his studies in Europe, where he had seen the naturalistic paintings of the French Barbizon school of landscape painting.[1] Unlike the French impressionists, who sought to make an objective record of optical impressions, the Barbizon school stressed the individual's subjective response to the landscape. Tryon adopted both the style and the subject matter of the Barbizon school, particularly the desire to depict nature's moods and phases as reflected upon a familiar landscape.[2] In addition, Tryon—influenced by the English Aesthetic movement—considered each painting to be an art object, a vehicle for an educated, aesthetic experience, rather than a souvenir of either a moment or a place.[3] Accordingly, he spent the summers sketching, committing the New England landscape to memory, and the winters in his New York studio, painting his idealized landscapes.

KUF

1. Charles H. Caffin includes *Summer—Connecticut* in his "List of the Most Important Pictures of Dwight W. Tryon to May MCMIX," in *The Art of Dwight W. Tryon: An Appreciation* (New York: Forrest Press, 1903), 56.
2. Tryon painted *Summer—Connecticut* around Hartford, Connecticut, his childhood home. For a discussion of Tryon's interest in the Barbizon school, see Linda Merrill, *An Ideal Country: Paintings by Tryon in the Freer Gallery* (Washington, DC: Smithsonian Institution, 1990).
3. Merrill, 51-61.

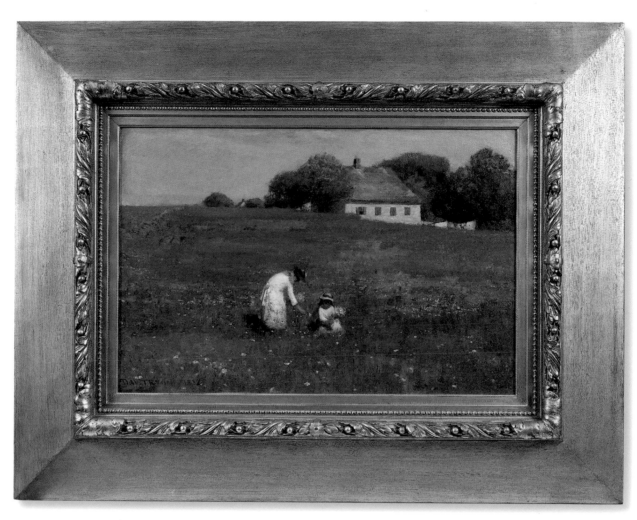

-4-

Charles Sprague Pearce
(1851-1914)

~5~

Femme sous le Directoire (Woman of the Directory), 1883

Oil on canvas

39-1/2 x 32-1/4"

Period European frame, 19th century

Almost a century after the Directory (1795-1799), Charles Sprague Pearce painted Louise Catherine Bonjean (known as Antonia) as a *merveilleuse*, one of the young women of the Directory and the First Empire who adopted sumptuous dress in reaction to the austere fashions of the French Revolution.[1] Bonjean, a fellow artist whom Pearce married in 1888, poses in a white First Empire dress and holds a gold-headed, tasseled walking stick.[2] Costume pictures such as this one allowed the artist to demonstrate not only historical knowledge, but also technical prowess. Upon viewing *Femme sous le Directoire*, one contemporary critic praised Pearce for his ability to render both texture and detail: "The fabric is exquisitely indicated, brought to that high pitch of soft, smooth solidity which conveys the impression that you might weigh in your hand the pith and substance of the material."[3]

KUF

1. Mary Lublin, *A Rare Elegance: The Paintings of Charles Sprague Pearce, 1851- 1914*, exhib. cat. (New York: Jordan-Volpe Gallery, 1993), 39-41; Samuel F. Scott and Barry Rothaus, *Historical Dictionary of the French Revolution, 1789-1799* (Westport, CT: Greenwood Press, 1985), s.v. "Directory."
2. Lublin discusses *Femme sous le Directoire* (22-23 and Fig. 10).
3. "Art Notes," *Daily Evening Transcript*, 3 November 1883, 10; quoted in Lublin, 22-23.

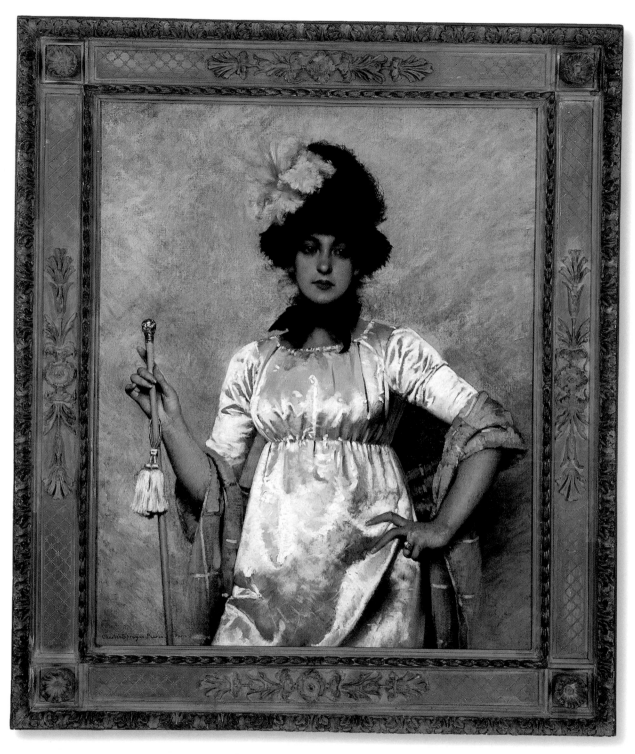

Anna Falconnet Hunter

(1855-1941)

~6~

Young Child (Artist's Niece) [Miss Anna Dunn], c. 1883

Oil on canvas

18-1/2 x 9-1/4"

Original Stanford White frame, c. 1890s, applied ornament and gilded, from Eli Wilner & Company Collection

Published sources offer little information about Anna F. Hunter, a member of an old Newport family.[1] She lived in Newport, Rhode Island, where she pursued painting, exhibiting her work at national venues in 1890, 1892, and 1894.[2] During 1883 and 1884, Hunter studied with Theodore Wendel (Plate 50) while the latter lived in Newport. In 1936, she loaned a portrait of her niece, Miss Anna Dunn, painted by Wendel, to an exhibition sponsored by the Art Association of Newport in order to celebrate the Rhode Island tercentenary.[3] That Hunter and Wendel both executed portraits of Dunn suggests that the paintings may be contemporaneous, perhaps the result of a studio exercise undertaken by both master and student.

KUF

1. Obituary, *Newport Mercury*, 6 June 1941. The Newport Historical Society, Newport, RI, holds Hunter's papers. My thanks to both M. Joan Youngken, Deputy Director for Collections, and Bertram Lippincott III, Librarian, Newport Historical Society for their assistance.

2. Hunter exhibited at the National Academy of Design in 1890 and 1892 (Maria Naylor, *The National Academy of Design Exhibition Record, 1861-1900*, 2 vols. (New York: Kennedy Galleries, 1973), s.v. "Anna F. Hunter"); at the Boston Art Club in 1892 and 1894 (Janice H. Chadbourne, Karl Gabosh, and Charles O. Vogel, eds., *The Boston Art Club: Exhibition Record, 1873-1909* (Madison, CT: Sound View Press, 1991), s.v. "Anna F. Hunter"); and at the Pennsylvania Academy of the Fine Arts in 1894 (Peter Hastings Falk, ed., *The Annual Exhibition Record of the Pennsylvania Academy of the Fine Arts*, rev. ed., 3 vols. (Madison, CT: Sound View Press, 1988), vol. 2, s.v. "Anna F. Hunter").

3. Art Association of Newport, Rhode Island, *Retrospective Exhibition of the Work of Artists Identified with Newport: Rhode Island Tercentenary, 1936, Newport, Rhode Island, July 25 to August 16, 1936*, exhib. cat. (Newport, RI: [Ward Print. Co.], 1936). Although the Newport catalogue states only that "Wendell [sic] came down from Boston to Newport during the latter part of the 19th century, and gave instruction to Miss Anna Hunter's class" (p. 27, cat. 93), John I. H. Baur established that Theodore Wendel lived in Newport, sharing a studio with Kenyon Cox, in 1883 and 1884. See Baur, *Theodore Wendel: An American Impressionist, 1859-1932*, exhib. cat. (New York: Whitney Museum of American Art, 1976).

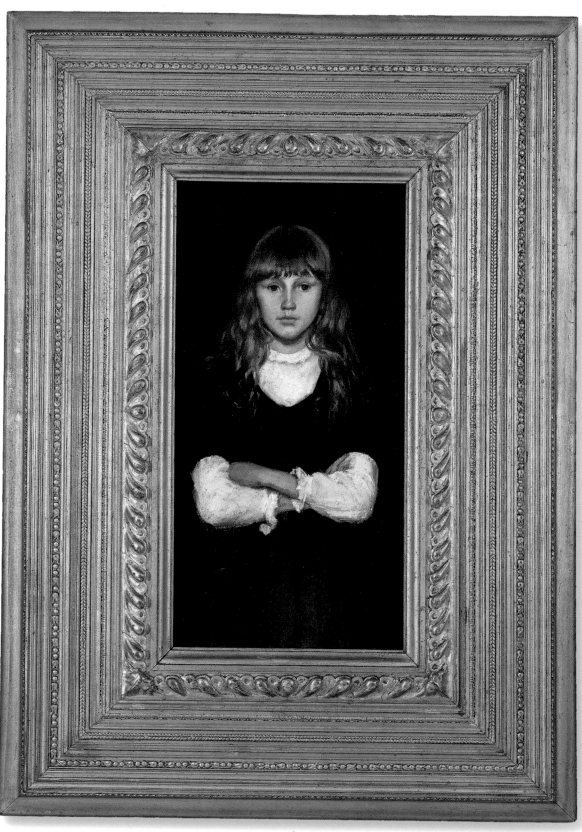

~7~

Waterlilies, 1884

Oil on canvas

28 x 25"

Period American frame, c. 1880s, applied ornament and gilded, from Eli Wilner & Company Collection

Nature served as both subject and solace for Abbott Thayer. As a young man, he not only hunted, trapped, and experimented with taxidermy, but also executed watercolor studies of wildlife, eventually developing a career by painting both animals and landscapes. Although he continued to paint nature studies, such as this one, after traveling to Paris in 1875 to study painting, Thayer achieved wider fame by depicting idealized, monumental, and sometimes winged, women wearing white robes.[1] The artist's lifelong study of nature prompted him to develop theories about protective coloration, and to propose camouflage as the military application of these ideas. Thayer, dubbed "the father of camouflage" by both friends and admirers, described his study of camouflage as "my second child," which frequently displaced his first child, figure painting.[2] His interest in the philosophy of Ralph Waldo Emerson, who had identified natural beauty as the earthly manifestation of spiritual power, unified the two aspects of the artist's œuvre—angelic women and nature studies.[3]

KUF

1. For an example of Thayer's figure painting, see *Winged Figure* (1889; The Art Institute of Chicago, 1947.32).
2. Roy R. Behrens, "The Theories of Abbott H. Thayer: Father of Camouflage," *Leonardo* 21 (1988): 291-296; Pratt Institute, *Exhibition of Paintings Illustrating Protective Coloration in Nature by Abbott H. Thayer and Gerald H. Thayer*, exhib. cat. (Brooklyn, 1920); Gerald H. Thayer, *Concealing Coloration in the Animal Kingdom: An Exposition of the Laws of Disguise through Colour and Pattern: Being a Summary of Abbott H. Thayer's Disclosures* (New York: Macmillan Co., 1909). Thayer describes the study of camouflage as "my second child" in a letter to William James, Jr.; quoted in Susan Hobbs, "Nature into Art: The Landscapes of Abbott Handerson Thayer," *American Art Journal* 14 (Summer 1982): 5.
3. Hobbs discusses Thayer's interest in Emersonianism.

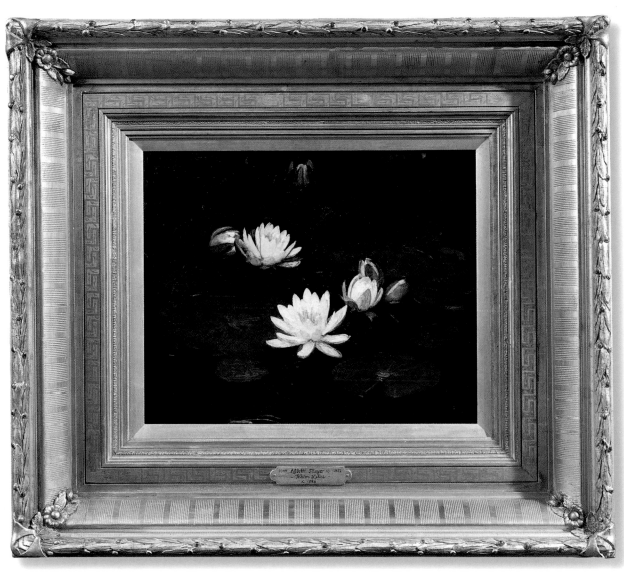

*T*homas Alexander Harrison

(1853-1930)

~*8*~

Crépuscule (Twilight), c. 1884

Oil on canvas

12 x 39-1/2"

Contemporary Eli Wilner & Company replica of a Stanford White design frame

"As a painter of surf [he] has no equal," asserted one contemporary critic when describing Alexander Harrison, who achieved fame with his images of gently breaking waves.[1] Harrison had spent nearly six years with the United States Coast and Geodetic Survey, charting New England coastline, Florida swamps, and Puget Sound, before pursuing his artistic training at the Art School of San Francisco and at the Ecole des Beaux-Arts.[2] The artist spent the rest of his career in France, dividing his time between Paris and Brittany, where he worked with both Arthur Wesley Dow and Jules Bastien-Lepage, the influential academic painter who prompted him to adopt the *plein-air* technique. In 1884, while walking along the beach with Bastien-Lepage, Harrison rendered the *plein-air* sketches that he developed into both *Crépuscule* and *The Wave*, both exhibited at the 1889 Universal Exposition in Paris.[3]

KUF

1. Charles Francis Browne, "Alexander Harrison—Painter," *Brush and Pencil* 4 (June 1899): 138.
2. Doreen Bolger Burke, *American Paintings in the Metropolitan Museum of Art*, new ed., 3 vols. (New York: Metropolitan Museum of Art, 1980), vol. 3, *A Catalogue of Works by Artists Born between 1846 and 1864*, 159.
3. Karen Zukowski, "Alexander Harrison," in Annette Blaugrund, *Paris 1889: American Artists at the Universal Exposition*, exhib. cat. (Philadelphia: Pennsylvania Academy of the Fine Arts in association with Henry N. Abrams, Inc., Publishers, New York, 1989), 161.

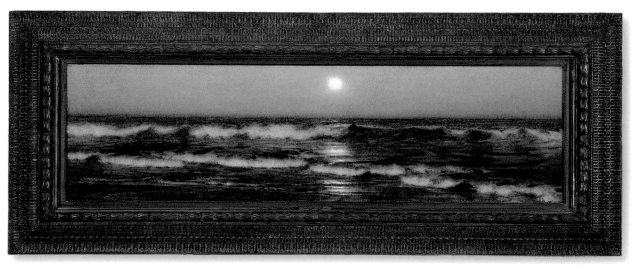

~8~

~9~

Brittany Farm, c. 1885

Oil on canvas

13 x 18"

Period American frame, c. 1890, gilded oak, applied ornament and gilded, from the Eli Wilner & Company Collection

In the summer of 1885 Dow and his friend Henry Kenyon left Paris to spend the remainder of the year on the Breton coast. The summer that year was particularly glorious, and it seems that Dow was initially disappointed: "With his friends he shared the view that dazzling sunlight and brilliant greenery destroyed any chance the artist may have had to discover harmonious relationships. And when the sun broke through the mists . . . there was unrelenting despair."[1] Unlike the impressionists, Dow was not searching for the fleetingness of sun-dappled scenes; for him, the silvery grays and musky browns of twilight were much more inviting.

But in *Brittany Farm* Dow succumbed to the inevitable and painted a farmyard alive with light and sunshine. He handles the scene itself in a traditional Barbizon manner but the vibrant color and shimmering surfaces show an inclination, a slight nod, towards the impressionists.

NEG

1. Frederick Campbell Moffatt, "The Breton Years of Arthur Wesley Dow," *Archives of American Art Journal*, 15, 2 (1975): 3

~9~

Arthur Wesley Dow
(1857-1922)

~10~

A Field, Kerlaouen, 1885

Oil on canvas

32 x 53"

Contemporary Eli Wilner & Company replica of an American reeded frame, applied ornament and gilded

In May 1885, with the financial assistance of the Farmers and three other patrons, Dow set off to Pont Aven to concentrate on painting landscapes. Attracted by the numerous similarities to Ipswich, he returned again the following year. The Breton coast, popularized twenty years previously by James McNeill Whistler and Gustave Courbet, in the 1880s developed into a thriving artists' colony. It was here that many of the Americans came, along with the synthetists, Gauguin, Serusier, and Bernard.

A Field, Kerlaouen was first shown at the Paris Salon in 1887 and again in Dow's first one-man show at the Chase Galleries, Boston, in January 1888, alongside his paintings of Ipswich.[1] Influenced by the work of Jules Bastien-Lepage, as well as Alexander Harrison and Charles Augustus "Shorty" Lazar, Dow's work retained a fresh American sensibility that won him the admiration of John Singer Sargent when he saw Dow's work at the 1889 Universal Exposition. It is a very fine example of Dow's Barbizon-related tonalist work and goes a long way towards explicating the connections Dow made between Brittany and his native Ipswich.

NEG

1. For some unknown reason, another canvas, *Ipswich at Dusk*, was stretched over this one and for many decades the whereabouts of *A Field, Kerlaouen* was unknown.

~10~

\mathcal{D}aniel Ridgway Knight

(1839-1924)

~//~

The Gardener's Daughter, 1885

Oil on canvas

32 x 25-3/4"

Period American frame, Barbizon style, c. 1880s, applied ornament and gilded

In 1874, Daniel Ridgway Knight adopted the French peasantry as his primary subject, receiving numerous awards for his representations of rural society.[1] Following the example of acclaimed Salon painter Jules Breton, Knight depicted the peasant happy and content amidst a paradisiacal landscape.[2] Many of his images include allegorical symbols, such as the rose, drawn from the seventeenth-century realist tradition.[3] In this painting, the gardener's daughter stands transfixed by reverie amidst a riot of roses, her hands still grasping the handles of the wheelbarrow which represents labor. The rose symbolizes virtues such as charity, forgiveness, martyrdom, and victory.[4] Although the artist took pains to use local peasants as models and to purchase authentic props, his images present a perfected vision of rural life that appealed to his urban audience.

KUF

1. Ridgway B. Knight, "Ridgway Knight: A Master of the Pastoral Genre," in *A Pastoral Legacy: Paintings and Drawing by the American Artists Ridgway Knight and Aston Knight*, organized by Pamela Beecher, exhib. cat. (Ithaca, New York: Herbert F. Johnson Museum of Art, Cornell University, 1989).

2. Hollister Sturges, *Jules Breton and the French Rural Tradition*, exhib. cat. (Omaha, NE: Joslyn Art Museum, 1982).

3. Knight, n.p.

4. J.E. Cirlot, trans. by Jack Sage, *A Dictionary of Symbols*, 2nd ed. (London: Routledge & Kegan Paul, 1962), s.v. "Rose"; Gertrude Jobes, *Dictionary of Mythology, Folklore and Symbols*, 2 vols. (New York: Scarecrow Press, 1962), s.v. "Rose" and "Wheel."

Charles Sprague Pearce
(1851-1914)

~12~

Peasant Model, 1885

Oil on canvas

16-1/4 x 12-1/2"

Period French frame, c. 1870s-1880s, incised, applied ornament and gilded, from the Eli Wilner & Company Collection

Charles Sprague Pearce first exhibited one of his peasant paintings at the Paris Salon of 1883, marking his turn from history painting to painting the French peasantry, a popular theme in the late-nineteenth century. Pearce modeled these paintings after those of influential Salon painter Jules Bastien-Lepage, who depicted individual peasants cloaked in an aura of melancholic introspection. Both American and European painters believed that the peasantry had remained untouched by industrialization, thereby maintaining an older way of life tied to nature and to traditional values.[1] In 1885, Pearce moved to the village of Auvers-sur-Oise, about twenty miles north of Paris; however, despite his efforts to document rural existence, his portrayals of peasant life reflect an artistic ideal rather than reality.

KUF

1. Julia Rowland Myers, "The American Expatriate Painters of the French Peasantry, 1863-1893 (Ph.D. diss., University of Maryland College Park, 1989); Hollister Sturges, *Jules Breton and the French Rural Tradition*, exhib. cat. (Omaha, NE: Joslyn Art Museum, 1982); Sturges, ed., *The Rural Vision: France and America in the Late Nineteenth Century* (Omaha, NE: Joslyn Art Museum, 1987); Gabriel P. Weisberg, "Jules Breton, Jules Bastien-Lepage, and Camille Pissarro in the Context of Nineteenth-Century Peasant Painting and the Salon," *Arts Magazine* 56 (February 1982): 115-119.

Peasant Model-1885
CHARLES SPRAGUE PEARCE

~12~

Irving Ramsey Wiles
(1861-1948)

~14~

Girl with Guitar, c. 1889

Oil on board

14-1/8 x 9"

Original American period frame, c. 1890s, applied ornament and gilded

During his career, Irving Ramsey Wiles won every major art prize in America. He first studied art with his father, Lemuel Maynard Wiles, a landscape painter and an art instructor, before attending schools in both New York City and Paris.[1] While at the Art Students League, he studied with William Merritt Chase (Plates 24, 34), who became both his friend and his mentor, and ranked Wiles among his most accomplished pupils. After returning from Paris in 1883, Wiles worked as an illustrator for magazines such as *Century, Scribner's,* and *Harper's*, while developing his career as a figure painter and a portraitist. An accomplished violinist, the artist created many images of women playing musical instruments, such as *Girl with Guitar*.[2] The fluid brushwork delineating both background and costume bespeaks the influence of Chase and of Emile Auguste Carolus-Duran, who taught both Wiles and John Singer Sargent.

KUF

1. Katharine Cameron, "The North Fork: Peconic and Irving Ramsey Wiles," in *The Artist as Teacher*: *William Merritt Chase and Irving Wiles*, exhib. cat. (East Hampton, NY: Guild Hall Museum, 1994), 25-26.
2. The date for this painting derives from a copy of a letter which accompanied the lot at auction, and from an unpublished report, prepared by Ronald G. Pisano (24 April 1994).

LADY WITH GUITAR
IRVING WILES, N. A.

~14~

Francis Coates Jones
(1857-1932)

~5~

Candlelight Romance, 1880s

Oil on canvas

21-1/2 x 30"

Period American frame, c. 1870s, applied ornament and gilded

During the 1880s, Francis Coates Jones painted sentimental genre scenes which use both gesture and detail to suggest a narrative.[1] In *Candlelight Romance*, a young woman looks coyly at her suitor who leans over her in a pose probably intended to appear protective. Their shadows, cast upon the wall, dramatize this romantic exchange and lend visual weight to the pair who might otherwise be lost amidst the furniture and other accouterments that, like the eighteenth-century costume, reflect the artist's interest in the Colonial Revival. In the late-nineteenth century, the Colonial era served as an idealized model of social order for many Americans who lived in a contemporary society strained by industrialization, urbanization, political disunity in the wake of the Civil War, and cultural plurality fostered by immigration. According to many commentators, Colonial decorative arts, such as the furniture featured in this painting, offered appropriate models for contemporary American industrial products.[2]

KUF

1. For a brief overview of Francis Coates Jones's artistic development, see Doreen Bolger Burke, *American Paintings in the Metropolitan Museum of Art*, new ed., 3 vols. (New York: Metropolitan Museum of Art, 1980), vol. 3, *A Catalogue of Works by Artists Born between 1846 and 1864*, 308-309.
2. For a discussion of the Colonial Revival, see Karal Ann Marling, *George Washington Slept Here: Colonial Revivals and American Culture, 1876-1986* (Cambridge, MA: Harvard University Press, 1988).

~15~

\mathscr{T}homas Worthington Whittredge
(1820-1910)

~16~

The Old Cart Road, late 1880s

Oil on canvas

11 x 15-1/2"

Period American frame, c. 1870, applied ornament and gilded, from Eli Wilner & Company Collection

After a brief, unsuccessful stint as a portraitist, Thomas Worthington Whittredge devoted his career to landscape painting. Initially self-taught, Whittredge studied in Europe from 1849-1859, and then returned to the United States where he associated with artists of the Hudson River School.[1] Whittredge, like other artists of that School, viewed nature as a moral authority and chose as his subject the untamed, primeval American landscape closest to New York City, including the Catskill Mountains and the Hudson River Valley. After the Civil War, however, American landscape painting reflected the changing attitude about the American landscape occasioned by settlement and by industrialization. *The Old Cart Road* partakes of this ideological shift and demonstrates the influence of the French Barbizon school which offered an alternative model of landscape painting.[2] Whittredge invested this agrarian scene with a calm, introspective mood intended to reflect his subjective experience of the altered landscape.

KUF

1. Munson-Williams-Proctor Institute, *Worthington Whittredge Retrospective*, exhib. cat. (Utica, NY: The Institute, 1969).
2. For a discussion of this period of Whittredge's career, as well as *The Old Cart Road*, see Anthony P. Janson, *Worthington Whittredge* (New York: Cambridge University Press, 1989), 192-200.

T. W. Whittredge
1820~1910
The Old Cart Road

~16~

\mathscr{A}rthur Wesley Dow
(1857-1922)

~*7*~

Ipswich at Dusk, 1890

Oil on canvas

32-1/2 x 53-3/4"

Contemporary Eli Wilner & Company replica of a 19th century, Dutch style frame

Ipswich at Dusk is an interesting transitional work for Dow, painted with a Barbizon sensibility while experimenting with non-Western ideas of space. Rejecting the obfuscation of soft twilights he attempted greater definition; and according to one historian, "he began with the horizon and, as it were, gradually moved forward . . . the effect created is one in which detailed drawings bisect more suggestive passages in forward positions. Consequently, the result is that distant objects lose their individuality to the amorphous disposition of space."[1]

At this time Dow was attempting to break into the tight Boston art circle, but he soon became discouraged by what he saw as the narrow-minded conservatism of that particular coterie. Simultaneously, he also came to doubt his own worth as a painter. Determined to go beyond the pedantic interests of the Boston art world, he spent many hours at the Boston Public Library, systematically examining Egyptian, Aztec, African, Oceanic, and Asian art. It was here that he found the work of Hokusai, an artist who changed his entire way of thinking.

NEG

1. Frederick C. Moffatt, *Arthur Wesley Dow* (Washington, DC: Smithsonian Institution, 1977), 43.

~17~

Robert William Vonnoh
(1858-1933)

~18~

The Brook, c. 1890

Oil on canvas

24 x 20"

Period American frame, c. 1910, carved and gilded, signed on verso by Walfred Thulin, from the Eli Wilner & Company Collection

Like many American impressionists, Robert Vonnoh mastered both academic and avant-garde modes of painting. Initially, Vonnoh traveled to both Boston and Paris to train in the academic mode, which emphasized figure painting, a subdued palette and precise brushstrokes. He also studied the impressionist mode during summer vacations at Grèz-sur-Loing, one of many artists' colonies dotting the French countryside.[1] Colonies, unlike academies, enabled artists to study landscape painting *en plein air* and to experiment with avant-garde modes such as impressionism. By 1888, he was painting both landscapes and nature studies in the impressionist style, which advocated spontaneity, simplified composition, pure color, and free application of paint.[2] Vonnoh excelled as a colorist, sometimes squeezing color from the tube onto the canvas in order to achieve both intense, saturated color and expressive texture.[3] *The Brook* typifies Vonnoh's work from 1887-1891, when the artist first became, in his own words, "a devoted disciple of the new movement in painting."[4]

KUF

1. May Brawley Hill, *Grez Days: Robert Vonnoh in France*, exhib. cat. (New York: Berry-Hill Galleries, 1987).
2. William H. Gerdts, *American Impressionism* (New York: Abbeville Press, 1984), 121.
3. Eliot Clark, "The Art of Robert Vonnoh," *Art in America* 16 (August 1928): 223-232.
4. *National Cyclopædia of American Biography* 7 (1897), s.v. "Robert William Vonnoh." Vonnoh made a second trip to France during 1887-1891. During those years, Vonnoh experimented with impressionist theories, developing his own approach to color. Similar composition, subject, palette, and brushwork characterize the artist's impressionist works from this time, and suggest that *The Brook* belongs to this period. *Spring in France* (1890; Art Institute of Chicago, 1982.272) provides a point of comparison for *The Brook*. Both have a high horizon line intersected by a diagonal compositional device (either a road or a brook) in order to establish recession in space. Not only similar brushstrokes, but also a palette of violets and blues unite foreground and background. Warm pinks and yellows differentiate the middleground.

~18~

De Scott Evans
(b. David Scott Evans, 1847-1898)

~19~

The Idlers, c. 1891

Oil on canvas

33-1/2 x 37-1/2"

Original American period frame, c. 1890s, applied ornament and gilded

Some mystery surrounds De Scott Evans, who painted *trompe l'oeil* still lifes under a variety of pseudonyms.[1] Contemporary critics praised Evans for his depictions of upper-middle-class women lounging in elegantly appointed interiors, and for his mastery of "stuffs."[2] His genre paintings emphasize interior setting and detail, rather than the narrative implied by the title. *The Idlers*, exhibited at the National Academy of Design in 1891, demonstrates his ability to capture the play of light upon materials such as the dress, the white fur throw, the velvet pillows, and the wallpaper.[3] For this painting, Evans arranged studio props such as the lute, the parrot, and the throw to create a stage set; however, these objects also suggest another narrative, one perhaps unintended by the artist. In some cultures, the parrot serves as a warning to unfaithful wives, while the lute, here cast aside, symbolizes connubial bliss.[4]

KUF

1. *A New Variety, Try One*: *De Scott Evans or S.S. David*, exhib. cat. (Columbus, OH: Columbus Museum of Art, 1985).
2. *Cleveland Leader*, September 1878; quoted in Clara Erskine Clement Waters and Laurence Hutton, *Artists of the Nineteenth Century and Their Works: A Handbook*, rev. ed. (St. Louis: North Point, 1969), s.v. "De Scott Evans." See also Cromwell Childe, "A Painter of Pretty Women," *Quarterly Illustrator* 1 (October-December 1893): 279-282.
3. Maria Naylor, *The National Academy of Design Exhibition Record, 1861-1900*, 2 vols. (New York: Kennedy Galleries, 1973), s.v. "De Scott Evans."
4. For the various meanings of both the parrot and the lute, see J.C. Cooper, *An Illustrated Encyclopædia of Traditional Symbols* (London: Thames and Hudson, 1978).

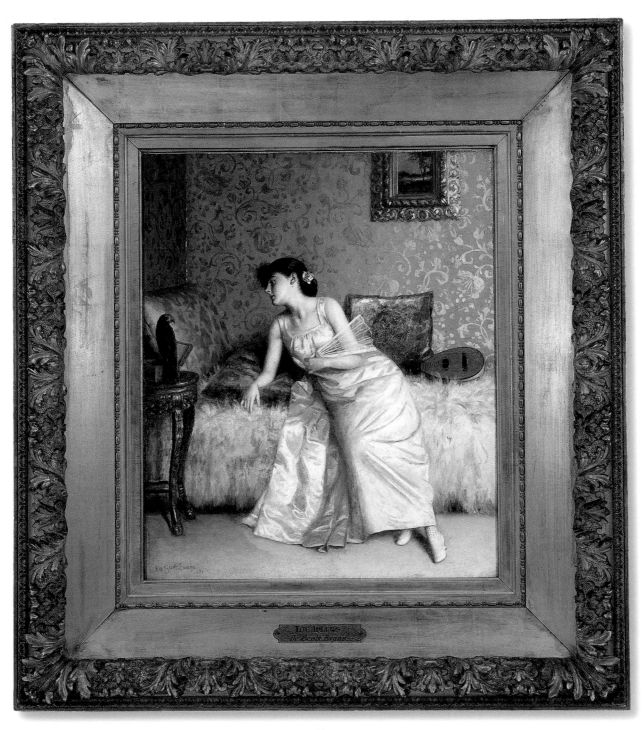

THE IDLERS
De Scott Evans

Arthur Wesley Dow
(1857-1922)

~20~

Twilight, 1893

Oil on canvas

26 x 36"

Original American period frame, c. 1890, applied ornament and gilded

Dow had a nineteenth century attitude towards a sense of place and over and over again he tried to capture the spiritual essence of his hometown.[1] Most of his paintings of Ipswich are coastal views, but occasionally he reverted to the town itself, its narrow pre-Revolutionary lanes guarded by fine New England saltbox homes. Rarely did he include figures. The time is almost always sunset when a veil of mystery blankets the scene as the last of the sun's rays glows against the red brick of a chimney or picks out highlights in the dense greenery of a tree, or glazes the sightless windows of the clapboard houses.

Twilight was painted while Dow was in the first flush of his association with Japanese art. The high horizon, the unusual color tones and the way the scene seems to extend beyond the canvas edges all reflect this new interest, and Dow infuses the scene with life by employing rapid brushwork and strong colors. Throughout his career Dow was constantly assimilating and changing under new influences, using nature as a reference point and guide but not succumbing to mere representation. In a 1915 article for *The Delineator* he clarified his feelings, saying: "the artist does not teach us to see facts: he teaches us to feel harmonies and to recognize supreme quality."[2]

NEG

1. The provenance for this painting is a private collection, Massachusetts.
2. Arthur Wesley Dow, "Talks on Appreciation of Art," *The Delineator* (January 1915): 15.

Willard Leroy Metcalf
(1858-1925)

~21~

Ebb Tide, 1895

Oil on canvas

13 x 16"

Period American frame by Yates, c. 1900-10, carved and gilded, from the Eli Wilner & Company Collection

Around 1895, Willard Metcalf began to adopt impressionist techniques, including broken brushwork, pure color, and unconventional composition, such as the high horizon line of *Ebb Tide*. Water, both reflective and transparent, occupies five-sixths of the canvas and serves as the focus of this composition, painted during the artist's first summer visit to Gloucester, Massachusetts.[1] Metcalf exhibited this painting at the 1901 exhibition of the Ten American Painters, a group of impressionists who seceded from the Society of American Artists in 1897 in order to protest that organization's conservative stylistic tendencies, restrictive exhibition policies, and commercialism. The Ten, including Childe Hassam (Plate 30) and William Merritt Chase (Plates 24, 34; who joined the group in 1902, after the death of John Twachtman), agreed to resign from the Society, to limit their membership to ten, and to exhibit together annually.[2]

KUF

1. *American Traditions: Art from the Collections of Culver Alumni*, exhib. cat. (Indianapolis: Museum of Art, 1993), 96; Doreen Bolger Burke, *American Paintings in the Metropolitan Museum of Art*, new ed., 3 vols. (New York: Metropolitan Museum of Art, 1980), vol. 3, *A Catalogue of Works by Artists Born between 1846 and 1864*, 323.
2. W. Hiesinger, "Impressionism and Politics: The Founding of the Ten," *Antiques* 140 (November 1991): 780-793; Hiesinger, *Impressionism in America: The Ten American Painters* (Munich: Prestel-Verlag, 1991).

Ebbing Tide - 1895
1858 - W. L. Metcalf 1925

~21~

\mathscr{J}ulius LeBlanc Stewart

(1855-1919)

~22~

Woman in an Interior, 1895

Oil on canvas

36 x 25-1/2"

Period American frame, c. 1885-95, applied ornament and gilded, from the Eli Wilner & Company Collection

Julius LeBlanc Stewart achieved success during the last two decades of the nineteenth century with his portraits of Parisian celebrities. Although born in Philadelphia, Stewart lived most of his life in Paris after his father, William Hood Stewart, moved his family at the end of the Civil War. Prosperous Cuban sugar plantations supported the Stewarts and enabled the elder Stewart to become one of the city's noted patrons of contemporary art.[1] The family's social connections assured Julius Stewart access to Parisian society, including wealthy patrons who favored the artist's paintings of the social elite at play. *Woman in an Interior* illustrates Stewart's formula: a modishly dressed woman assumes a confident, casual pose that accentuates her tiny, corseted waist. According to one contemporary, "[Stewart] is a painter of thoroughly chic portraits of women, and . . . always produced genteel results. He never paints a woman who appears to be of lower rank than that of baroness, and all his young girls look like daughters of duchesses."[2]

KUF

1. W.R. Johnston, "W.H. Stewart, the American Patron of Mariano Fortuny," *Gazette des Beaux-Arts* 77 (March 1971): 183-188; Karen Zukowski, "Julius LeBlanc Stewart," in Annette Blaugrund, *Paris 1889: American Artists at the Universal Exposition*, exhib. cat. (Philadelphia: Pennsylvania Academy of the Fine Arts in association with Henry N. Abrams, Inc., Publishers, New York, 1989), 211-213.
2. D. Dodge Thompson, "Julius L. Stewart, A 'Parisian from Philadelphia,'" *Antiques 130* (November 1986): 1047; quoting "Report on the Fine Arts," *Reports of the United States Commissioners to the Universal Exposition of 1889 at Paris* (Washington, DC, 1891), 69.

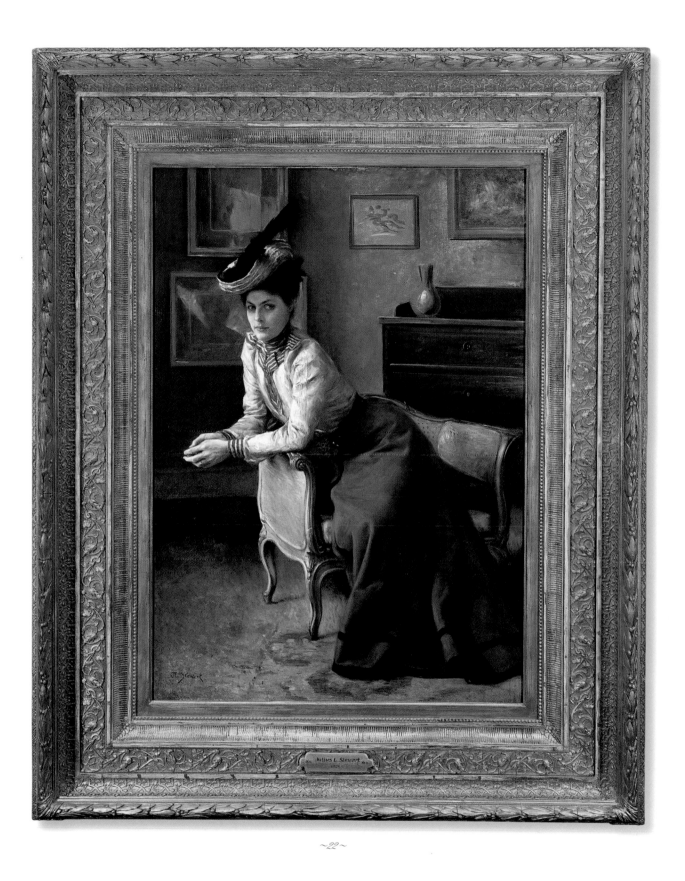

John Joseph Enneking

(1841-1916)

~23~

Spring Storm Approaching, 1897

Oil on canvas

22 x 30"

Contemporary Eli Wilner & Company replica of a Barbizon style frame, c. 1880s, applied ornament and gilded

Praised by his contemporaries for his ability to capture the seasonal moods of the New England landscape, John J. Enneking won awards, served on art juries, received lucrative commissions, and exhibited alongside artists such as Willard Metcalf (Plates 21, 35) and Childe Hassam (Plate 30). Believing that "nature is truth," the artist not only painted the New England landscape, but also worked to preserve it from "desecration" and from "obnoxious utilitarianism" by serving as Park Commissioner for Hyde Park and Boston.[1] In 1915, Enneking's contemporaries honored him with a testimonial dinner attended by more than 500 admirers. At the end of the evening, Cyrus Dallin (Plates 81, 82) crowned the artist with a laurel wreath, hailing him as "the supreme artist among those who paint New England."[2] Enneking's reputation rapidly faded into obscurity after his death, only to be revived by the discovery of some 100 paintings, the contents of his studio at his death, during the demolition of a Boston warehouse in 1960.[3]

KUF

1. Enneking stated, "Study nature, nature is truth," in *Boston Journal*,1886; quoted in Patricia Jobe Pierce and Rolf H. Kristiansen, *John Joseph Enneking: American Impressionist Painter*, exhib. cat. (Hingham, MA: Pierce Galleries, 1972), 98. For the artist's statement regarding the desecration of nature, see Pierce and Kristiansen, 125.
2. Quoted in Pierce and Kristiansen, 160.
3. Rolf [H.] Kristiansen, "John J. Enneking: An Artist Rediscovered," *American Artist* 26 (October 1962): 45-47, 71-72.

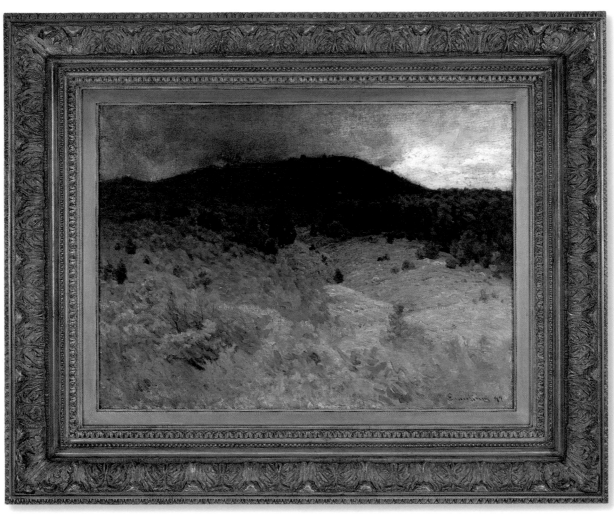

~24~

Red Roofs of Bristol, Pennsylvania, 1899

Oil on canvas

20 x 30"

Period French frame, Barbizon style, c. 1880s, applied ornament and gilded

By the time William Merritt Chase painted this view of Bristol, a mill town northeast of Philadelphia, critics, artists, audiences, and patrons regarded him as the only resident American painter equal to celebrated expatriates John Singer Sargent and James Abbott McNeill Whistler. Chase's reputation derived from both his artistic accomplishments and his role as a teacher at schools such as the Art Institute of Chicago, the Art Students League, the Pennsylvania Academy of the Fine Arts, and his own schools, including the summer school at Shinnecock, Long Island, which he founded in 1891 as the first major school of *plein-air* painting in the United States. He painted *Red Roofs of Bristol, Pennsylvania* while teaching at the Pennsylvania Academy, a position he held from 1896 to 1909.[1] At least one day a week, he traveled from New York to Philadelphia, where he both taught and undertook portrait commissions.

KUF

1. The checklist of known works included in the catalogue for the *Chase Centennial Exhibition, Commemorating the Birth of William Merritt Chase, November 1, 1849*, exhib. cat. (Indianapolis, IN: John Herron Art Museum, 1949) lists three paintings of Bristol, PA: *Bristol, Pennsylvania* (oil on canvas), *Old Mill at Bristol* (oil on canvas), and a second *Old Mill at Bristol*. *Red Roofs of Bristol, Pennsylvania* may be either the painting listed as *Bristol, Pennsylvania* or a fourth painting omitted from the checklist.

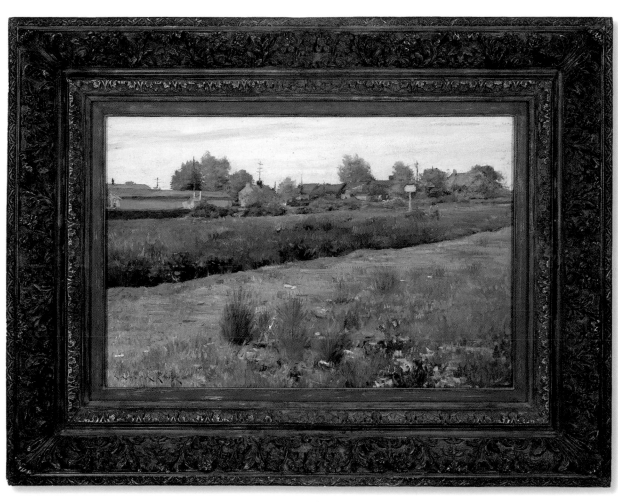

~24~

Charles Sprague Pearce
(1851-1914)

~25~

Returning Home, 1890s

Oil on canvas

29 x 23-1/2"

Period American frame, c. 1890, applied ornament and gilded

Charles Sprague Pearce first won acclaim for his paintings of Biblical subjects, later drawing upon the Christian iconographic tradition in order to imbue peasant paintings such as *Returning Home* with spiritual symbolism.[1] A peasant woman returning from the fields at the end of the day stands silhouetted against a panoramic view of the French countryside. The hayrake and the basket, a modest cornucopia, identify her as an allegorical representation of agriculture, an association strengthened by the natural cycles implied by both dusk and harvest. The rake resting on her shoulder, as well as the footpath through the field, connote Christ on the road to Calvary, Christ's last journey from the house of Pilate to the hill of Golgotha where He was crucified. Pearce invokes both mythological and Biblical symbolism in *Returning Home*, thereby attributing to the French peasant both innate spirituality and harmony with nature.

KUF

1. For a discussion of Pearce's Biblical paintings, see Mary Lublin, *A Rare Elegance: The Paintings of Charles Sprague Pearce, 1851-1914*, exhib. cat. (New York: Jordan-Volpe Gallery, 1993).

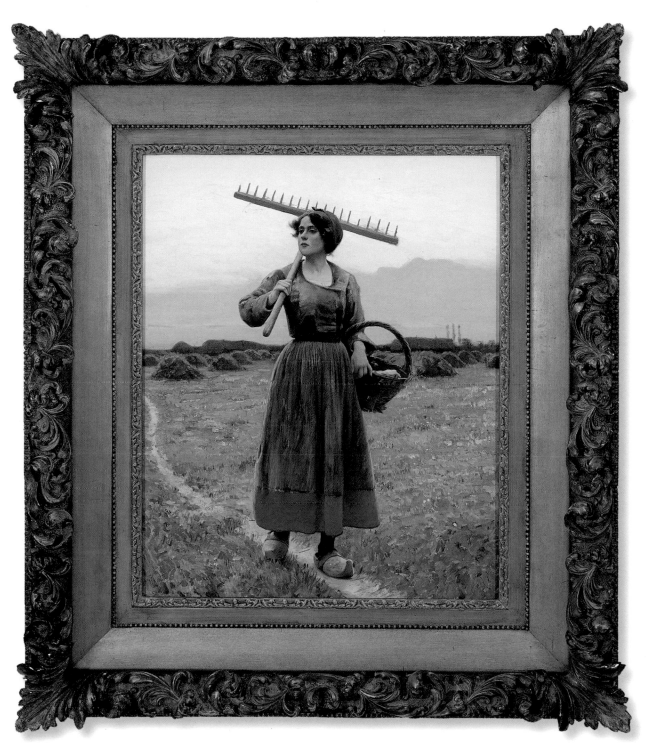

~25~

Charles Sprague Pearce
(1851-1914)

~26~

The Woodcutter's Daughter, 1890s

Oil on canvas

47 x 40"

Contemporary Eli Wilner & Company replica of an American period frame, c. 1880s, applied ornament and gilded

Charles Sprague Pearce invested his peasant paintings with symbolism drawn from Christian, mythological, and folkloric traditions. As with *Returning Home* (Plate 25)*, The Woodcutter's Daughter* invokes the notion of the Christian burden, here symbolized by the fagot rather than by the hayrake. Pearce also may have had in mind the numerous European folktales concerning the woodcutter's daughter. Such stories usually describe a father and his daughter, who, although tempted by various magical woodland creatures to abandon her familial duty, remains steadfast in her devotion.[1] Images of dutiful, productive peasants found favor with politicians of the French government who claimed that the French peasantry embodied the moral values summarized by the Revolutionary motto, "Liberty, Equality, Fraternity."[2]

KUF

1. See Norma Olin Ireland, *Index to Fairy Tales, 1949-1972* (Westwood, MA: F.W. Faxon Co., Inc., 1973); James M. McGlathery, *Fairy Tale Romance: The Grimms, Basile, and Perrault* (Urbana, IL: University of Illinois Press, 1991).
2. Robert J. Bezucha, "The Urban Image of the Countryside in Late Nineteenth-Century French Painting: An Essay on Art and Political Culture," in *The Rural Vision: France and America in the Late Nineteenth Century*, ed. Hollister Sturges (Omaha, NE: Joslyn Art Museum, 1987), 13-21.

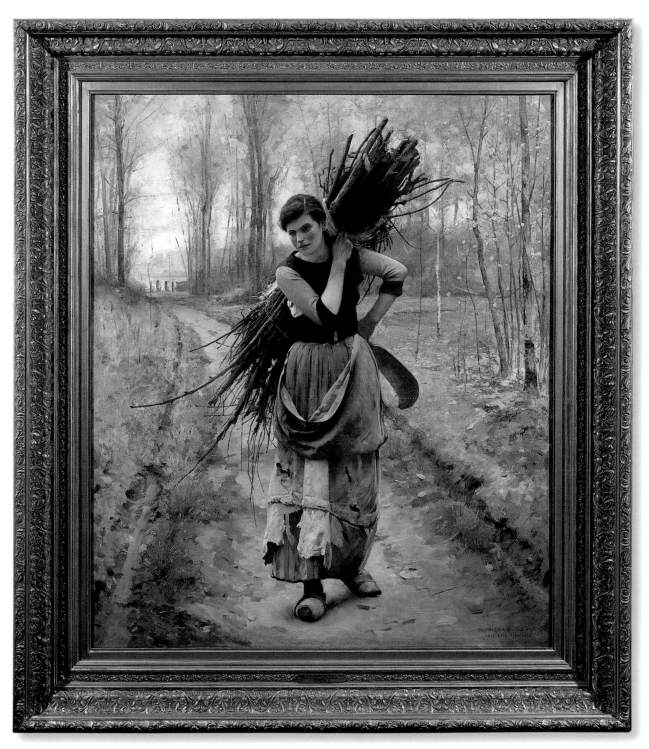

Sören Emil Carlsen
(b. Copenhagen, Denmark, 1853-1932)

~27~

Moonlight and Sea, n.d.

Oil on canvas

32-1/4 x 34-1/4"

Original American frame by Hermann Dudley Murphy, signed and dated, carved and gilded

Trained as an architect in Copenhagen, Emil Carlsen came to the United States in 1872, initially settling in Chicago and serving as a studio assistant to a Danish marine painter. Although he first distinguished himself as a still life painter, he eventually turned to landscapes, particularly marines, when still life painting proved to be less popular with patrons. The artist's contemporaries praised his unique approach to painting the sea, one which stressed texture, pattern, and "a certain trance-like mood."[1] *Moonlight and Sea* typifies Carlsen's marine paintings: the sea occupies less than one-third of the canvas, and the sky fills the remainder. The same tonal range and the same surface texture express both sky and sea, a technique that unifies air and water into a modulated mass of color and light.

KUF

1. Duncan Phillips, "Emil Carlsen," *International Studio* 61 (June 1917): cvi.

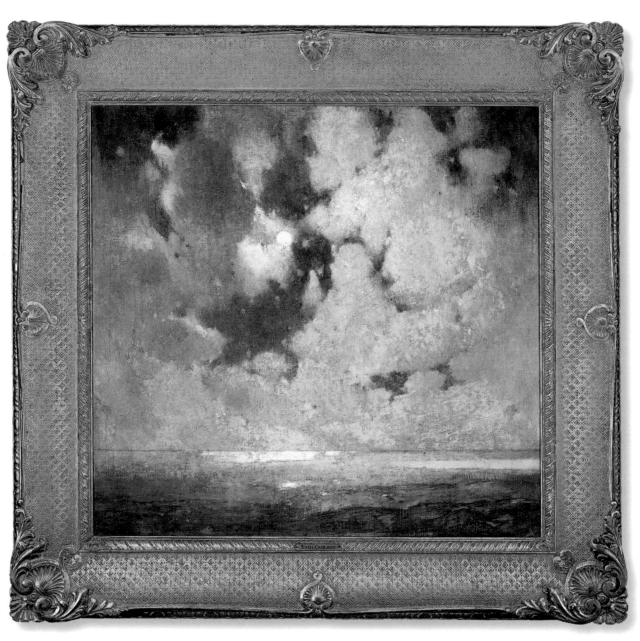

Edwin Willard Deming
(1860-1942)

~28~

An Indian Competition, n.d.

Oil on canvas

32 x 60"

Period American frame, c. 1910-20, carved and gilded, from the Eli Wilner & Company Collection

Contemporary critics praised Edwin Willard Deming's efforts to document "the Redman, so quickly passing away."[1] As a "pioneer boy," in the words of one biographer, the artist had associated with Indians, and by the late 1870s, had decided to become an artist in order to record Indian life.[2] In 1893, Deming and DeCost Smith both wrote and illustrated articles for *Outing* magazine, such as "Sketching Among the Crow Indians" and "With Gun and Palette among the Red Skins," the latter illustrated by Frederic Remington.[3] After his marriage, he and his family traveled throughout the United States, either visiting or living among various Indian tribes and witnessing many historic events. Despite the artist's desire to make a pictorial record of Indian culture, his images more accurately capture the romantic ideals cherished not only by many Caucasian Americans, but also by some American Indians.[4]

KUF

1. *Paintings, Decorations and Bronzes of American Indians and Animals by Edwin Willard Deming*, exhib. cat. (New York: Brooklyn Museum, 1923).
2. "Edwin Willard Deming, A Sketch" in *Edwin Willard Deming*, ed. Henry Collins Walsh (New York: Riverside Press, 1925), 9-19.
3. Peggy and Harold Samuels, *The Illustrated Biographical Encyclopedia of Artists of the American West* (Garden City, NY: Doubleday, 1976), s.v. "Edwin Willard Deming."
4. In addition to a sketch of the artist's life, Walsh reproduces letters, articles, and other material, including a letter from Francis LaFleshe, an Omaha, that praises Deming's work.

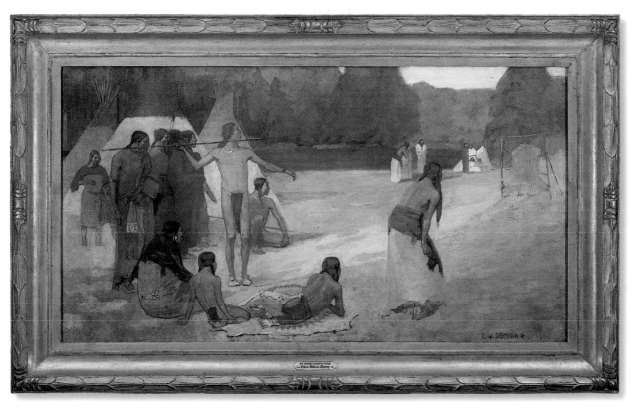

~28~

Irving Ramsey Wiles
(1861-1948)

~29~

The Yellow Rose, c. 1900

Oil on canvas

27 x 35"

Contemporary Eli Wilner & Company replica of an American period frame, c. 1880s, applied ornament and gilded

The Yellow Rose, which won the Shaw Fund Prize for the best figure painting from the Society of American Artists in 1900, exemplifies Irving Ramsey Wiles's portraits of genteel, well-dressed women engaged in leisurely pursuits.[1] Like many American artists of the 1880s and 1890s, Wiles experimented with impressionist techniques, particularly the interplay of light and color, here illustrated by the illuminated flesh of the model's face, neck, and arms. Wiles said, "Flesh has no color. Color is whatever light makes it and light changes and transforms everything. Light is beauty."[2] *The Yellow Rose* documents not only the artist's assimilation of aspects of impressionism, but also his adaptation of popular subject matter. The woman adorning herself before a mirror suggests the *femme fatale*, an association prompted by her provocative pose before a mirror, symbol of vanity, and the yellow rose, symbol of jealousy according to some nineteenth-century florigraphy dictionaries.[3]

KUF

1. Gary A. Reynolds, *Irving R. Wiles* (New York: National Academy of Design, 1988), 19. Wiles also showed *The Yellow Rose* at the Pennsylvania Academy of the Fine Arts in 1901 (Peter Hastings Falk, ed. *The Annual Exhibition Record of the Pennsylvania of Academy of the Fine Arts*, rev. ed., 3 vols. (Madison, CT: Sound View Press, 1988), vol. 2, s.v. "Irving R(amsay) [*sic*] Wiles)."

2. Unpaginated clipping in possession of Ronald G. Pisano, *Morning Telegraph*, 11 December 1927; quoted in Pisano, "William Merritt Chase and Irving R. Wiles," in *The Artist as Teacher: William Merritt Chase and Irving Wiles*, exhib. cat. (East Hampton, NY: Guild Hall Museum, 1994), 18.

3. For a brief overview of the nineteenth-century interest in the language of flowers, see Jean Marsh, "A Manner of Speaking," in Kate Greenaway, *The Illuminated Language of Flowers: Over 700 Flowers and Plants Listed Alphabetically with Their Meanings* (New York: Holt, Rinehart, and Winston, 1978), 9-18.

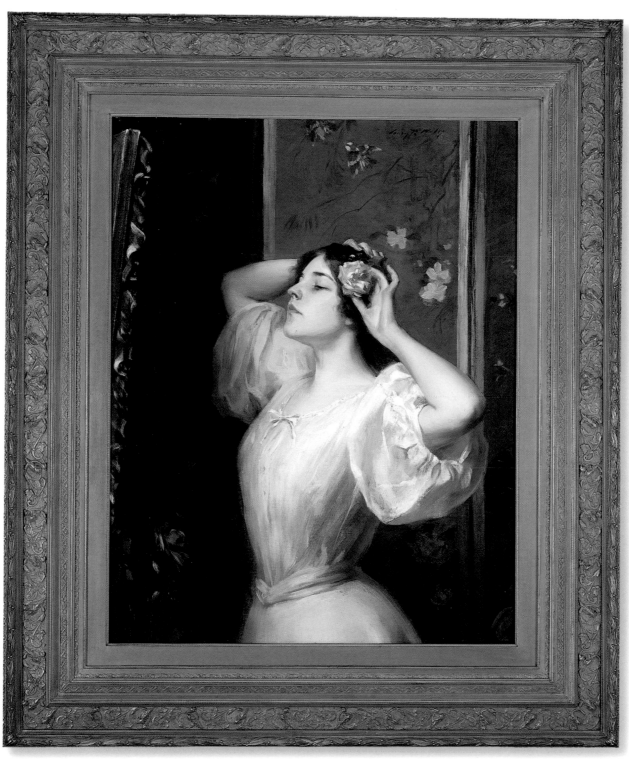

Frederick Childe Hassam
(1859-1935)

~30~

Lyman's Ledge, Appledore, 1901

Oil on canvas

25 x 30"

Period American frame, c. 1890, gilded, from the Eli Wilner & Company Collection

Images of Appledore Island, one of the Isles of Shoals, Maine, comprise about ten percent of Childe Hassam's oeuvre.[1] From 1884 until 1916, the artist spent part of most summers on the island, where he participated in the cultural salon conducted by his friend, Celia Laighton Thaxter. A renowned poet and an avid horticulturalist, she suggested that he drop his given name, "Frederick," and use his more exotic middle name, "Childe." Until Thaxter's death in 1894, Hassam painted her famous cutting garden, culminating in his illustrations for her book, *An Island Garden* (1894)[2] Although Hassam avoided Appledore Island for some years after her death, he returned every year after 1901. *Lyman's Ledge, Appledore* demonstrates his change of focus following this hiatus. Rather than painting Thaxter's island garden, Hassam now considered the juxtaposition of rocky coast, sea, and sky.

KUF

1. Ulrich W. Hiesinger, *Impressionism in America: The Ten American Painters* (Munich: Prestel-Verlag, 1991), 239.
2. For discussions of Thaxter's garden, see *Childe Hassam: An Island Garden Revisited*, exhib. cat. (Denver, CO: The Denver Art Museum, 1990); May Brawley Hill, "'Grandmother's Garden,'" *Antiques* 142 (November 1992): 726-735; Stephen May, "Island Garden," *Historic Preservation* 43 (September-October 1991): 38-45, 95.

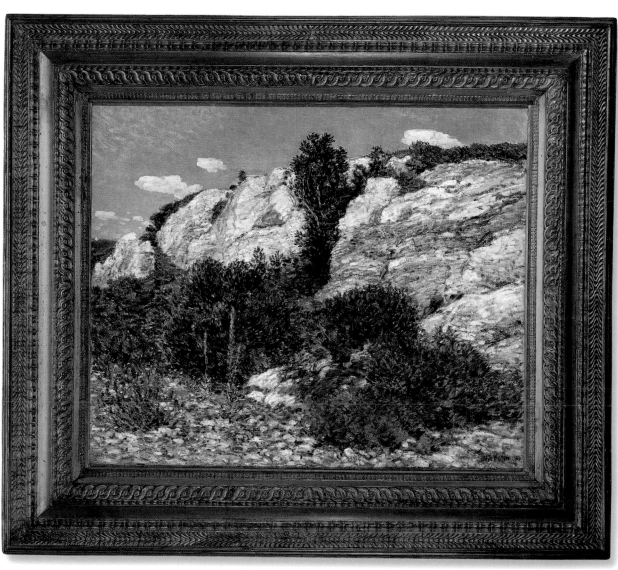

Elizabeth Vila Taylor Watson

(active 1898-1953)[1]

~31~

The White Dress, 1903

Oil on canvas

32 x 22"

Period American frame, c. 1900-10, carved and gilded

The White Dress evinces the hallmarks of the Boston School aesthetic, a style associated with the School of the Museum of Fine Arts, Boston. In the first three decades of the twentieth century, the Museum School championed an aesthetic that both combined academic draftsmanship with the bravura brushstroke associated with John Singer Sargent, and applied this mode primarily to figurative subjects.[2] Impressionist brushstroke, subdued palette, draftsmanship, and the subject matter, a female portrait, all betoken Elizabeth Vila Taylor Watson's training at the Museum School under Edmund Tarbell, Frank Benson, and Joseph DeCamp, three of the founding members of the Ten American Painters.[3] Both Benson and Tarbell often painted young women dressed in white, a theme that facilitated the Boston School's emphasis on both ideal composition and mood, and one which was enhanced by evocative titles, such as *The White Dress.*[4]

KUF

1. Published sources offer little information about Watson. See Jim Collins, *Women Artists in America*: *18th Century to the Present* (1970-1980), s.v. "Elizabeth V. Watson"; Peter Hastings Falk, ed., *Who Was Who in American Art* (Madison, CT: Sound View Press, 1985), s.v. "Elizabeth V(ila) (Taylor) Watson (Mrs.)"; John William Leonard, ed. *Woman's Who's Who of America* (New York: American Commonwealth Co., 1914), s.v. "Elizabeth Vila Taylor Watson (Mrs. Albert Mortimer Watson)"; Glenn B. Opitz, ed., *Mantle Fielding's Dictionary of American Painters, Sculptors and Engravers*, rev. ed. (Poughkeepsie, NY: Apollo, 1983), s.v. "Elizabeth V. Taylor Watson"; Chris Petteys, *Dictionary of Women Artists: An International Dictionary of Women Artists Born before 1900* (Boston: G.K. Hall, 1985), s.v. "Elizabeth Vila Taylor," with bibliography.
2. For a discussion of the Boston School, see Trevor J. Fairbrother, *"Painting in Boston, 1870-1930," in The Bostonians*: *Painters of an Elegant Age, 1870-1930*, exhib. cat. (Boston: Museum of Fine Arts, Boston, 1986), 31-92.
3. Watson probably attended the School of the Museum of Fine Arts, Boston, around 1889, the only year that all three men—Benson, Tarbell, and DeCamp—taught at the School. See Cynthia D. Fleming, "Appendix: Instructors and Courses in the Museum School," in *The Bostonians*, 233-235.
4. Carol Troyen mentions Tarbell's interest in the theme of women dressed in white in *The Boston Tradition: American Paintings from the Museum of Fine Arts, Boston*, exhib. cat. (New York: Museum of Fine Arts, Boston and the American Federation of Arts, 1980), 188.

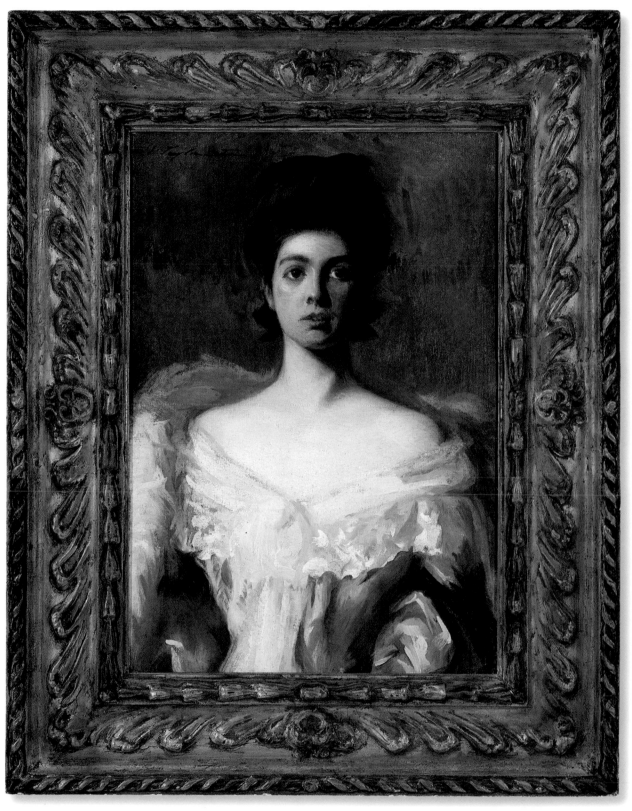

Arthur Wesley Dow
(1857-1922)

~92~

Distant Trees, 1905

Oil on canvas

30 x 40"

Contemporary Eli Wilner & Company replica of a gold-on-oak frame, c. 1890, applied ornament and gilded

Even as a child, Dow went for long solitary walks along the shores and among the dunes of his native Ipswich, getting to know its every mood, in every season.[1] Although he labored for years to earn enough money to study in Europe, after five years away he returned with a renewed interest in the freshness of the surroundings of his youth. His biographer, Arthur Warren Johnson noted, "The years in France had one salutary effect and it was that the native town was examined with eyes trained to see the utmost possibility of any landscape."[2] In his short story (unpublished) called *Wooden-Leg Joe,* Dow described a lone figure that could have easily been himself, upon his return: "So he gazed upon familiar scenes and floated out upon the calm bay where sky and water were the same silvery tone of grey."[3]

In *Distant Trees*, Dow's contemplative communion with nature and his respect and appreciation of all its glories shine through. There is an intimacy here, a knowingness, of a man who has truly experienced this landscape, with all its variations and vagaries, and has learned to humble himself before it. This is the strength and the beauty of the Ipswich landscapes and explains why Dow returned there again and again.

NEG

1. The provenance for this painting is from a private collection, California.
2. Arthur Warren Johnson, *Arthur Wesley Dow, Historian, Artist, Teacher* (Ipswich, MA: Ipswich Historical Society, 1934), 43.
3. Frederick Moffatt, "The Life, Art and Times of Arthur Wesley Dow" (Ph. D. diss., University of Chicago, 1972): 10.

~32~

George Benjamin Luks
(1867-1933)

~33~

The Bread Line, 1905-25

Oil on panel

17 x 21"

Period American frame by Frederick Harer, c. 1910-20, carved and gilded, from the Eli Wilner & Company Collection

Both style and subject matter marked George Luks as one of The Eight, a group of eight artists, including William Glackens (Plate 38) and John Sloan (Plate 49), who staged an exhibition at the Macbeth Galleries in 1908 in order to protest the exhibition practices of the National Academy of Design. The group sought to formulate a new American art which would depict the gritty, modern reality of New York City.[1] Like other members of The Eight, George Luks began his career as both a newspaper artist and an illustrator, occupations that not only supported his painting but also necessitated close observation of metropolitan life. Luks painted the city's underclasses using a strongly brushed, tonal mode indebted to Dutch, seventeenth-century realists such as Frans Hals (1584-1666). *The Bread Line* exemplifies his early work: the neutral backdrop as well as the lack of detail render his figures universal types, and both the vigorous, graphic brushstrokes and the dark palette infuse the image with drama.

KUF

1. For a discussion of The Eight, also known as the "Ashcan School," see Rebecca Zurier, Robert W. Snyder, and Virginia M. Mecklenberg, *Metropolitan Lives: The Ashcan Artists and Their New York*, exhib. cat. (New York: National Museum of American Art in association with W. W. Norton & Company, 1995).

William Merritt Chase
(1849-1916)

~34~

Ponte Vecchio, 1907

Oil on panel

8-3/8 x 12-1/4"

Period American frame by Max Kuehne, c. 1910, carved, incised and silver gilded, from the Eli Wilner & Company Collection

Venice became a popular destination for both artists and patrons in the second half of the nineteenth century.[1] In the summer of 1877, William Merritt Chase made his first trip to Venice accompanied by Frank Duveneck and by John Twachtman. The three friends stayed in Venice for nine months, unable to leave due to both lack of funds and Chase's nearly fatal illness. During his stay, Chase copied paintings in museums, painted small oil studies of architectural subjects, collected *objets d'art*, and acquired two monkeys.[2] He returned to Italy in 1907, spending much of his time in Venice, although he held his summer class in Florence and purchased a villa in nearby Fiesole. Like many American artists who painted views of Venice, Chase excluded the human figure in order to focus on architectural elements in the light.[3]

KUF

1. Margaretta M. Lovell, *Venice: The American View, 1860-1920*, exhib. cat. (San Francisco: The Fine Arts Museums of San Francisco, 1984). See also Regina Soria, *Dictionary of Nineteenth-Century American Artists in Italy, 1760-1914* (East Brunswick, NJ: Associated University Presses, 1982); Theodore E. Stebbins, *The Lure of Italy: American Artists and the Italian Experience, 1760-1914*, exhib. cat. (Boston: Museum of Fine Arts, 1992).
2. Katharine Metcalf Roof, *The Life and Art of William Merritt Chase* (New York: Charles Scribner's Sons, 1917), 45-53. Lovell states that "[w]e know by title about twenty Venetian paintings by Chase, but less than half of these have been located" (32). The checklist of known works included in the catalogue of the *Chase Centennial Exhibition, Commemorating the Birth of William Merritt Chase, November 1, 1849*, exhib. cat. (Indianapolis, IN: John Herron Art Museum, 1949) omits *Ponte Vecchio*, although *On the Balcony: Souvenir of Italy* may be an alternate title for this painting which features the top of either a ledge or a railing in the lower left corner. In addition, the dimensions of *On the Balcony*, 8 1/4 x 12 inches, approximate those of *Ponte Vecchio*.
3. For a discussion of the omission of Venetian figures from views of Venice by American artists, see Lovell, 13.

~34~

Willard Leroy Metcalf
(1858-1925)

~35~

Midwinter (Number One), 1907

Oil on canvas

29 x 26"

Period American frame, c. 1910, carved and gilded

Willard Metcalf studied in Boston before traveling to France in 1883 to pursue further training at the Académie Julian and at artists' colonies such as Giverny, where he worked alongside Theodore Wendel (Plate 50), and Grèz-sur-Loing, where he met Emil Carlsen (Plate 27) and Robert Vonnoh (Plate 18).[1] Despite this exposure to impressionism, Metcalf worked in an academically-oriented style until the mid-1890s, when he began to adopt the impressionist mode, perhaps due to the influence of friends such as Childe Hassam (Plate 30). After 1903, he devoted himself to painting the New England landscape and made a particular study of snow scenes which brought him both critical acclaim and financial reward.[2] One critic wrote: "No one ever painted lovelier snow picture than he Metcalf shows us the winsome side of winter, not the frosty air, the biting cold, but the caressing touch of the golden sunlight, the soft mantle of snow resting ever so lightly on the shoulders of the world."[3]

KUF

1. Ulrich W. Hiesinger, *Impressionism in America: The Ten American Painters* (Munich: Prestel-Verlag, 1991), 241.
2. Although Elizabeth de Veer argues that Metcalf began painting winter landscapes after 1909, both date and title of *Midwinter (Number One)* suggests that Metcalf may have begun painting snow scenes as early as 1907. See Elizabeth de Veer, "Willard Metcalf in Cornish, New Hampshire," *Antiques* 126 (November 1984): 1208-1215.
3. Anonymous critic reviewing Metcalf's one-man show at the Corcoran Gallery of Art, *Washington Post*, 11 January 1925; quoted in De Veer, 1214.

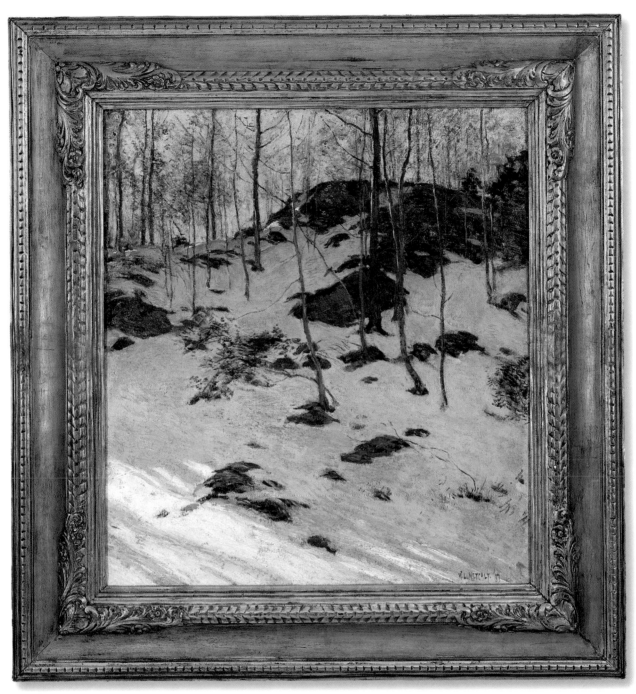

Adam Emory Albright

(1862-1957)

~36~

Summer Outing, 1908

Oil on canvas

36 x 72-1/4"

Contemporary Eli Wilner & Company replica of an American period frame, c. 1895-1900, applied ornament and gilded

Like J. G. Brown (Plate 3), Adam Emory Albright predicated his career upon representations of what one contemporary critic called "the universal spirit of childhood."[1] Albright's images of country children offered urban audiences his vision of an ideal social order, couched in metaphorical terms. This painting depicts not only a summer outing, but also a spirit of cheerful cooperation between the sexes as a boy offers a helping hand to a girl, while another pair carry the large basket between them. Although he painted *Summer Outing* in 1908, the artist dressed these children in clothing appropriate to the late-nineteenth century—sunbonnets and short pants with suspenders—underscoring the pioneer spirit many viewers nostalgically associated with the countryside and its youthful inhabitants.

KUF

1. Minnie Bacon Stevenson, "A Painter of Childhood," *American Magazine of Art* 11 (October 1920): 434.

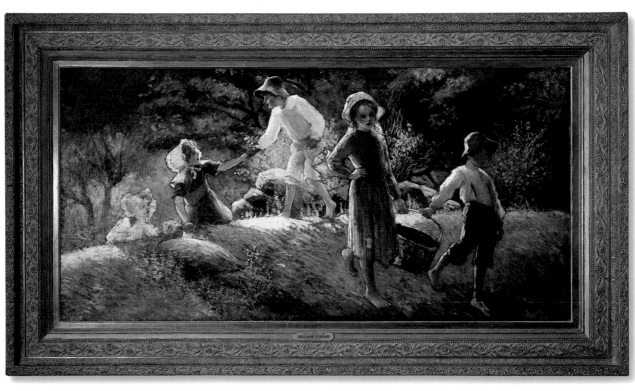

~36~

George Hitchcock
(1850-1913)

~37~

La Fleur de Fevrier: Zeeland, 1908

Oil on canvas

44 x 35"

Period European, Dutch style frame, c. 1900

This image of a Dutch girl, "the flower of February," posed amid early spring flowers epitomizes George Hitchcock's paintings of "a joyous, radiant, flower-bright Holland," in the words of one contemporary critic who dubbed the artist the "painter of sunlight."[1] While in his late twenties, Hitchcock renounced his law practice in order to pursue a career in art, first studying in Paris at the Académie Julian before settling in Egmond, near Amsterdam, where he maintained a studio. His images of peasant women in regional dress often have religious overtones, and evoke the work of French academic painter Jules Bastien-Lepage, who also influenced both Charles Sprague Pearce (Plates 5, 12, 25, 26) and Daniel Ridgway Knight (Plate 11). Hitchcock combined this academic interest in religious genre scenes with impressionist techniques, adopting *plein-air* painting, which emphasized the study of light, as well as bright color and decorative pattern, such as that created by the bare tree trunks of *La Fleur de Fevrier: Zeeland*.

KUF

1. Christian Brinton, "George Hitchcock, Painter of Sunlight," *International Studio* 26 (September - October 1905): i-vi.

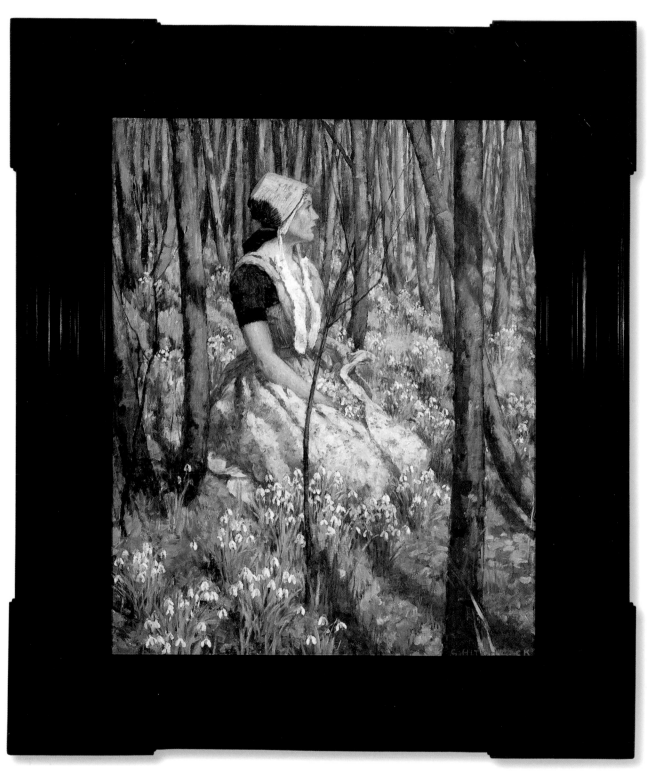

~37~

William James Glackens
(1870-1938)

~38~

Treading Clams, Wickford, 1909

Oil on canvas

25-1/4 x 30-1/8"

Period American frame, c. 1920, carved and gilded, from the Eli Wilner & Company Collection

Painted the year after William Glackens exhibited with The Eight, *Treading Clams, Wickford* numbers among the beach scenes that marked a point of departure for the artist.[1] Like George Luks (Plate 33) and John Sloan (Plate 49), he had worked as a sketch-reporter and had painted in a Manet-influenced mode which complemented the urban scenes favored by The Eight. In 1908, after making his second trip to France, the artist renounced his earlier style and embraced the impressionist aesthetic, particularly as practiced by Auguste Renoir. This painting employs the high-keyed palette, the broken brushstroke, and the subjects—recreation and landscape—associated with impressionism. Glackens not only painted in that mode, but also encouraged his friend and former schoolmate, Albert C. Barnes, to purchase the European impressionist works that formed the nucleus of the Barnes Foundation collection (Merion, Pennsylvania).[2]

KUF

1. William H. Gerdts, New York, "William James Glackens, *Treading Clams, Wickford*," unpublished report, 1996; *William Glackens: The Formative Years*, exhib. cat. (New York: Kraushaar Galleries, 1991).
2. For a discussion of the relationship between Albert Barnes and William Glackens, see Richard J. Wattenmaker, "Dr. Albert C. Barnes and the Barnes Foundation," in *Great French Paintings from the Barnes Foundation: Impressionist, Post-Impressionist, and Early Modern* (New York: Alfred A. Knopf in association with Lincoln University Press, 1993), 3-27.

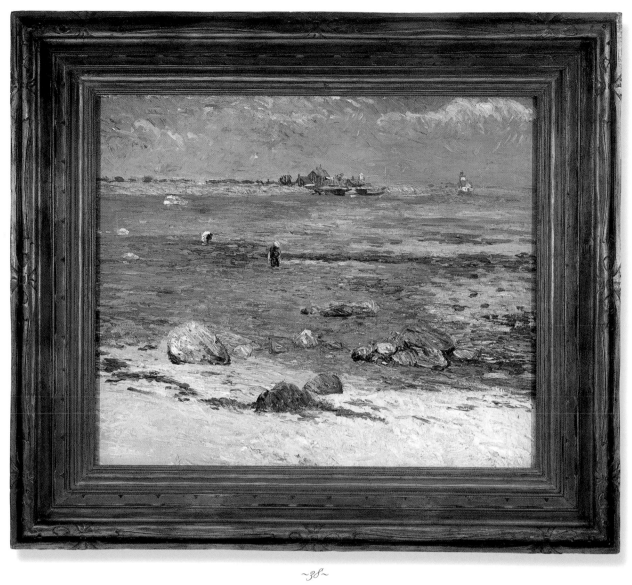

~38~

Frederick Judd Waugh
(1861-1940)

~39~

Low Spring Tide, 1909

Oil on canvas

29 x 36"

Period American frame, 1922, carved and gilded, signed and dated on verso Walfred Thulin, from the Eli Wilner & Company Collection

In 1909, the year Frederick J. Waugh painted *Low Spring Tide*, he achieved his first fame as a marine painter with the exhibition of *The Roaring Forties* (1908), an image of crashing waves which George A. Hearn purchased for the Metropolitan Museum of Art.[1] Waugh had first studied the sea intensively while vacationing on the Island of Sark in the English Channel, where he and his family remained for over two years.[2] In an essay published in 1910, the artist described his approach to painting seascapes, advocating careful observation of the sea in order to determine its characteristic patterns, followed by the development of these sketches on canvas.[3] Waugh spent the summers sketching and the winters in his studio, rapidly producing both small and large canvases, at times as many as ten in one month.[4] *Low Spring Tide* depicts the coast off Bailey Island, Maine, where he summered in 1908 and 1909.[5]

KUF

1. Doreen Bolger Burke, *American Paintings in the Metropolitan Museum of Art*, new ed., 3 vols. (New York: Metropolitan Museum of Art, 1980), vol. 3, *A Catalogue of Works by Artists Born between 1846 and 1864*, 410-411.
2. R. W. Norton Art Gallery, *Majesty in Motion: The Paintings of Frederick J. Waugh*, exhib. cat. (Shreveport, LA, 1990).
3. Frederick J. Waugh, "Some Words upon Sea Painting," *Palette and Bench 3* (November 1910): 32-33.
4. *Majesty in Motion*. Another exhibition catalogue states that Waugh "was a skilled craftsman, painting with 'uncanny speed' when deeply interested in his subject, for he has been known to complete a 30 x 40 canvas in a single day" (Brooks Memorial Art Gallery, *Paintings of the Sea: Frederick Judd Waugh, N.A., 1861-1940* [Memphis, TN, 1945]).
5. Waugh first visited Bailey Island in 1905. See *Paintings by Frederick J. Waugh (1861-1940) from the Edwin A. Ulrich Collection*, exhib. cat. (Trenton: New Jersey State Museum and Cultural Center, 1968). In 1910, the Macbeth Gallery included *Low Spring Tide* in its exhibition, "Paintings of Bailey's [sic] Island by Frederick Waugh."

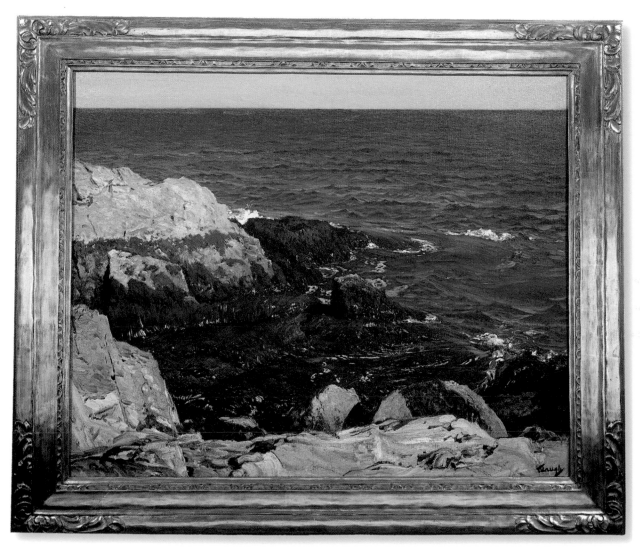

~40~

Field of Poppies, n.d.

Oil on canvas

20 x 32"

Period gold-on-oak American frame, c. 1890s, applied ornament and gilded, from the Eli Wllner & Company Collection

Jean Mannheim typifies those artists who, having first trained in Europe and in the eastern United States, then settled in the Los Angeles area in the first two decades of the twentieth century and contributed to the development of both a local artistic community and an identifiable regional style heavily influenced by impressionism.[1] The climate of Southern California readily accommodated the impressionist emphasis on *plein-air* painting, while the verdant landscape prompted local artists to use strong, earthy colors. *Field of Poppies* may commemorate the death of Mannheim's second wife, Eunice Drennan, who died soon after the family moved to Pasadena in 1908: the poppy symbolizes night, sleep, and consolation, while the reaper connotes death.[2]

KUF

1. Edan Milton Hughes, *Artists in California, 1786-1940*, 2nd ed. (San Francisco: Hughes Publishing Co., 1989), s.v. "Jean Mannheim"; Nancy Dustin Wall Moure, *Los Angeles Painters of the Nineteen-Twenties*, exhib. cat. (Claremont, CA: Pomona College Gallery, 1972); Moure, *Dictionary of Art and Artists in Southern California before 1930*, Publications in Southern California Art, no. 3 (Los Angeles: Privately printed, 1974), s.v. "Jean Mannheim," with bibliography; Ruth Lilly Westphal, *Plein Air Painters of California: The Southland* (Irvine, CA: Westphal Publishing, 1982), especially 78-83.
2. J.E. Cirlot, trans. by Jack Sage, *A Dictionary of Symbols*, 2nd ed. (London: Routledge & Kegan Paul, 1962), s.v. "Scythe"; Gertrude Jobes, *Dictionary of Mythology, Folklore and Symbols*, 2 vols. (New York: Scarecrow Press, 1962), s.v. "Poppy" and "Reaper."

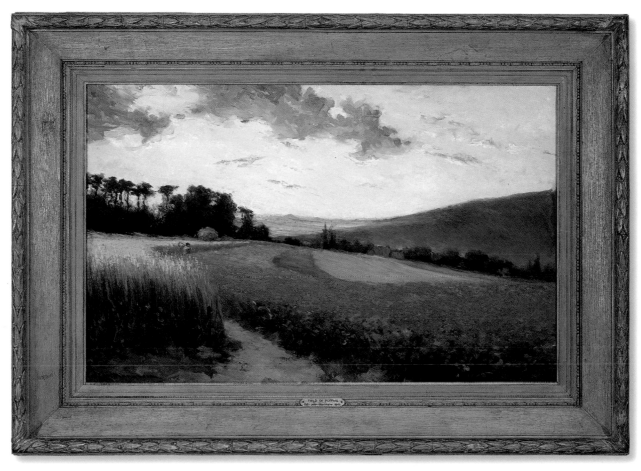

~40~

Arthur Wesley Dow
(1857-1922)

~41~

A Bright Sky with a Breeze, 1910

Oil on canvas

33 x 54"

Period American frame by Renner, c. 1900, applied ornament and gilded, from the Eli Wilner & Company Collection

Every autumn Dow returned to his native Ipswich to paint during the height of the foliage's brilliant color transformation.[1] The year 1910 was no exception. Dow painted several canvases that fall in luxuriously riotous oranges, lime greens, and cobalt blues, including two related paintings *A Bright Sky with a Breeze* and *Still Water* (Collection, Ipswich Historical Society) which were both exhibited in his 1911 show at the Montross Gallery, New York. In both, Dow's palette reflects his increasing interest in fauvist coloration as the saturated hues denote an almost surreal experience of the Ipswich landscape.

In 1929 the Arthur Wesley Dow Association held an exhibition at the Los Angeles County Museum of History, Science, and Art (now the Los Angeles County Museum of Art) posthumously honoring their former professor, and as a gift from Dow's widow, the museum's director chose *A Bright Sky with a Breeze* for the collection.[2] W. Alanson Bryan, the director, wrote to Minnie stating that "our desire was to secure a thoroughly satisfactory and really representative painting, and in this choice we have been guided by the feeling that Mr. Dow's work could hardly have a better representation than in the example selected."

NEG

1. The provenance of the painting is as follows: by descent to the artist's wife; to the Los Angeles County Museum of History, Science and Art, gift of Mrs. Dow, 1929; de-accessioned 1961 to a private collection.
2. The Arthur Wesley Dow Association, founded in 1923, sponsored annual exhibitions and published a magazine, *Art and Education*, continuing Dow's aims and goals.

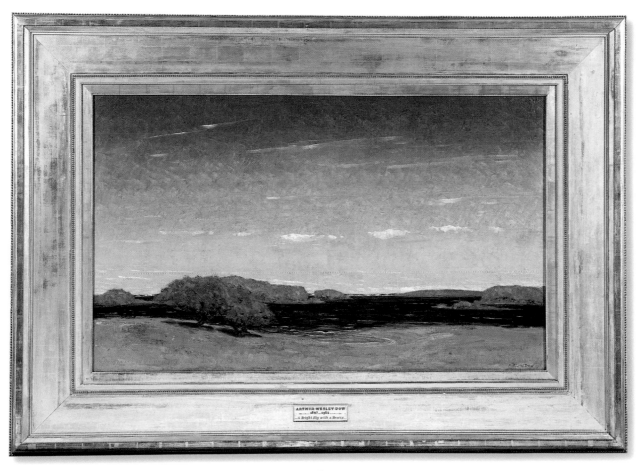

ARTHUR·WESLEY·DOW
1857—1922
~A Bright Sky with a Breeze~

~41~

~42~

Ipswich Study—Flowerfield, 1910

Oil on panel

4-1/4 x 6-3/8"

Period American frame, c. 1890-1900, gilded oak, applied ornament and gilded

Ever a close observer of nature, Dow often made detailed notations in both his diary and his sketchbooks recording color and weather changes as they occurred throughout the day. His descriptions often verge on poetry, such as this observation made en route to France for the first time: "There was a fine sunset—horizon misty then (above) a belt of red melting into a yellowish sky, purple clouds."[1] He often incorporated this knowledge into his canvases of twilights and sunsets, his favorite time of day.

In this charming painting the afterglow of a brilliant sunset picks out the vibrant centers of the yellow daisies and makes the whole field come alive. Dow often reminded his students of Whistler's injunction that "nature is seldom right" and admonished them to recognize that "the subject is in you, nature giving only the suggestions." The result for Dow was a scene, such as this, denoting great magic and mystery and harboring untold secrets.

NEG

1. Arthur Wesley Dow, in diary kept by the artist from October 4 through December 31, 1884, entry for October 4. The diary is now on file at the Society for the Preservation of New England Antiquities, Boston.

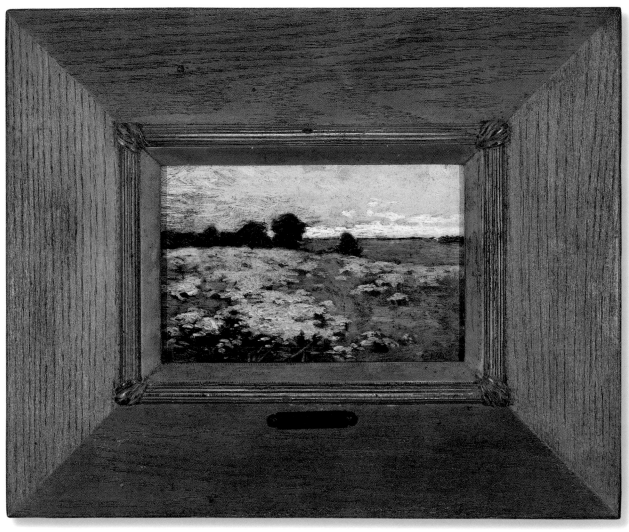

~42~

Francis Coates Jones
(1857-1932)

~43~

Mother and Daughter Playing Checkers, c. 1910

Oil on canvas

22 x 32"

Period 19th century Italian frame, carved, incised and gilded, from Eli Wilner & Company Collection

Mother and Daughter Playing Checkers demonstrates that by about 1910, Francis Coates Jones had altered both his style and his subject matter.[1] Informal scenes of domestic life, rather than detailed genre scenes such as *Candlelight Romance* (Plate 15), now occupied the artist. Although less detailed than his earlier interiors, polished wood floors, carpets, and clothing underscore the wealth of the household captured in this tableau. Both subject—interior scenes of women engaged in either leisure activities or light domestic tasks—and style—impressionist brushwork and subdued palette—reflect the cosmopolitan aestheticism associated with the work of artists such as John Singer Sargent, Edmund Tarbell, and other painters of the Boston School.

KUF

1. Doreen Bolger Burke, *American Paintings in the Metropolitan Museum of Art*, new ed., 3 vols. (New York: Metropolitan Museum of Art, 1980), vol. 3, *A Catalogue of Works by Artists Born between 1846 and 1864*, 309.

Francis Coates Jones
(1857-1932)

~44~

Tea Leaves, after 1910

Oil on canvas

30 x 35-3/4"

Period American frame, c. 1890-1900, gilded oak, applied ornament and gilded, from the Eli Wilner & Company Collection

Tea Leaves partakes of the impressionist mode that Francis Coates Jones embraced in the early years of the twentieth century with paintings such as *Mother and Daughter Playing Checkers* (Plate 43). The artist applied both pastel colors and broken brush-strokes to each compositional element, thereby flattening the sense of perspective created by both overlapping and modeling. Although Jones's later work eschewed the detailed interiors essential to sentimental genre scenes such as *Candlelight Romance* (Plate 15), his enduring interest in the decorative arts prompted him to detail the china tea service set upon the table. The artist and his brother, landscape painter Hugh Bolton Jones, collected, designed, and crafted furniture, textiles, and other objects for their studio-apartment which was featured in *Good Furniture Magazine* in 1918.[1]

KUF

1. William Laurel Harris, "Mobilizing Industrial Design: Unused Resources of American Artists," *Good Furniture Magazine: The Magazine of Decoration* 10 (March 1918): 129-148.

~44~

~*45*~

The Bathers, after 1910[1]

Oil on canvas

24-1/4 x 30-1/2"

Period American frame, c. 1910-20, carved and gilded by the Newcomb-Macklin Company, from the Eli Wilner & Company Collection

During the 1880s, Edward Henry Potthast traveled in Europe, not only learning the academic mode, but also experimenting with impressionism under the influence of Robèrt Vonnoh (Plate 18), whom he met while visiting the artists' colony at Grèz-sur-Loing in 1888.[2] Potthast adopted the impressionist mode, including high-keyed color, broken brushwork, and plein-air painting, in 1896 after moving to New York, where he also continued to illustrate popular magazines. His work as an illustrator may have prompted his series of bathing scenes featuring working class families rather than the middle- and upper-class subjects favored by many American impressionists.[3] The title, "The Bathers," functions much like the caption to an illustration, expanding the scope of the image by making an ironic reference to an exterior idea, in this case, the canonical paintings of the idealized female nude in a landscape executed by celebrated artists such as Paul Cézanne and William-Adolphe Bouguereau.

KUF

1. By 1910, Potthast was painting bathing scenes in an impressionist mode, suggesting that the artist painted *The Bathers* after 1910. See Karen Zukowski, "Edward Henry Potthast," in Annette Blaugrund, *Paris 1889: American Artists at the Universal Exposition*, exhib. cat. (Philadelphia: Pennsylvania Academy of the Fine Arts in association with Henry N. Abrams, Inc., Publishers, New York, 1989), 199.
2. Zukowski, 199.
3. Diane Smith-Hurd discusses class, leisure, and Potthast's bathing scenes in "Potthast as Impressionist and Realist," in *Edward Henry Potthast (1857-1927): An American Painter: Selections from Private Collections*, exhib. cat. (Art Academy of Cincinnati, 1994).

~45~

~46~

Lavender and Green, 1912

Oil on canvas

26 x 36"

Period American frame, c. 1900, carved and gilded

One of Dow's favorite scenes, the Blue Dragon featured in many of his paintings.[1] His home and studio on Bayberry Hill overlooked this panoramic view and inspired many of his students to try to capture this elusive subject in their own work. One of the most successful was Alvin Langdon Coburn who, in his 1903 gum platinum print called *The Dragon*, captures much of the same beauty that Dow himself endeavored to articulate. Dow painted this scene during all seasons and under all weather conditions, producing a document not unlike Cézanne's homage to Mont Ste-Victoire or Monet's visions of Rouen Cathedral.

The Blue Dragon refers to the sinuous line of the inland waterway formed twice daily with the ebb and flow of the tides, creating an island among the marshes. Helen Kimberly McElhone's poem *Dragon Creek, Ipswich*, which was probably printed by Dow's private Ipswich Press, epitomized his own feelings for the view from his studio:

> *Twice every day from that boundless main*
>
> *To lie in bondage safe and still*
>
> *And guard my house upon the hill.*[2]

NEG

1. The provenance for the painting is as follows: Artist's Estate; Sold, Estate Sale, American Art Galleries, New York, March 28-29, 1923, to Joseph Wiseltier.
2. Frederick Moffatt, "The Life, Art and Times of Arthur Wesley Dow" (Ph. D. diss., University of Chicago, 1972): 144; the poem is filed with the AWD Papers, Ipswich Historical Society.

~46~

Arthur Wesley Dow
(1857-1922)

~47~

The Unpeopled Cities: The Grand Canyon, Arizona, 1912

Oil on canvas

12 x 22"

Period American frame, c. 1910, carved and gilded

Dow first arrived in the Grand Canyon in the winter of 1911-12, accompanied by his former student, the pictorialist photographer Alvin Langdon Coburn. This trip had long been anticipated, inspired by Dow's friendship with the ethnologist Frank Hamilton Cushing. Cushing had spent five years—1879 to 1884—residing with the Zuñi and researching connections between Indian, Asian and European ideas and habits (a thesis Dow pursued in his own writing). In his sketchbook from this trip Dow noted that "the Grand Cañon and the old pines and cedars should not be painted for themselves but to express emotion. Express this emotion by mystery of line and Notan."[1] Hence a clear connection with non-western art was made.

Dow returned to the Grand Canyon in 1919, searching again for the beauty and mystery that attracted his deeply spiritual nature. In the Grand Canyon pictures Dow opened up to all the possibilities of a modernist style, using more aggressive brushstrokes and a brilliant color vocabulary, something found nowhere else in his oeuvre.

NEG

1. 1911-12 Sketchbook, unpaginated, AWD Papers, Ipswich Historical Society.

~47~

Arthur Wesley Dow
(1857-1922)

~48~

Gay Head, c. 1913

Oil on canvas

10-1/2 x 8-1/2"

Period American frame, c. 1910, carved and gilded, from the Eli Wilner & Company Collection

Dow probably made his first visit to Gay Head, at the northern tip of Martha's Vineyard, with the Farmers sometime in the early 1880s. It became a favored place, and he returned there again in 1898 with his friend, the collector and writer Denman Ross, and again in the summer of 1913.[1] Both his sketchbooks and his canvases from these trips show an increasing appreciation for the deep drifts of the dunes and the startling colors inspired by the sun at its summer peak.

Both the Grand Canyon pictures and the paintings of Gay Head reflect Dow's struggle to come to grips finally with the enigma of color. Using nature as his reference point, Dow had always approached color tentatively. In his 1913 edition of *Composition* he wrote, "Color, with its infinity of relations, is baffling; its finer harmonies, like those of music, can be grasped by the appreciation only, not by reasoning or analysis."[2] It is interesting that this admission came about in 1913, the year after the Grand Canyon paintings and the same year as a trip to Gay Head. This insight expresses just how intuitive he considered color to be and how fragile the connection with the artist.

NEG

1. Denman Ross and Dow became friends while Dow was working as assistant curator of Japanese art at the Museum of Fine Arts, Boston. Their friendship blossomed and Dow visited Ross in Venice in 1896 and the two traveled to Scituate and Gay Head in the summer of 1989. In 1912 Ross published his own version of *Composition*, entitled *On Drawing and Painting* (Houghton Mifflin) and in it he discussed many of the same issues, including line, Notan and color, without crediting either Dow or Fenollosa.
2. Arthur Wesley Dow, *Composition* (New York: Doubleday, Doran and Co., Inc., 1913), 100.

~48~

John Sloan
(1871-1951)

~49~

Sea Monsters, 1914

Oil on canvas

20 x 24"

Period American frame, c. 1915-20, carved and gilded, from Eli Wilner & Company Collection

After participating in the exhibition of The Eight (1908), in the exhibition of Independent Artists (1910), and in The Armory Show (1913), John Sloan spent five summers in Gloucester, Massachusetts, exploring his craft. Sloan saw pure landscape as an opportunity to experiment with color, line, and composition, unfettered by the constraints associated with naturalistic figural painting.[1] Painted in 1914, during his first summer in Gloucester, *Sea Monsters* demonstrates the brighter palette that he adopted as a result of his interest in Hardesty Maratta's color system. Maratta had developed a table of twelve basic colors that the painter could use to determine complementary hues as well as pigment saturation.[2] The fanciful title of this image suggests that the artist invested this coastal scene with the narrative element that often characterized both his illustrations and his figural paintings.

KUF

1. *John Sloan: The Gloucester Years*, exhib. cat. (New York: Kraushaar Galleries, Inc., n.d.).
2. For brief discussions of Maratta's system, see both *John Sloan: The Gloucester Years,* n.p; and Matthew Baigell, *A Concise History of American Painting and Sculpture* (New York: Harper & Row, 1984), 199.

\mathcal{T}heodore Wendel

(1859-1932)

~50~

Ten Pound Island, Gloucester, c. 1915

Oil on canvas

30 x 36"

Contemporary Eli Wilner & Company replica of a Foster Brothers frame, c. 1910, applied ornament and gilded

Ten Pound Island, Gloucester demonstrates the enduring influence of Theodore Wendel's early contact with impressionism. The high horizon line characteristic of many impressionist compositions focuses attention upon the foreground, where scattered fishing tackle creates a still life composition framed by the intensely colored landscape. Wendel, who arrived in Giverny in 1886, numbered among the first Americans to study the impressionist mode with Claude Monet.[1] In 1898, Wendel and his family settled in Ipswich, Massachusetts, where the artist continued painting while his wife, Philena Stone, ran the farm she had inherited from her father. During the next fifteen years, he produced some of his most acclaimed canvases, many of either Ipswich or Gloucester subjects.[2] Wendel probably painted *Ten Pound Island, Gloucester* during this period.

KUF

1. John I. H. Baur, *Theodore Wendel: An American Impressionist, 1859-1932*, exhib. cat. (New York: Whitney Museum of American Art, 1976); Baur, "Introducing Theodore Wendel," *Art in America* 64 (November-December 1976): 102-105.
2. Wendel won the Sesnan Medal for landscape painting from the Pennsylvania Academy of the Fine Arts in 1909, a bronze medal at the International Exposition in Buenos Aires in 1910, and a silver medal at the Panama-Pacific International Exposition in 1915. After 1917, he painted little due to illness.

~50~

Louis Ritman
(b. Odessa, Russia, 1889-1963)

~51~

Spring in the Valley, c. 1916

Oil on canvas

26 x 32"

Period American frame, c. 1915-20, carved and gilded by the Newcomb-Macklin Company, from the Eli Wilner & Company Collection

Louis Ritman first studied in Chicago before traveling to Europe where he, and fellow Midwesterners such as Frederick Frieseke and Lawton Parker, constituted the second generation of American expatriate painters who settled in Giverny, home of Claude Monet. Most of the first generation, including Willard Metcalf (Plates 21, 35) and Theodore Wendel (Plate 50), had left Giverny by 1890, making way for a group more interested in the figure than in the landscape, and more influenced by both Auguste Renoir and Paul Cézanne than by Monet.[1] Ritman probably painted this work around 1916, the year he eschewed academic painting principles in favor of impressionist techniques, characterized by expressive brush work, pure color, and an overriding interest in light.[2] His paintings from this time exhibit both a distinctive pink and lavender palette, and the use of both brushwork and color to create an all-over pattern which renders the canvas more decorative object than representational image.

KUF

1. William H. Gerdts, "Giverny: The Second Generation," in *American Impressionism* (New York: Abbeville Press, 1984), 261-273.
2. Richard H. Love, *Louis Ritman, from Chicago to Giverny: How Louis Ritman Was Influenced by Lawton Parker and Other Midwestern Impressionists* (Chicago: Haase-Mumm Publishing Company, 1989), xiv.

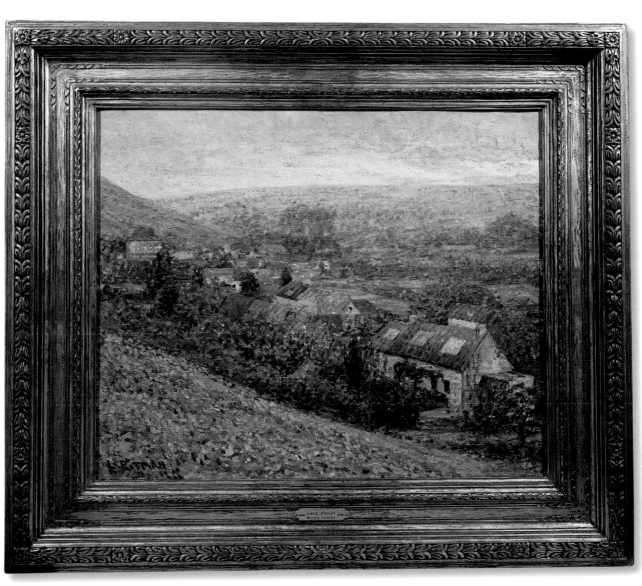

~51~

Reginald Marsh
(1898-1954)

~52~

Golf Course Scene, 1922

Oil on canvas, three panels

72 x 75"

In 1920, Reginald Marsh graduated from Yale University, where he had majored in art and had drawn caricatures of campus life for the Yale *Record*, a humor magazine. The artist—perhaps best known for "the Marsh girl," the voluptuous shopper who dominated his urban realist paintings of working-class Manhattan—began his career as an illustrator for publications such as *Vanity Fair, The New Yorker,* and the *New York Daily News*.[1] *Golf Course Scene* drew upon both his upper-middle-class background and his experience in illustration. Marsh established the composition with pencil; and line, rather than either color or modeling, delineates the golfers, who variously stride across the grounds of the country club, hunt for lost balls, or tipple in the bushes. Close examination of the surface will reveal at least three instances where the artist sketched in a figure, but neglected to flesh out the caricature with the oil wash.

KUF

1. For a discussion of the Marsh girl, see Ellen Wiley Todd, *The "New Woman" Revised: Painting and Gender Politics on Fourteenth Street* (Berkeley: University of California Press, 1993).

Robert Brackman
(b. Odessa, Russia, 1898-1980)

~53~

Lady Seated in a Restaurant, 1927

Oil on canvas

28 x 22"

Contemporary Eli Wilner & Company replica of an American period frame by Yates, c. 1920s, carved and gilded

Both the model's costume, including the mannish tie, and the urban scene framed by the window cast her in the role of office worker, one of the many single woman who undertook clerical work between school and marriage. Most of these women belonged to the working class, but through interaction with their better-educated superiors could transcend social background and achieve middle-class status.[1] Although the setting partakes of the urban realist mode popular between the world wars, other features demonstrate the artist's overriding concern with painterly problems, rather than with social documentation. For example, the tilted table and still life with apple, teacup, and vase pay homage to Paul Cézanne, as do the fractured and melded planes that constitute the room's corner. Critics routinely praised Brackman's command of both academic and modernist modes, as well as his draftsmanship.[2]

KUF

1. For a discussion of the representation of the female office worker in the interwar years, see Ellen Wiley Todd, "Isabel Bishop: The Question of Difference," *Smithsonian Studies in American Art* 3 (Fall 1989): 25-41.
2. "Brackman Wins High Praise of the Critics," *Art Digest* 8 (1 December 1933): 39; Malcolm Vaughan, "Robert Brackman," *Creative Art* 12 (April 1933): 276-283.

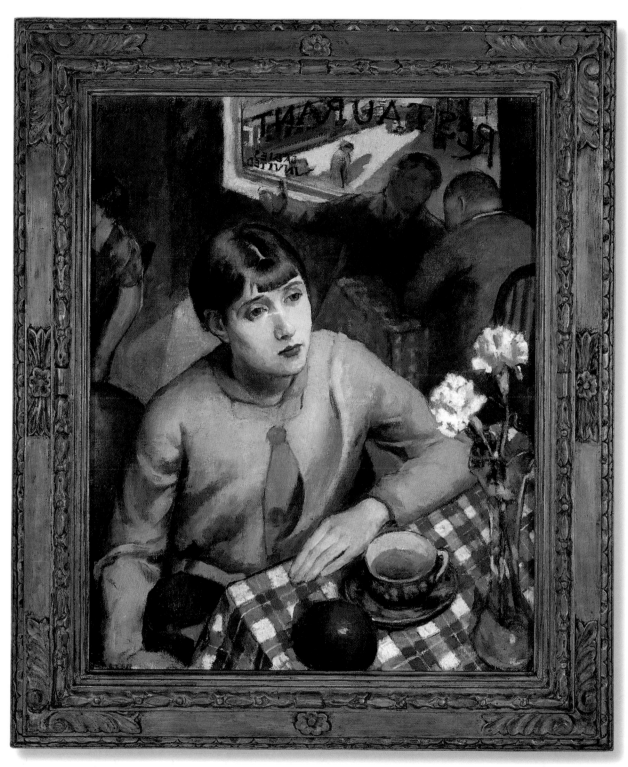

Edward Dufner
(1872-1957)

~54~

Golden Days, 1928

Oil on canvas

54 x 54"

Period American frame, c. 1910, carved and gilded, from the Eli Wilner & Company Collection

Of *Golden Days*, painted in Boothbay Harbor, Maine, near his summer home, Edward Dufner said: "My first thought was to give expression to the joy children feel in the movement and abandon of the game 'Ring Around the Rosy.'"[1] Drawing upon impressionist techniques, he reinforced the movement suggested by the composition with distinct, diagonal brushstrokes of pure color. He had adopted the impressionist mode around 1910, using both the high-keyed palette and the broken brushwork to create a popular series of images of women and children enjoying the sunsplashed countryside, often near a lake.[2] A comparison of *Golden Days* with Georges Schreiber's painting, *Night Haul, Boothbay Harbor, Maine* (Plate 59), demonstrates the divergent artistic modes which characterized twentieth-century American art after The Armory Show (1913) had introduced many American artists, collectors, and critics to neoteric, European movements such as expressionism and cubism.[3]

KUF

1. Sotheby's, New York, *American Paintings, Drawings and Sculpture*, auction cat. (30 November 1989), lot 216.
2. *Edward Dufner, American Impressionist, 1872-1957*, exhib. cat. (New York: David Findlay, Jr., Inc., n.d.).
3. For a discussion of The Armory Show and its influence upon American art, see Meyer Schapiro, "The Introduction of Modern Art in America: The Armory Show," in *Modern Art, 19th & 20th Centuries: Selected Papers* (New York: George Braziller, 1978), 135-178.

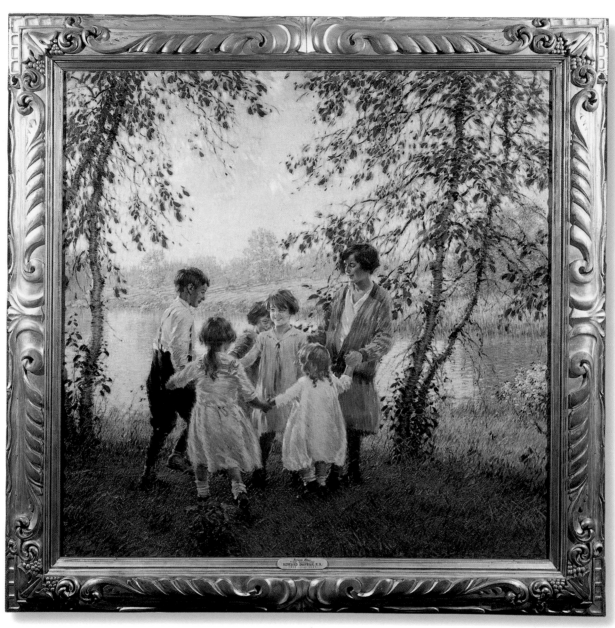

Margarett Williams Sargent
(1892-1978)

~55~

Bathers, 1929

Oil on canvas

31 x 38-1/4"

Period American frame, c. 1930s, applied ornament and gilded, from the Eli Wilner & Company Collection

Margarett Sargent's brief artistic career began in 1916 and ended in 1936. During those years, she studied painting with George Luks (Plat 33), mounted nine solo shows, and participated in thirty-four group shows. *Bathers* demonstrates her dedication to modernism, an artistic practice that prioritizes the purification of artistic form over subject matter. Sargent cropped the bather's bodies, pulling abstract shapes from the vibrant suits, the pale limbs, the dark hair, and the summery sky. Of her artistic method she said: "The greater the complication, the clearer the drawing it necessitates. Simplification . . . exceeds the opening of a window in stifling air."[1] Despite her professional successes, the artist was best known for her colorful life: born into a wealthy Boston family, she married well, had affairs with both men and women, lived abroad, collected modern art, threw lavish parties, and numbered among her friends artists, celebrities, and social luminaries.[2]

KUF

1. *Margarett Sargent: A Modern Temperament,* exhib. cat. (Wellesley, MA: Davis Museum and Cultural Center, Wellesley College, 1996).
2. See also *Margarett Sargent*, essay by Linda Nochlin, exhib. cat. (New York: Berry-Hill Galleries, 1996); Honor Moore, *The White Blackbird: A Granddaughter's Life of the Painter Margarett Sargent* (New York: Viking, 1996).

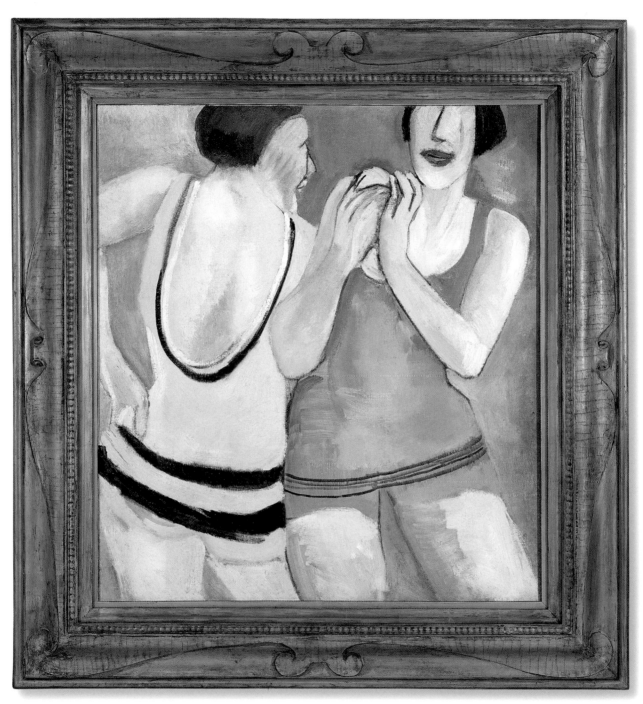

Doris Lee
(1905-1983)

~50~

Orchard, 1932

Oil on canvas

20 x 30"

Contemporary Eli Wilner & Company replica of an American period frame by George Of, c. 1910, carved and gilded

In this early painting by Lee, executed three years before her career would take off with the success of *Thanksgiving* and the accompanying conflict it stirred at the Art Institute of Chicago, the artist sets out to capture her impressions of a field in Woodstock, New York. In 1946, Lee states, in reference to this painting, that "I enjoy people, the orchard and garden, watching birds, collecting shells, stones and butterflies and many other things."[1]

After studying in Paris, Kansas City and San Francisco, Lee and her first husband, the photographer Russell Lee, moved to the tiny artist colony of Woodstock in 1931. In Woodstock, the couple joined many other artists, including (Lee's soon-to-be second husband) Arnold Blanch, Lucille Blanch, Konrad Cramer. Similar to its current reputation, Woodstock enjoyed the position as an oasis for artists. New York City's Art Students League offered classes in Woodstock, and the town emerged as a center for the visual arts during the 1930s. From the Maverick concerts founded in the first decades of this century onward, Woodstock attracted attention for its acceptance of all types of people.

TDS

1. *Doris Lee* (New York: American Artists Group, 1946), n.p.

~56~

~57~

August Afternoon, 1936

Oil on canvas

38 x 50"

Contemporary Eli Wilner & Company replica of an American frame by the Newcomb-Macklin Company, c. 1910, carved and

gilded

August Afternoon stands as a prototypical work by Doris Lee. The easy readability, the focus on human interaction amidst a rural

setting and a concentration on the world of women characterize Lee's output during the later 1930s and the 1940s. In this

instance, the doyenne of the American Scene painters captures the life of a farmer's wife and daughter. The gracefulness of the

woman and the *joie de vivre* of the daughter are offset by nature and the chores which await the elder figure. By placing such

work within the setting of nature, the painting also seems to shore up gender roles, suggesting that this is a "natural" place for

the women and that the transmittal of such practices and ideologies will easily pass from one generation to another. Lee herself

wrestled with the place of the woman within society, presenting herself at different times as both feminist and anti-feminist.

TDS

~57~

Joseph Hirsch
(1910-1981)

~58~

Hercules Killing the Hydra, 1937

Oil on panel

11 x 8"

Modern period frame

Joseph Hirsch, who studied with George Luks (Plate 33), painted in a social realist mode that exaggerates the human form in order to make political statements about iniquitous social relationships.[1] In this image, the artist used Greek mythology to express support for the contemporary labor movement. With conscious irony, Hirsch cast the policemen in the role of Hercules, the hero who completed twelve labors as a penance for slaying his own children; and the many-headed, many-armed worker in the role of the Lernaean hydra, the seven-headed water-snake who ravaged Lerna until vanquished by Hercules, symbolizing the triumph of right over wrong. In the artist's version of this myth, however, the policeman appears as a monstrous abuser of the authority embodied in both the uniform and the weapon. The worker, denigrated by contemporary anti-labor sentiment as an evil worthy of Hercules, splays upon a placard declaring "we want," his many arms struggling to ward off the blows.

KUF

1. *Joseph Hirsch*: *Recent Paintings and Drawings*, exhib. cat. (New York: Forum Gallery, 1969); *Joseph Hirsch*, essay by Frank Getlein, exhib. cat. (Athens, GA: Georgia Museum of Art, University of Georgia, 1970); *Joseph Hirsch: Recent Paintings*, exhib. cat. (New York: Kennedy Galleries, 1976); *Joseph Hirsch: Recent Paintings and Drawings*, exhib. cat. (New York: Kennedy Galleries, 1980).

~58~

203

~59~

Night Haul, Boothbay Harbor, Maine, 1939

Oil on canvas

41 x 56"

Contemporary Eli Wilner & Company replica of a 1920s frame, carved and stained surface

Like many regionalist artists, Georges Schreiber traveled across the United States, painting and sketching typical American scenes and, in his own words, "documenting with my work my chosen country."[1] In Boothbay Harbor, Maine, the artist sailed on a fishing boat in order to apprehend the fisherman's experience. As with *I Raise Turkeys and Chickens* (Plate 62), he both generalized and idealized his subjects, emphasizing the work-hardened arms which strain to set the nets. An eerie, acidic light suffuses the scene and implies drama as well as danger. Of that glow Schreiber said:

> *Suddenly the magic night was transformed into an unreal brilliance by the glitter of countless thousands of small herrings, whipping up the calm waters as the nets hit the surface. It was this strange night light effect, mixed with the phosphorescence of the sea, which created the light in my painting.*[2]

KUF

1. *Georges Schreiber: Watercolors, 1969-1970*, exhib. cat. (New York: Kennedy Galleries, 1970).
2. Grace Pagano, *Contemporary American Painting: The Encyclopædia Britannica Collection* (New York: Duell, Sloan & Pearce, 1945), cat. no. 98.

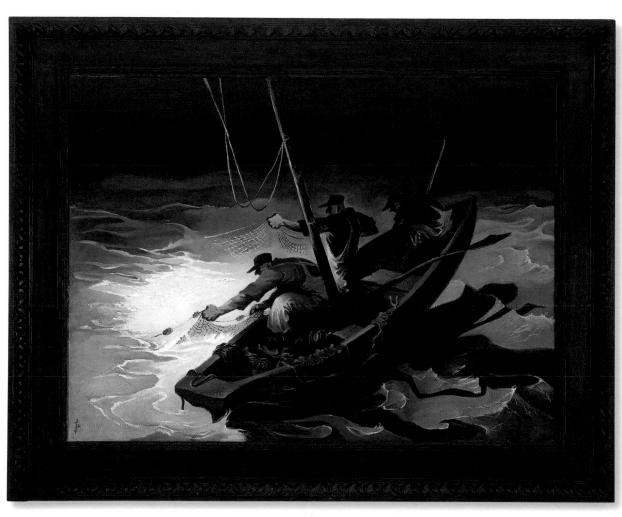

Robert MacDonald Graham, Jr.
(b. 1919)

~60~

Jessie and Greenberry Ragan, 1940

Egg tempera on panel

36 x 48"

Replica of an American modernist style frame, c. 1940, carved, incised and painted

While a student at the Kansas City Art Institute, Bob Graham exhibited *Jessie and Greenberry Ragan* at the 1940 Mid-Western Regional Exhibition. Although the judges wanted to reject the painting, Graham's teacher, Thomas Hart Benton, demanded its inclusion and Henry Haskill, art critic for the *Kansas City Star*, praised it as evidence of "a new talent worth watching." The art critic did, however, criticize the red drapery behind Greenberry Ragan, stating that it "looks as if it might have been left behind by an absent-minded interior decorator."[1] After the exhibition, Graham scraped out the red drapery and replaced it with the begonia on the plant stand. For over forty years, this painting hung in the dining room of the artist's family home in Kansas City. "It was," he wrote, "part of what made it just that—home."[2]

KUF

1. Exhibition review, 9 February 1940; quoted in Marianne Berardi, *Under the Influence: The Students of Thomas Hart Benton*, exhib. cat. (St. Joseph, MO: Albrecht-Kemper Museum of Art, 1993), 80.
2. Letter from Robert MacDonald Graham, Jr., to Jim Dicke, II, 16 April 1990.

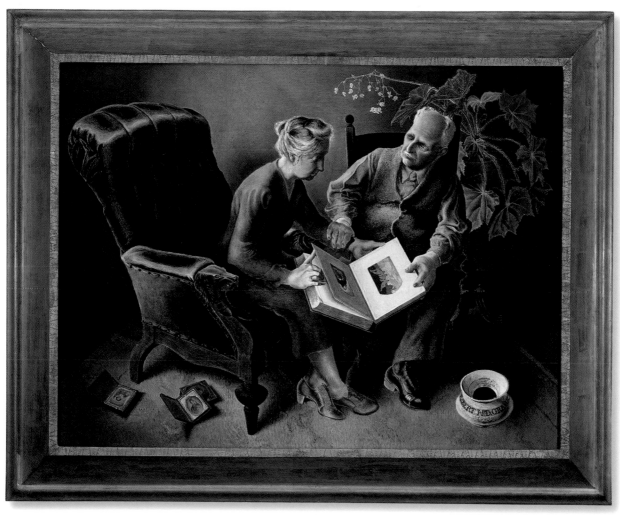

~60~

<p style="text-align:center">
Doris Lee

(1905-1983)
</p>

~61~

Johnny Appleseed, c. 1940

Oil on canvas

36 x 42"

Contemporary Eli Wilner replica of an Americam period frame by Max Kuehne, c. 1920-30, silver gilded with incised surface decoration

First exhibited at the Carnegie Institute Annual Exhibition in 1940, Lee's painting of Johnny Appleseed reflects a growing cultural interest in this mythical figure of agricultural beneficence. Born Jonathan Chapman in Leominster, Massachusetts in 1774, the character better known by his sobriquet Johnny Appleseed joined the ranks of folk figures whose actual lives were investigated during the 1930s and 1940s.[1]

Account after account chronicled the real-life adventures of Chapman from his early days in Massachusetts to his life in the Ohio and Indiana regions. While today most remember Appleseed for his distribution of apple seeds and the establishment of orchards, the interest in him during the 1930s and 1940s resulted in a more complete picture of the man. For example, he was instrumental in the dispersal of the tenets of Swedenborgian philosophy throughout the Midwest.

Often presented as the American pioneer sower, Lee chooses a different setting for America's premiere orchardist. Most representations, both visual and literary, paint a different picture of the man, often without shoes and wearing a sack as his only piece of clothing.[2] Lee provides the viewer one of the most cleaned up and domesticated images of the character.

TDS

1. In a period when the stakes were high for the codification of national heroes, the intense scrutiny placed on the real life of Chapman resulted in such declarations as a 1936 *New York Sun* headline: "Johnny Appleseed, A Fact, Not Fiction." With the debunking of fictional national myths during the 1920s coupled with the emphasis which the leftist organizations, primarily the Communist Party of the United States, placed on establishing their lineage within a tradition of American history and with the mounting fears of international crisis, it is not surprising that many factions fought for the rights to certain national figures, both real and fictive.
2. The New York World's Fair in 1939 featured a sculptural group by Edward Amateis and a figural work by Anna Coleman Ladd depicting Appleseed. Lee's colleague, Anton Refreger, executed a mural of the legendary journeyman in a Plainfield, New Jersey post office.

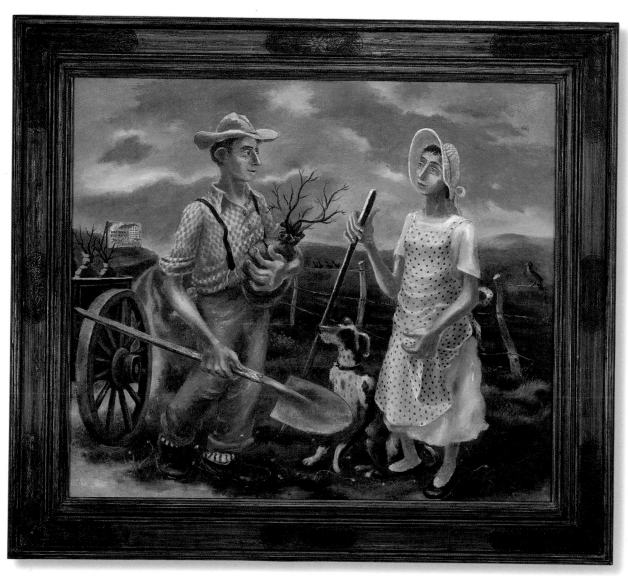

Georges Schreiber
(b. Brussels, Belgium, 1904-1977)

~62~

I Raise Turkeys and Chickens, 1942

Oil on canvas

24 x 20"

Contemporary Eli Wilner & Company replica of an American frame, c. 1910, carved and gilded

Although both born and trained in Europe, Georges Schreiber adopted the style as well as the subject matter associated with the regionalist folk aesthetic which flourished in America between the world wars. Regionalist artists sought to document both native landscape and indigenous character, and believed that agrarian culture had sustained the moral values needed to reform contemporary American society. *I Raise Turkeys and Chickens* offers not a portrait, but a type, the hard-working and work-worn woman whose relationship with the land has served as a source of both strength and pride. Accordingly, Schreiber highlighted not only her shadowed and impassive face, but also the strong forearms and swollen knuckles that attest to her productive labor. Borrowing a camera angle from contemporary film, he monumentalized his subject who stands steadfast before the wind which bends the cornstalks around her.[1]

KUF

1. Erika Doss discusses the relationship between regionalist style and popular culture, including film and advertising, in "The Art of Cultural Politics: From Regionalism to Abstract Expressionism," in *Recasting America: Culture and Politics in the Age of Cold War*, ed. Lary May (Chicago: University of Chicago Press, 1989), 195-220.

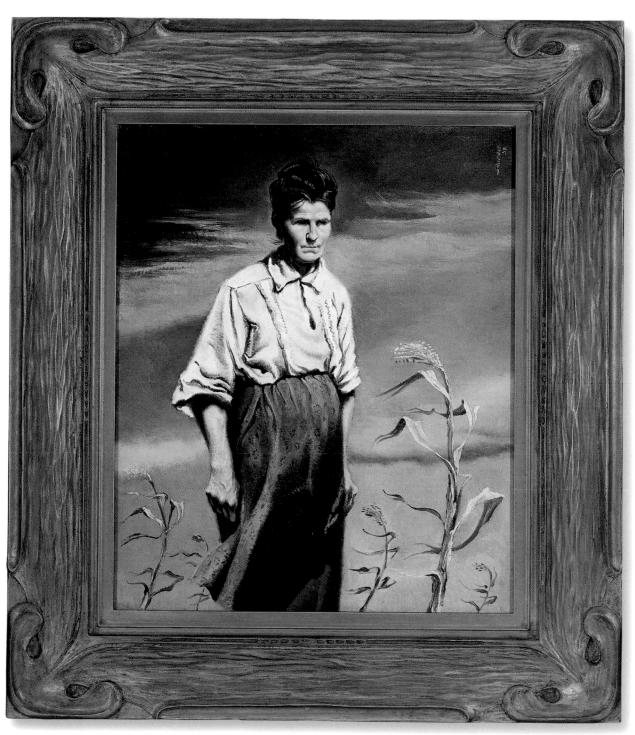

211

Doris Lee
(1905-1983)

~63~

Fox and Geese, n. d.

Oil on canvas

34 x 24"

Period American frame, c. 1940, carved and painted, from the Eli Wilner & Company Collection

The title of this painting refers to the popular children's game. In this activity, one character adopts the persona of a fox and chases the other players who are the geese. The action takes place around the rim and on the spokes of a wheel-shaped outline drawn in the snow.

Due to her subject matter and style, Lee was often compared to Grandma Moses. While both artists did focus on the pleasures of rural, uncomplicated life in a rather schematized manner, distinctions were made between the untutored background of Moses and the highly educated pedigree of Lee. In the end, though, many viewers during the 1940s saw these two women artists as part of the same interest on behalf of contemporary artists and the public in primitive and naive art.

Like many of Lee's images, this painting captures the joys of childhood and innocence. Yet, Lee often resisted the characterization that her art was untroubled, attempting, instead, to introduce a "sense of violence into her works." To this effect, we might consider how the childlike bliss is offset by the approaching hunter and by the upturned perspective of the canvas.

TDS

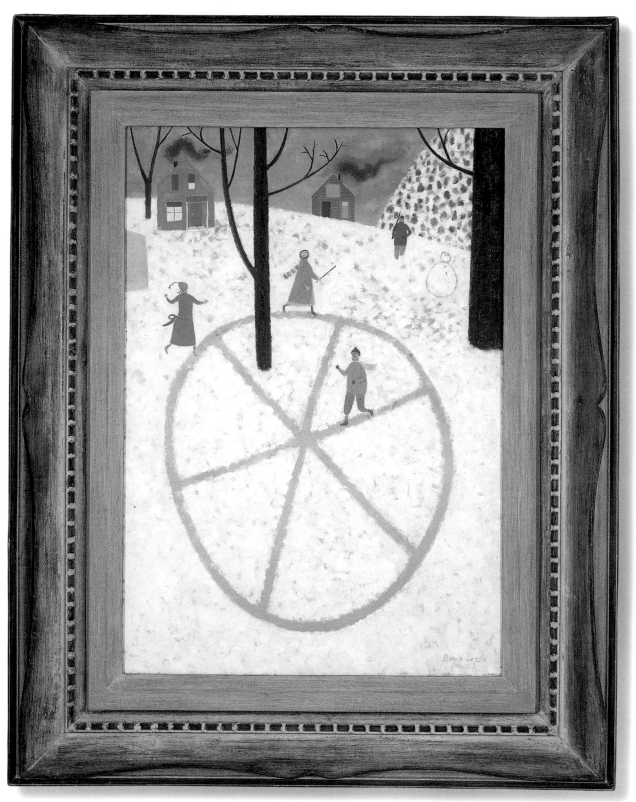

~64~

Harvest Time, 1945

Oil on canvas

28 x 24"

Contemporary Eli Wilner replica of an American period frame, by the Newcomb-Macklin Company, c. 1910, carved and gilded

Beginning in 1945, the United States Brewers Foundation, representing an industry struggling to improve its market share in face of a heavy tax burden and competition from soft drinks, embarked upon an active advertising campaign to increase the sales and reputation of beer. The organization commissioned many of the country's leading representational artists to produce imagery to be used in a national attempt to attract drinkers, eventually offering prints, "suitable for framing," to its customers. Lee, no stranger to the world of advertising, was one of the first artists sought by the Foundation and its advertising agency, J. Walter Thompson. The copy for the published advertisement reads:

> *Neighbors sharing the toil and feast of a Kansas harvest— family fun and frolic at a seaside amusement park . . .*
> *lovers dreaming to the music of a starlight concert . . . all these are America, the land we love, the land that today*
> *we still are fighting for.*
> *In this America of tolerance and good humor, of neighborliness and pleasant living, perhaps no beverage more*
> *fittingly belongs than wholesome beer. And the right to enjoy this beverage of moderation . . . this, too, is part of*
> *our own American heritage of personal freedom.*

Harvest Time presents Lee's stock-in-trade composition and style and cloaks the serving of beer amidst a stagelike grouping of folksy props in an attempt to position beer as a wholesome all-American potable.

TDS

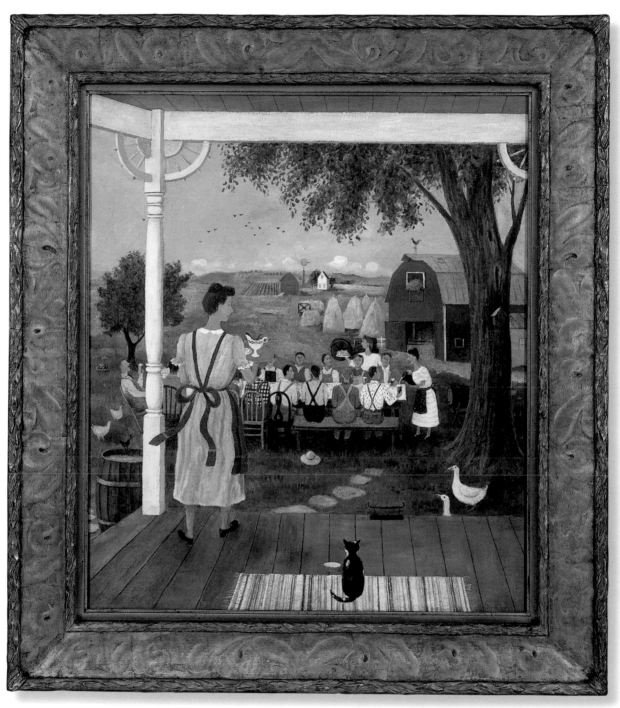

~64~

~65~

Haying, 1948

Oil on canvas

22-1/4 X 34-1/8"

Period American frame, modernist style, c. 1930s - 40s, painted and rubbed surface

Born on his father's grain and livestock farm in David City, Nebraska, Dale Nichols drew upon his rural roots for his subject matter, depicting the diurnal and seasonal activities that regulate agrarian life. Like other regionalist artists, Nichols wanted to make fine art accessible to the broader American public, and to this end painted typical American subjects in a naturalistic mode that rejected European influences. In addition, he advocated the use of fine art in both advertising and commercial illustration, an endeavor that would not only make such images more available, but also forge a stronger connection between the artist and society. Nichols, who had worked as a commercial artist, welcomed the reproduction of his paintings for promotional items such as the plastic and aluminum serving trays that General Mills, Inc. offered to purchasers of Gold Medal Flour.[1]

KUF

1. Nichols outlined his philosophy in a flier that accompanied a serving tray bearing a reproduction of his painting, *Company for Supper*, copyright 1947 (tray and flier, collection of the author).

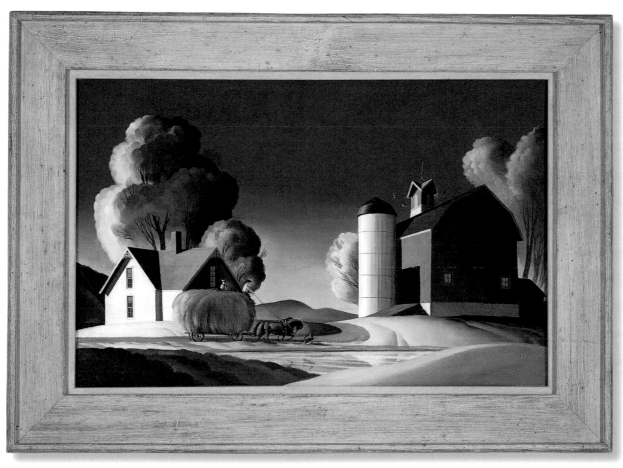

~65~

\mathcal{D}oris Lee
(1905-1983)

~07~

The Bather, 1950

Oil on canvas

35-1/2 x 28-1/2"

Replica of a modern period frame, c. 1950s

Doris Lee, along with her husband Arnold Blanch, divided her time from the 1940s onward between Woodstock, New York and

Florida, primarily Key West. What characterizes her imagery produced after trips to the Sunshine State is a higher-keyed palette,

more abstract translations of the landscapes and even more schematized figural representations. In more than her other works,

her Florida canvases and prints demonstrate Lee's fascination with the most current artistic innovations. One critic has noted

that "Lee transforms Rothko-like abstractions into lighthearted landscapes, populated with Picassoesque bathers and Matissean

palm trees. A sprinkling of Gottlieb's color doodles are strewn around for spice."[1]

TDS

1. Thomas W. Styron, *Doris Lee: The Florida Paintings*. exhib. brochure (Greenville, SC: Greenville County Museum of Art, n.d.), n. p.

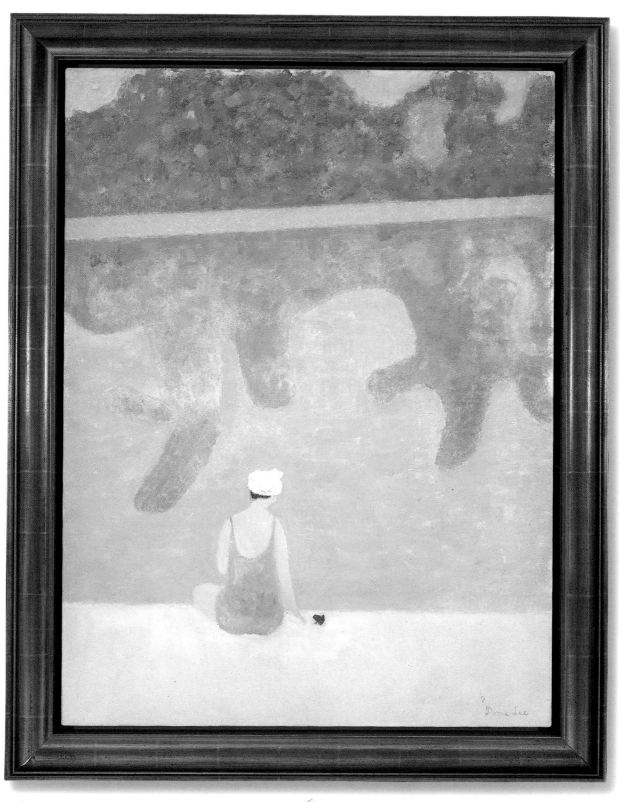

Andy Warhol
(1928-1987)

~68~

Printed Dollar, 1962

Acrylic on canvas

4-3/4 x 9-7/8"

Period American frame, c. 1880-90, applied ornament and gilded, from the Eli Wilner & Company Collection

Around 1960, Andy Warhol, having received numerous awards as a commercial artist, focused on a career as a fine artist.[1] A graphic sensibility continued to shape his works, which challenged prevailing ideals of both creativity and originality. *Printed Dollar* suggests that creativity and originality inform not only artistic production, but also mechanical reproduction, thereby undermining the conventional notion that commercial art, such as currency design, cannot achieve high-art status. Warhol simplified the dollar's design in order to emphasize both the portrait—a traditional, fine-art subject—and the official signatures—established proof of authenticity. The messy, blurred letters and numbers not only confirm that mechanical reproduction produces a series of impressions, each unique; but also mock the assumption that uniqueness, as a measure of either originality or monetary value, behooves the fine arts alone.

KUF

1. Jesse Kornbluth, *Pre-Pop Warhol* (New York: Panache Press at Random House, 1988).

~68~

Fairfield Porter
(1907-1975)

~69~

The Desk, 1963
Oil on canvas
28 x 22"

Period American frame, c. 1920s, carved and gilded, from Eli Wilner & Company Collection

Essentially self-taught, Fairfield Porter modeled his subject matter upon the *intimiste* works of Edouard Vuillard, and his gestural style upon that of his friend, Willem de Kooning, the abstract expressionist most dedicated to figural representation. Porter wrote, "When I paint I try not to see the object as what it is; I try to see only very concrete shapes which have no association except as themselves."[1] *The Desk* makes evident his dedication to painterly concerns: a familiar, domestic setting serves as the pretext for the exploration of the medium. Blocks of color, at once abstract and representational, interlock upon the canvas, thereby demonstrating the component parts of representation, while affirming the flatness of the support. Dubbed the last American impressionist, he used color to convey the quality of light. Here, gray, a favored color, predominates, and, like a pearl, sustains the soft sunlight seeping through the sheers.

KUF

1. Letter to Allen C. Dubois, 8 April 1963; quoted in *Fairfield Porter: An American Painter*, exhib. cat. (Southampton, NY: The Parrish Art Museum, 1993), 77.

~69~

Joan Mitchell
(1926-1992)

~70~

Untitled triptych, late 1960s

Acrylic on canvas, three panels

12-1/2 x 27-7/8"

Contemporary Eli Wilner & Company replica of a 1930s silver leaf frame

Critics numbered Joan Mitchell among the second generation of abstract expressionists, although she rejected "action painting" as a description of her method, asserting that her compositions resulted from design, rather than chance.[1] The artist, who trained at the Art Institute of Chicago with Louis Ritman (Plate 51), used abstraction to represent the feeling-states induced by landscapes.[2] Throughout her career, Mitchell employed the multiple-panel format which enabled her both to increase the scale of the work, and to introduce the vertical line dividing the panels as a compositional element. The three panels of this untitled triptych, inscribed "To my sister Jackie, Love J" on the reverse, structure the viewer's experience by suggesting not only a linear narrative when read left to right, but also the interdependence of the panels when viewed as a whole. The triptych format also evokes medieval and Renaissance altarpieces, an association that not only lends authority, but also underscores the presence of content.[3]

KUF

1. Francoise S. Puniello and Halina Rusak, *Abstract Expressionist Women Painters: An Annotated Bibliography* (Lanham, MD: Scarecrow Press, 1995), 287.
2. Marcia Tucker, *Joan Mitchell*, exhib. cat. (New York: Whitney Museum of American Art, 1974), 8.
3. For a discussion of the Mitchell's multiple format and its meaning, see Judith E. Bernstock, *Joan Mitchell*, exhib. cat. (New York: Hudson Hills Press in association with the Herbert F. Johnson Museum of Art, Cornell University, 1988), 89, 119-120; Tucker, 14.

~70~

Raphael Soyer
(1899-1987)

~71~

Woman Biting Her Nails, c. 1972

Oil on canvas

40 x 32"

Contemporary Eli Wilner & Company replica of a mid-20th century American frame, applied ornament and gilded

Widely regarded, along with his brothers, Moses and Isaac, as a leader in the art of urban realism in the 1930s and 1940s, Raphael Soyer continued to produce art through the 1970s. In general, his style focused on the close analysis of the human condition, representation tinged with an exploration of the subject's psyche. At the same time as this painting, one critic noted of Soyer that "he applies his stupendous skills to rendering likenesses of the souls of men and women he has observed with warmth and sympathy."[1] While painting from a live model, Soyer makes the female not a particular portrait image but a more generalized and universal figure, capturing what he calls the subject's character, its reality.

Quoted in the wake of this painting's exhibition at the Forum Gallery in 1972, Soyer emphasizes his interest in this psychological aspect of his art. He states that "the psychological element, for which I so admire Degas, is not found in either formalistic Oriental painting or any kind of abstract art, which may be the reason for my not being involved with them, esthetic and beautiful though they may be."[2]

TDS

1. Alfred Werner, "Raphael Soyer," *Art News* 71 (November 1972): 80.
2. Israel Shenker, "Raphael Soyer: 'I Consider Myself A Contemporary Artist Who Describes Contemporary Life,'" *Art News* 72 (November 1973): 56.

Paul Giovanopoulos
(b. Kastoria, Macedonia, Greece, 1939)

~72~

Button Up B, 1989

Mixed media on canvas

60 x 45"

Contemporary frame

Paul Giovanopoulos uses both repetition and reproduction to challenge the status accorded museum masterpieces. In each of twenty-five squares, the suit functions as a screen upon which to project motifs derived from artists ranging from Henri Matisse to Jasper Johns, from Salvador Dali to David Hockney. As a symbol, rather than a screen, the suit evokes both the corporate authority wielded by museums, and the reproduction of art icons upon book bags, T-shirts, coffee mugs, and other consumer goods which enable the viewer to own the copy, if not the original. The artist assumes that the viewer—who has gleaned art historical knowledge from both the media and the marketplace—will understand some, if not all, of these visual references.[1]

KUF

1. *Paul Giovanopoulos*, exhib. cat. (New York: Louis K. Meisel Gallery, 1990).

\mathscr{S}am Gilliam
(b. 1933)

~73~

Cyclone, 1991

Acrylic on canvas

55 x 38 x 6"

In 1970, critic Barbara Rose identified Sam Gilliam as "[a] leading member of the Washington school of color painting," a mode of abstract expressionism.[1] Gilliam uses color and shape, scale and texture to demarcate the boundaries of his medium. Like the draped canvases for which he is best known, *Cyclone* challenges the flatness that, according to formalist critics, differentiates painting from any other medium.[2] The geometric elements inscribed upon the surface, as well as the shaped support, assert flatness; yet the free-form, sculptural skin, as well as the overlapping triangles, declare depth. Motion, implied by the apparent slippage between the two panels, connotes density and mass, both sculptural, rather than painterly, qualities. The title not only intensifies the perception of motion, but also affirms the life-cycle of Gilliam's work: "Eleven years ago, coming off the flat surface was exciting. Now I'm discovering how exciting being flat is again."[3]

KUF

1. "Black Art in America," *Art in America* 58 (September 1970): 57.
2. See, for example, Michael Fried, *Three American Painters*, exhib. cat. (Cambridge, MA: Fogg Art Museum, Harvard University, 1965).
3. Quoted in John Strand, "Flat Out," *Museum & Arts* 7 (May-June 1991): 59.

Julian Lethbridge
(b. 1947)

~74~

Untitled, 1991

Oil on canvas

30 x 23-5/8"

In the wake of conceptualism and other art movements which have challenged the dominance of painting within contemporary art and the critics who have championed this shift away from conventional canvas work, artists such as Julian Lethbridge have revisited the questions of the medium's formal qualities. According to one critic, Lethbridge is part of a group of painters who "attempt to recapture the vitality of abstract expressionism, using painting to create complex visual, emotional and tactile sensation in the viewer."[1] Based on the motif of broken glass, *Untitled* pays homage to the movement and vitality of Jackson Pollock's drip paintings, while also foregrounding the physicality of the creative act.

This work was created during Lethbridge's sabbatical at a studio in Rome funded by art dealer Barbara Gladstone. Operated from 1989 to 1991, this venture provided twelve artists, including Cindy Sherman, Richard Prince and Gary Hume, an opportunity to create far from the pressures of everyday life.

TDS

1. Quoted in Mark Selwyn, "Three Painters. The Pursuit of Formal, Optical and Tactile Investigations." *Flash Art* n. 149 (November-December 1989): 126.

~74~

David Humphrey
(b. 1955)

~75~

First Supper, 1992

Oil on canvas

72 x 82"

David Humphrey, a neo-surrealist, makes the familiar strange by introducing disquieting elements into generic scenes derived from family photographs.[1] In *First Supper*, one of a series based on his parents' wedding album, he uses foreign elements to highlight the relationships between the four guests seated at the banquet table. Described by the artist as an "cardio-ornamental blob," the icy blue line reinforces the horizontal momentum created by the three guests who look outside the frame.[2] The nine brown, parodic heads not only link the laughing guests, but also bring the number of heads to thirteen, suggesting a parallel between the newlywed's first supper and the Last Supper. The flash hovering above the central figure betokens the gaze of the photographer, who, like the viewer, observes the wedding supper from a distance, not unlike the woman who stares disconsolately at her plate.

KUF

1. Dan Cameron, "Neo-Surrealism: Having It Both Ways," *Arts Magazine* 59 (November 1984): 68-72.
2. Elaine A. King, "Interview," in *David Humphrey: Paintings and Drawings, 1987-1994*, exhib. cat. (Cincinnati, OH: Contemporary Arts Center, 1995), 12.

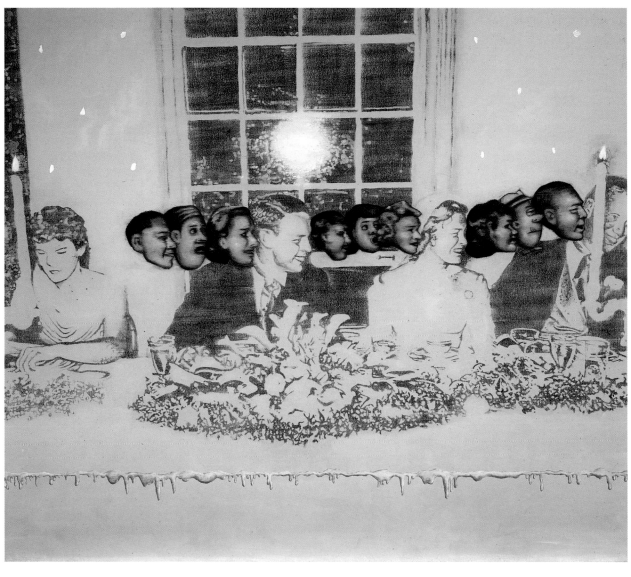

~75~

~76~

Full Dress A Coat, 1993

Oil on board

35 x 24"

To state the obvious, Otto Duecker explores the conventions of realism. His constructed works of clothing, including *Full Dress A Coat*, are created within a traditional vocabulary of representation: the transcription of pleats and folds owes an immense debt both to the late-nineteenth-century *trompe l'oeil* still-lives of artists such as William Harnett and to the photorealism of the 1960s and 1970s of Audrey Flack and Richard Estes. What separates Duecker from these traditions, however, is that what he creates is literally separate from a canvas/frame setup. By freeing his creations from the confines of a frame, he places his realistic objects in a more complicated relationship with the realism of the outside world. His pieces do not enjoy the luxury and/or the restriction of a self-contained narrative. Instead, his objects interact with whatever context they are placed. According to the artist, "when people stand in front of a conventional painting they limit their scope to the borders of that work."[1] For Duecker, these borders should be set by the viewer and not by the frame.

TDS

1. Quoted in *New Works by Otto Duecker*, exhib. brochure (Tulsa, OK: Philbrook Museum of Art, 1987), n.p.

Caio Fonseca
(b. 1959)

~77~

Florence 1993 #1, 1993

Acrylic on canvas

50-1/2 x 39-1/2"

Both Caio Fonseca and his critics use musical terms such as harmony, counterpoint, and interval to describe the relationships between the abstract shapes which he culls from a textured field of color, and links by lines both incised and raised.[1] An accomplished pianist who favors Baroque music, the artist composed *Florence 1993 #1* in much the same way that a musician writes music. First, Fonseca applied raised, horizontal ridges, much like musical staves, to establish the structure of the composition. Next, he covered the canvas with the blue layer, thereby setting the tone, or the mood, of the piece. Then, the white layer obscured all but the blue shapes which harmonize, like musical notes. Finally, both interfigural lines and gold highlights underscored relationships between the primary, blue forms and controlled the tempo of the composition.

KUF

1. *Caio Fonseca*, essay by Brooks Adams, exhib. cat. (New York: Charles Cowles Gallery, 1993); *Caio Fonseca*, text by Karen Wilkin, exhib. cat. (New York: Charles Cowles Gallery, 1994); George Melrod, "Looking Back," *Art & Antiques* 18 (April 1995): 29; Melrod, "Order Beneath the Chaos," *Art & Antiques* 19 (Summer 1996): 113-118.

~78~

Illinois Flatscape #56, 1994

Acrylic on canvas

60 x 82"

Contemporary frame

Harold Gregor began to paint Illinois farmscapes in 1971, after accepting a teaching position at Illinois State University, Normal. Two modes, both photo-derived, distinguish the artist's approach to landscape painting: photorealist vistas and "Flatscapes." The latter are colorful, loosely worked aerial views of agricultural complexes which allow him to both perpetuate the nineteenth-century, American tradition of landscape painting and experiment with color-formed space. A design silk-screened on a cloth cornmeal bag found at a flea market inspired his Flatscapes, and prompted him to hire a pilot. Gregor makes at least one aerial flight each year, during which he takes the photographs that both serve as preparatory sketches and help render perspective.[1]

KUF

1. *Harold Gregor*, essay by Gerald Nordland, exhib. cat. (Rockford, Il: Rockford Art Museum, 1994), with bibliography.

~78~

Stephen Hannock
(b. 1951)

~79~

Flooded Delta with Approaching Fog (for Kensett), 1994

Polished oil over monotype on envelope

4-1/2 x 9-1/2"

Contemporary frame

Stephen Hannock began his career in Massachusetts, near many of the natural landscape features recorded by artists of the Hudson River School, such as Thomas Worthington Whittredge (Plate 16) and John F. Kensett (1816-1872). *Flooded Delta with Approaching Fog (for Kensett)* reprises Kensett's tranquil, idealized landscapes which posited nature as a moral authority, and the American landscape as a component of national identity. Although Hannock, too, has described nature as a cleansing, moral force; both the small scale and the dark palette convey a contemporary conception of the landscape as a site threatened by industrialization, pollution, and urbanization.[1] The used, business envelope visible through the layers of polished oil suggests that commerce has entrapped not only nature, but also art.[2]

KUF

1. Robert Rosenblum, "Art: Contemporary Romantic Landscapes," *Architectural Digest* 50 (May 1993): 195.
2. For a discussion of Hannock's technique, see the exhibition review by Paul Smith in *Art in America* 76 (February 1988): 148.

~79~

Nelson Shanks
(b. 1937)

~80~

Sophia's Head/Portrait, 1994

Oil on canvas

16 x 24"

Contemporary frame

Nelson Shanks has received international recognition for his portraits of prominent people, including Luciano Pavarotti and Diana, Princess of Wales. The artist claims that his paintings "are inspired by the fact that paintings can be *beautiful, informative, and emotional.*"[1] Critics have praised Shanks, who studied with Robert Brackman (Plate 53), for his attention to painterly concerns—including composition, color, draftsmanship, and brushwork—as well as the didacticism that characterizes his still lifes, nudes, and portraits.[2] The artist often includes objects, such as the black beads adorning Sophia, one of the artist's frequent models, that suggest the transience of human life, a thematic tradition derived from seventeenth-century, Northern European painting. Sophia's shiny, black beads not only symbolize the emptiness of earthly possessions; but also contrast with the creamy tones of her skin, thereby underscoring the fleeting beauty of the human form.

KUF

1. Quoted in "A Survey of Contemporary Art of the Figure," *American Artist* 49 (February 1985): 71.
2. See *Nelson Shanks: Paintings and Drawings*, exhib. cat. (Allentown, PA: Allentown Art Museum, 1976); *Paintings by Nelson Shanks*, intro. by Michael Gitlitz, exhib. cat. (Philadelphia: Museum of American Art at the Pennsylvania Academy of the Fine Arts, 1996).

~80~

247

Cyrus Edwin Dallin
(1861-1944)

~*81*~

Medicine Man, 1899

Bronze

31 x 23-1/2 x 7"

Between 1889-1909, Cyrus Dallin developed four monumental, equestrian statues—including *Medicine Man and Appeal to the Great Spirit* (Plate 82)—each depicting the American Indian as the dignified representative of a vanishing civilization. In order to compose these romantic images, Dallin drew upon both his familiarity with the Ute and the Piute Indians, with whom he had associated as a youth, and Buffalo Bill's Wild West Show, which he had sketched as an art student in Paris. His "Indian cycle" won both critical and public acclaim.[1] Monumental versions adorned public spaces, and small-scale reproductions met consumer demand for these figures which conveyed, according to one contemporary critic, "the tragic history and the pathetic destiny of the aborigines of America."[2]

KUF

1. Kent Ahrens notes that neither critics nor Dallin conceptualized these four sculptures as a cycle until after the last, *Appeal to the Great Spirit,* had been cast. See Ahrens, *Cyrus E. Dallin: His Small Bronzes and Plasters*, exhib. cat. (Corning, NY: Rockwell Museum of Art, 1995), 37-39.
2. Alvan F. Sanborn, "Mr. Dallin in Paris," *Boston Evening Transcript*,17 April 1909; quoted in Ahrens, 37.

249

Cyrus Edwin Dallin

(1861-1944)

~82~

Appeal to the Great Spirit, 1909

Bronze (cast 1912)

39-1/2 x 26 x 9-1/4"

Appeal to the Great Spirit, fourth in the cycle that includes *Medicine Man* (Plate 81), secured Cyrus Dallin's reputation, and by the 1920s had inspired both poetry and musical lyrics. Reproduced in three sizes in both plaster and bronze, *Appeal to the Great Spirit* proved popular with educational institutions eager to obtain a small-scale version of the monumental bronze installed outside the Museum of Fine Arts, Boston.[1] Of this composition Dallin wrote, "It has frequently been misinterpreted . . . after the Indian had offered his signal of peace . . . and it had been rejected, I wanted to show the Indian as making a final appeal to the Great Spirit for peace with the white man."[2] European artistic tradition informs this romantic image of the mounted Indian who appeals to a higher power with a supplicatory gesture: the Romans commemorated great leaders with equestrian monuments, and European artists depicted Christian suppliants with arms outstretched.

KUF

1. Kent Ahrens, *Cyrus E. Dallin: His Small Bronzes and Plasters*, exhib. cat. (Corning, NY: Rockwell Museum of Art, 1995), 45-52.
2. Quoted in Ahrens, 45-47.

251

Alexander Calder
(1898-1976)

~♃~

Seven White Dots, c. 1950

Painted metal

12 x 16 x 5"

Before launching his artistic career, Alexander Calder— both the son and the grandson of sculptors—worked as a draftsman as well as an engineer, experiences that informed his art, including the linear quality of his drawing and the structure of his sculpture. In 1931, he created his first mobile, a term coined by Marcel Duchamp to describe Calder's kinetic objects. *Seven White Dots*, a standing mobile, exemplifies the artist's idea that "art is the disparity that exists between form, masses, and movement": wires suspend simplified, geometric forms painted black, white, and red.[1] After he won the grand prize for sculpture at the 1952 Venice Biennale, where he represented the United States, he increasingly gained commissions for monumental, public works. Diverse audiences favored his work, including engineers at M.I.T., who praised the scientific element of his art; collectors, who considered his work avant-garde; and consumers, who snapped up decorator imitations of his objects.[2]

KUF

1. Quoted in *Alexander Calder: From the Collection of the Ruth and Leonard J. Horwich Family*, exhib. cat. (Chicago: Museum of Contemporary Art, 1992), 7.
2. See Mildred Glimcher, "Alexander Calder: Toward Monumentalism," in *Alexander Calder: The 50's,* exhib. cat. (New York: PaceWildenstein, 1995), 5-21.

Louise Nevelson
(b. Kiev, Russia, 1900-1988)

~84~

Untitled, 1985

Painted wood

64 x 43-1/2 x 8"

In the late 1950s, Louise Nevelson, calling herself an "architect of shadows," began to exhibit sculptural walls composed of black boxes.[1] Each box provided a frame in which she arranged found objects, primarily scraps of wood. Often, after painting the assemblage black, she combined these boxes into walls, which, when installed in either a gallery or museum, created a large-scale environment. Although Nevelson drew upon many artistic modes throughout her career, her black boxes, when assembled *en mass*, parallel the work of abstract expressionists such as Joan Mitchell (Plate 70), who combined canvases to create large-scale works that document the artist's struggle to express either elemental forces or essential ideas. Nevelson's assemblages suggest that she subscribed to the modernist notion of artistic alchemy; that is, that creative genius enabled the artist to transform raw materials, such as wood scraps and found objects, into art.

KUF

1. *Nevelson*, exhib. cat. (New York: Whitney Museum of American Art, 1987), 11.

~84~

I. Paintings

(Height preceeds width)

1. Albright, Adam Emory
 1862-1957
 Summer Outing, 1908
 Oil on canvas
 36 x 72-1/4"
 Plate 36

2. Brackman, Robert
 1898-1980
 Lady Seated in a Restaurant, 1927
 Oil on canvas
 28 x 22"
 Plate 53

3. Brown, John Appleton
 1844-1902
 Summer Landscape, c. 1889
 Oil on canvas
 31 x 42"
 Plate 13

4. Brown, John George
 1831-1913
 Little Girl with a Broken Toy, 1866
 Oil on canvas
 8 x 8"
 Plate 3

5. Carlsen, Soren Emil
 1853-1932
 Moonlight and Sea, n.d.
 Oil on canvas
 32-1/4 x 34-1/4"
 Plate 27

6. Chase, William Merritt
 1849-1916
 Ponte Vecchio, 1907
 Oil on panel
 8-3/8 x 12-1/4"
 Plate 34

7. Chase, William Merritt
 1849-1916
 Red Roofs of Bristol, Pennsylvania,
 1899
 Oil on canvas
 20 x 30"
 Plate 24

8. Deming, Edwin Willard
 1860-1942
 An Indian Competition, n.d.
 Oil on canvas
 32 x 60"
 Plate 28

9. Dow, Arthur Wesley
 1857-1922
 Twilight, 1893
 Oil on canvas
 26 x 36"
 Plate 20

10. Dow, Arthur Wesley
 1857-1922
 Ipswich at Dusk, 1890
 Oil on canvas
 32-1/2 x 53-3/4"
 Plate 17

11. Dow, Arthur Wesley
 1857-1922
 Ipswich Study—Flowerfield, 1910
 Oil on panel
 4-1/4 x 6-3/8"
 Plate 42

12. Dow, Arthur Wesley
 1857-1922
 Distant Trees, 1905
 Oil on canvas
 30 x 40"
 Plate 32

13. Dow, Arthur Wesley
 1857-1922
 A Field, Kerlaouen, 1885
 Oil on canvas
 32 x 53"
 Plate 10

14. Dow, Arthur Wesley
 1857-1922
 A Bright Sky with a Breeze, 1910
 Oil on canvas
 33 x 54"
 Plate 41

15. Dow, Arthur Wesley
 1857-1922
 Lavender and Green, 1912
 Oil on canvas
 26 x 36"
 Plate 46

16. Dow, Arthur Wesley
 1857-1922
 Brittany Farm, 1885
 13 x 18"
 Oil on canvas
 Plate 9

17. Dow, Arthur Wesley
 1857-1922
 *The Unpeopled Cities: The Grand
 Canyon, Arizona*, 1912
 Oil on canvas
 12 x 22"
 Plate 47

18. Dow, Arthur Wesley
 1857-1922
 Gay Head, c. 1913
 Oil on canvas
 10-1/2 x 8-1/2"
 Plate 48

19. Duecker, Otto
 b. 1948
 Full Dress A Coat, 1993
 Oil on board
 35 x 24"
 Plate 76

20. Dufner, Edward
 1872-1957
 Golden Days, 1928
 Oil on canvas
 54 x 54"
 Plate 54

21. Enneking, John Joseph
 1841-1916
 Spring Storm Approaching, 1897
 Oil on canvas
 22 x 30"
 Plate 23

22. Evans, De Scott
 1847-1898
 The Idlers, c. 1891
 Oil on canvas
 33-1/2 x 37-1/2"
 Plate 19

23. Fonseca, Caio
 b. 1959
 Florence 1993 #1, 1993
 Acrylic on canvas
 50-1/2 x 39-1/2"
 Plate 77

24. Gilliam, Sam
 b. 1933
 Cyclone, 1991
 Acrylic on canvas
 55 x 38 x 6"
 Plate 73

25. Giovanopoulos, Paul
 b. 1939
 Button Up B, 1989
 Mixed media on canvas
 60 x 45"
 Plate 72

26. Glackens, William James
 1870-1938
 Treading Clams, Wickford, 1909
 Oil on canvas
 25-1/4 x 30-1/8"
 Plate 38

27. Graham, Jr., Robert MacDonald
 b. 1919
 Jessie and Greenberry Ragan,
 1940
 Egg tempera on panel
 36 x 48"
 Plate 60

28. Gray, Henry Peters
 1819-1877
 The Spirit of the Times, 1861
 Oil on canvas
 9 x 7"
 Plate 1

29. Gregor, Harold
 b. 1929
 Illinois Flatscape #56, 1994
 Acrylic on canvas
 60 x 82"
 Plate 78

30. Hannock, Stephen
 b. 1951
 *Flooded Delta with Approaching
 Fog (for Kensett)*, 1994
 Polished oil over monotype on
 envelope
 4-1/2 x 9-1/2"
 Plate 79

31. Harrison, Thomas Alexander
 1853-1930
 Crepuscule (Twilight), c. 1884
 Oil on canvas
 12 x 39-1/2"
 Plate 8

32. Hassam, Frederick Childe
 1859-1935
 Lyman's Ledge, Appledore, 1901
 Oil on canvas
 25 x 30"
 Plate 30

33. Hirsch, Joseph
 1910-1981
 Hercules Killing the Hydra, 1937
 Oil on panel
 11 x 8"
 Plate 58

34. Hitchcock, George
1850-1913
La Fleur de Fevrier: Zeeland, 1908
Oil on canvas
44 x 35"
Plate 37

35. Humphrey, David
b. 1955
First Supper, 1992
Oil on canvas
72 x 82"
Plate 75

36. Hunter, Anna Falconnet
1855-1941
Young Child (Artist's Niece) [Miss Anna Dunn], c. 1883
Oil on canvas
18-1/2 x 9-1/4"
Plate 6

37. Jones, Francis Coates
1857-1932
Candlelight Romance, 1880s
Oil on canvas
21-1/2 x 30"
Plate 15

38. Jones, Francis Coates
1857-1932
Mother and Daughter Playing Checkers, c. 1910
Oil on canvas
22 x 32"
Plate 43

39. Jones, Francis Coates
1857-1932
Tea Leaves, after 1910
Oil on canvas
30 x 35-3/4"
Plate 44

40. Knight, Daniel Ridgway
1839-1924
The Gardener's Daughter, 1885
Oil on canvas
32 x 25-3/4"
Plate 11

41. Lambdin, George Cochran
1830-1896
A Recruiting Party, c. 1864
Oil on canvas
10-1/2 x 14"
Plate 2

42. Lee, Doris
1905-1983
August Afternoon, 1936
Oil on canvas
38 x 50"
Plate 57

43. Lee, Doris
1905-1983
The Bather, 1950
Oil on canvas
35-1/2 x 28-1/2"
Plate 67

44. Lee, Doris
1905-1983
Orchard, 1932
Oil on canvas
20 x 30"
Plate 56

45. Lee, Doris
1905-1983
The Designers, 1948
Oil on canvas
24-1/4 x 40"
Plate 66

46. Lee, Doris
1905-1983
Fox and Geese, n.d.
Oil on canvas
34 x 24"
Plate 63

47. Lee, Doris
1905-1983
Harvest Time, 1945
Oil on canvas
28 x 24"
Plate 64

48. Lee, Doris
1905-1983
Johnny Appleseed, c. 1940
Oil on canvas
36 x 42"
Plate 61

49. Lethbridge, Julian
b. 1947
Untitled, 1991
Oil on canvas
30 x 23-5/8"
Plate 74

50. Luks, George Benjamin
1867-1933
The Bread Line, 1905-25
Oil on panel
17 x 21"
Plate 33

51. Mannheim, Jean
1861/3-1945
Field of Poppies, n.d.
Oil on canvas
20 x 32"
Plate 40

52. Marsh, Reginald
1898-1954
Golf Course Scene, 1922
Oil on canvas, three panels
72 x 75"
Plate 52

53. Metcalf, Willard Leroy
1858-1925
Ebb Tide, 1895
Oil on canvas
13 x 16"
Plate 21

54. Metcalf, Willard Leroy
1858-1925
Midwinter (Number One), 1907
Oil on canvas
29 x 26"
Plate 35

55. Mitchell, Joan
1926-1992
Untitled triptych, late 1960s
Acrylic on canvas, three panels
12-1/2 x 27-7/8"
Plate 70

56. Nichols, Dale
1904-1995
Haying, 1948
Oil on canvas
22-1/4 x 34-1/8"
Plate 65

57. Pearce, Charles Sprague
1851-1914
Peasant Model, 1885
Oil on canvas
16-1/4 x 12-1/2"
Plate 12

58. Pearce, Charles Sprague
1851-1914
Returning Home, 1890s
Oil on canvas
29 x 23-1/2"
Plate 25

59. Pearce, Charles Sprague
1851-1914
Femme sous le Directoire (Woman of the Directory), 1883
Oil on canvas
39-1/2 x 32-1/4"
Plate 5

60. Pearce, Charles Sprague
1851-1914
The Woodcutter's Daughter, 1890s
Oil on canvas
47 x 40"
Plate 26

61. Porter, Fairfield
1907-1975
The Desk, 1963
Oil on canvas
28 x 22"
Plate 69

62. Potthast, Edward Henry
1857-1927
The Bathers, after 1910
Oil on canvas
24-1/4 x 30-1/2"
Plate 45

63. Ritman, Louis
1889-1963
Spring in the Valley, c. 1916
Oil on canvas
26 x 32"
Plate 51

64. Sargent, Margarett Williams
1892-1978
Bathers, 1929
Oil on canvas
31 x 38-1/4"
Plate 55

65. Schreiber, Georges
1904-1977
I Raise Turkeys and Chickens, 1942
Oil on canvas
24 x 20"
Plate 62

66. Schreiber, Georges
1904-1977
Night Haul, Boothbay Harbor, Maine, 1939
Oil on canvas
41 x 56"
Plate 59

67. Shanks, Nelson
b. 1937
Sophia's Head/Portrait, 1994
Oil on canvas
16 x 24"
Plate 80

68. Sloan, John
1871-1951
Sea Monsters, 1914
Oil on canvas
20 x 24"
Plate 49

69. Soyer, Raphael
1899-1987
Woman Biting Her Nails, c. 1972
Oil on canvas
40 x 32"
Plate 71

70. Stewart, Julius
1855-1919
Woman in an Interior, 1895
Oil on canvas
36 x 25-1/2"
Plate 22

71. Thayer, Abbott Handerson
1849-1921
Waterlilies, 1884
Oil on canvas
28 x 25"
Plate 7

72. Tryon, Dwight William
1849-1925
Summer—Connecticut, 1882
Oil on canvas
20-1/4 x 30-1/4"
Plate 4

73. Vonnoh, Robert William
1858-1933
The Brook, c. 1890
Oil on canvas
24 x 20"
Plate 18

74. Warhol, Andy
1928-1987
Printed Dollar, 1962
Acrylic on canvas
4-3/4 x 9-7/8"
Plate 68

75. Watson, Elizabeth Vila Taylor
(active, 1898-1953)
The White Dress, 1903
Oil on canvas
32 x 22"
Plate 31

76. Waugh, Frederick Judd
1861-1940
Low Spring Tide, 1909
Oil on canvas
29 x 36"
Plate 39

77. Wendel, Theodore
1859-1932
Ten Pound Island, Gloucester,
c. 1915
Oil on canvas
30 x 36"
Plate 50

78. Whittredge, Thomas Worthington
1820-1910
The Old Cart Road, late 1880s
Oil on canvas
11 x 15-1/2"
Plate 16

79. Wiles, Irving Ramsey
1861-1948
Girl with Guitar, c. 1889
Oil on board
14-1/8 x 9"
Plate 14

80. Wiles, Irving Ramsey
1861-1948
The Yellow Rose, c. 1900
Oil on canvas
27 x 35"
Plate 29

II. WORKS ON PAPER

(Height precedes width)

81. Adams, Mark
b. 1925
Black Water Jar, 1982
Aquatint/etching
16-1/2 x 16-3/4"

82. Baril, Tom
b. 1952
No. 484 "Rosebuds 96", 1996
Photograph
20 x 26"

83. Cornell, Joseph
1903-1972
Untitled Collage, 1960
Collage
14-3/4 x 11-3/4 x 1-3/8"

84. Curry, John Stewart
1897-1946
Baptism in Big Stranger Creek,
1932
Lithograph
12 x 15"

85. Dow, Arthur Wesley
1857-1922
Modern Art, 1895
Color lithograph
17 x 13"

86. Dow, Arthur Wesley
1857-1922
The Dory, 1895
Color woodcut
5 x 2-1/4"

127. Warhol, Andy

1928-1987

Campbell's Chicken 'N Dumplings,

1970s

Lithograph

31 x 43"

128. Whistler, James A. McNeill

1834-1903

Fumette, 1857

Etching

9-1/4 x 6-1/2"

III. SCULPTURE

(Height precedes length precedes width)

129. Alexander Calder

1898-1976

Seven White Dots, 1950

Painted metal

12 x 16 x 5"

Plate 83

130. Cyrus Dallin

1861-1944

Appeal to the Great Spirit, 1909

Bronze (cast 1912)

39-1/2 x 26 x 9-1/4"

Plate 82

131. Cyrus Dallin

1861-1944

Medicine Man, 1899

Bronze

31 x 23-1/2 x 7"

Plate 81

132. Louise Nevelson

1900-1988

Untitled, 1985

Painted wood

64 x 43-1/2 x 8"

Plate 84